More Women Can Run

MORE WOMEN CAN RUN

Gender and Pathways to the State Legislatures

Susan J. Carroll

and

Kira Sanbonmatsu

OXFORD
UNIVERSITY PRESS

Oxford University Press is a department of the University of Oxford.
It furthers the Universitys objective of excellence in research, scholarship,
and education by publishing worldwide.

Oxford New York
Auckland Cape Town Dar es Salaam Hong Kong Karachi
Kuala Lumpur Madrid Melbourne Mexico City Nairobi
New Delhi Shanghai Taipei Toronto

With offices in
Argentina Austria Brazil Chile Czech Republic France Greece
Guatemala Hungary Italy Japan Poland Portugal Singapore
South Korea Switzerland Thailand Turkey Ukraine Vietnam

Oxford is a registered trademark of Oxford University Press in the UK and certain other
countries.

Published in the United States of America by
Oxford University Press
198 Madison Avenue, New York, NY 10016

Library of Congress Cataloging-in-Publication Data
Carroll, Susan J., 1950–
More women can run : gender and pathways to the state legislatures / Susan J. Carroll,
Kira Sanbonmatsu.
 pages cm.
Includes bibliographical references and index.
ISBN 978–0–19–932243–5 (pbk. : alk. paper) — ISBN 978–0–19–932242–8
(hardcover : alk. paper) 1. Women political candidates—United States.
2. Women politicians—United States. 3. Women legislators—United States.
4. Women—Political activity—United States. I. Sanbonmatsu, Kira, 1970– II. Title.
HQ1391.U5C367 2013
320.082'0973—dc23
2013005488

9 8 7 6 5 4 3 2 1
Printed in the United States of America
on acid-free paper

CONTENTS

LIST OF TABLES

LIST OF FIGURES

ACKNOWLEDGMENTS

This book is the product of research conducted by the Center for American Women and Politics (CAWP) at the Eagleton Institute of Politics at Rutgers University. Several years ago, CAWP convened a conference to reflect on the status of women in politics and the reasons for the flagging numbers of women serving in the state legislatures. As a result of that conference, CAWP decided to replicate a major CAWP study of women's routes to office conducted in 1981. That study, published as a CAWP report in 1983 authored by Susan J. Carroll and Wendy Strimling, provided a comprehensive look at women's and men's pathways to office and found substantial gender differences in how officials reach office. Thanks to the tireless efforts of CAWP's Director Debbie Walsh and the very generous support of our funders, CAWP was able in 2008 to conduct a follow-up study of women's recruitment to state legislative office, repeating many of the questions asked in the 1981 survey.

This study was made possible by a Leadership Matching Grant from the Barbara Lee Family Foundation and motivated in part by CAWP's Recruitment Research Project conference in 2006, which Barbara Lee also funded and attended. We acknowledge with gratitude the generosity of the organizations and individuals who provided additional matching support: Susie Tompkins Buell Foundation; Wendy Mackenzie; AGL Resources; Robert Asaro-Angelo; Nancy H. Becker; Christine L. Cook; Jo-Ann C. Dixon; Mindy Tucker Fletcher; Katherine E. Kleeman; Phyllis Kornicker with Johnson & Johnson matching gift; Lintilhac Foundation, Inc.; Holly Mitchell; Gilda M. Morales in memory of Ms. Hilda M. Hernandez; Connie C. Murray; Nestlé USA, Inc.; New Jersey Laborers-Employers Cooperation and Education Trust; Barbara O'Brien; Maureen B. Ogden; Roxanne Parker; Marnie Pillsbury; Schering-Plough Corporation; Service Employees International Union (SEIU); Candace L. Straight; Christine Todd Whitman; and Otto H. York Foundation.

The encouragement and expertise of CAWP Director and our collaborator, Debbie Walsh, was especially important to the success of this project. This book would not have been possible without her support for and contributions to the research on which it is based. Also at CAWP, Ruth B. Mandel, Gilda Morales, Katherine E. Kleeman, Sue Nemeth, Linda Phillips, Jean Sinzdak, and Jessica Thompson provided invaluable support, information, and assistance. Kelly Dittmar deserves special thanks for the help she provided throughout the project, from the planning stages and data collection to her comments on the manuscript. Kelly's hard work and thoughtful suggestions were critical to the completion of this project. Janna Ferguson's conscientious research assistance also was extremely helpful.

We thank Barbara Burrell, Deborah G. Carstens, Richard L. Fox, Mary Hughes, Gary F. Moncrief, Barbara Palmer, Cindy Simon Rosenthal, Marya Stark, Candace L. Straight, and Wendy G. Smooth for their participation in CAWP's Recruitment Research Project conference and the useful ideas that emerged there. Jane Campbell, Rose Heck, Robin Kelly, Jennifer Lawless, William Pound, Alan Rosenthal, and Cliff Zukin provided valuable feedback and assistance on the survey. We also thank Abt/SRBI Inc. for its capable administration of the survey for the 2008 CAWP Recruitment Study.

We are especially grateful to the many state legislators who responded to our survey and to those women state legislators who took part in follow-up telephone interviews. Without their participation and willingness to share their experiences, this book would not have been possible.

We also thank Angela Chnapko at Oxford University Press for her support and enthusiasm and the anonymous reviewers of the manuscript for their constructive comments. Tracy Osborn and Beth Reingold provided helpful suggestions on conference papers related to this project; we also received valuable feedback at talks at Columbia University, Temple University, and the University of Pittsburgh and on panels at the Midwest Political Science Association, the American Political Science Association, and the State Politics and Policy Conference.

Kira thanks Tim, Vanya, and her family and friends for their support and encouragement. Sue thanks Millie, Sadie, and Luce for demanding walks, playtime, and attention whenever she became too absorbed in her work, thereby keeping her grounded and happy.

Rethinking Candidate Emergence

Almost half a century after the emergence of the contemporary feminist movement with its emphasis on equality for women in all spheres of life, women continue to be dramatically under-represented among public officials in the United States. Women hold fewer than one in five seats in the U.S. Congress and fewer than one in four seats across all the nation's fifty state legislatures (Center for American Women and Politics 2013b). No woman has won election to the presidency. Nationally, women have not reached parity with men at any level of office, and at the state legislative, statewide, and federal levels women have never constituted more than about one-quarter of all officeholders. As of 2013, twenty-four states have never had a woman as governor and twenty-two have never been represented by a woman in the U.S. Senate (Center for American Women and Politics 2013a, 2013f).

The under-representation of women in office persists despite a long history of women's political involvement. Women have been running for public offices—including the presidency—since the late 1800s. Nearly half a century has transpired since the emergence of the modern women's movement which aimed, among other objectives, to increase the number of women in elective office. Progress for women in running for and holding elective office in the United States is apparent in historic firsts, such as Geraldine Ferraro's and Sarah Palin's nominations as vice presidential candidates and Nancy Pelosi's selection as Speaker of the House. Although a woman has yet to win the presidency, the recent candidacies of Hillary Clinton and Michele Bachmann suggest that such a milestone is imaginable. And while women fall slightly short of men's levels in most forms

of political participation other than office holding, on one very important measure of political involvement—voting—women participate at higher rates than men and have since 1980 (Center for American Women and Politics 2011a).

Women enjoy the freedom to stand for office and are therefore on an equal footing with men in a legal sense. But the persistent gender imbalance in office holding raises questions about democratic legitimacy, the inclusivity of American politics, and the quality of political representation. The degree of correspondence between the characteristics of a population and the faces of its governmental officials conveys a message about the capabilities of different groups (Mansbridge 1999). Important policy implications also flow from the presence—or absence—of women in government.[1] The perceived openness of government, the ability of groups to mobilize and voice their interests, the climate within political institutions, the political agenda, and policy outcomes—in short, the conduct of American politics—are shaped by the extent to which elected officials resemble the people.

Despite a half century of activism devoted to electing more women to office and considerable academic research on this topic, there is still disagreement about which strategies would be most effective in increasing the numbers of women in office. Some believe the problem is largely internal to women themselves and that women must be socialized to be more politically ambitious. Others argue that societal changes in gender roles and responsibilities are necessary before women will seek and win election in much larger numbers. Still others believe the answer lies in recruitment efforts by parties and organizations. While some argue for encouraging women to run everywhere, others believe in a more focused strategy of targeting open seats. Some believe that more needs to be done to raise large sums of money for women candidates; others feel public financing of campaigns is a preferable strategy.

Our objective in this book is to move the debates over why women continue to be under-represented forward by reconsidering some of the critical assumptions underlying both academic research and activist efforts. But in order to do so, we first need to review in more detail four of the most common explanations for women's under-representation: political opportunity, voter bias, social roles, and political factors.

1. For a review of the literature about women's representation in the United States, see Reingold (2008).

POLITICAL OPPORTUNITY

One class of explanations centers on the shortage of openings for new candidates. Political scientists have long emphasized the important role that the political opportunity structure plays in restricting the flow of women into public office. Electoral arrangements are not necessarily gender-neutral and can work to women's collective advantage or disadvantage.

Studies from the 1970s and 1980s found that women candidates for legislative seats fared better in multimember than in single-member districts (e.g., Carroll 1994; Darcy, Welch, and Clark 1994; Rule 1990). Apparently, party leaders were more likely to put forward a woman candidate and voters were more likely to support her when she would occupy one of several seats, rather than the *only* seat. In fact, when multiple seats were at stake, the presence of a woman candidate was often thought to help the party's ticket appear more balanced. However, all congressional seats are single-member. And at the state legislative level, the long-term trend has been one of conversion of multimember to single-member districts, spurred in large part by the Voting Rights Act and concern over equitable representation of minorities. As a result, most legislators, at the state as well as at the national level, are now elected in single-member districts.

While the movement away from multimember districts has made this feature of the electoral system less significant today than in the past, a second feature of the political opportunity structure—the power of incumbency—appears potentially as important now as in the 1970s. Scholars of women and politics have long argued that incumbency poses an obstacle slowing the movement of women into public office (e.g., Burrell 1994; Carroll 1994; Darcy, Welch, and Clark 1994; Fox 2000). Most incumbents seek re-election, and most of those who seek re-election win. For example, at the congressional level, more than 90 percent of incumbents who seek re-election have won their races in recent elections. When an incumbent does finally step aside, a backlog of candidates often exists, most of them men, eager to run for the vacated seat. The electoral advantages that accrue to incumbents, including name recognition and fundraising, virtually insure that women's advancement into public office will be slow and incremental, and scholars have frequently viewed the staying power of incumbents as the most important obstacle standing between women and parity in representation.

However, recent evidence from states where term limits have been implemented for state legislative seats suggests that incumbency may not be the most important impediment to women's numerical representation after all, or at least its effects are not as straightforward as once thought.

Forced retirements created by term limits in more than two dozen states have provided numerous political opportunities for women in the form of open seats. Yet, research has found that in many cases women have not taken advantage of these opportunities. For example, Susan J. Carroll and Krista Jenkins (2001) found that no woman candidate entered either party's primary for more than two-fifths of all state house seats vacated because of term limits in 1998 and 2000. And in both 1998 and 2000, more women nationwide were forced to leave state houses because of term limits than were elected to house seats that opened up because of term limits. While term limits broke the stranglehold of incumbency and created possible opportunities for women to seek and win legislative seats in record numbers, far too few women candidates pursued these opportunities, and consequently term limits did not lead to large increases in the number of women legislators in most states where they were implemented.

Thus, removing the barrier of incumbency does not seem sufficient in and of itself to dramatically increase the number of women officeholders. And a change in electoral rules that would mandate an increase in women candidates, such as a gender quota, does not appear to be on the horizon in the United States.

VOTER BIAS AND GENDER STEREOTYPES

The second set of explanations for women's under-representation centers on voter attitudes toward women candidates. The fact that voters have both positive and negative stereotypes of women candidates has been well documented in numerous studies conducted over the years by both scholars and activist groups such as the National Women's Political Caucus and the Barbara Lee Family Foundation (National Women's Political Caucus 1984, 1987; Alexander and Andersen 1993; Huddy and Terkildsen 1993a, 1993b; Kahn 1996; Barbara Lee Family Foundation 2001, 2002). On the one hand, voters view women candidates as more compassionate, caring, honest, inclusive, and consensus-oriented and as more likely to have new ideas, stand up for their beliefs, and understand the needs of voters. Women candidates are seen as more competent than men on issues such as child care, health care, women's issues, the environment, and poverty. On the other hand, women are viewed as less able than men to handle the emotional demands of public life, less able to handle a crisis, not as tough, and less decisive. Women also are viewed as less competent than men on financial issues, military concerns, and foreign policy.

Moreover, there are some voters who are predisposed to vote against women candidates. Since 1937 the Gallup polling organization has asked Americans if they would vote for a woman for president. The proportion of citizens who reported that they would not vote for a woman has declined dramatically over time, and in recent years only about one in ten or fewer admit to having an anti-woman bias (Dolan 2004; Lawless 2004b). However, scholars have long suspected that this question is subject to strong social desirability effects and that the proportion of voters who would not vote for a woman is actually higher. Based on a list experiment, one recent study estimated the proportion of voters who are angry or upset over the idea of a woman presidential candidate is about one-fourth, suggesting that voter bias against women candidates may indeed be greater than indicated in polling results (Streb et al. 2008).

While research has clearly demonstrated that gender stereotypes and voter bias exist, answering the question of whether and how these affect women's campaigns and election outcomes has proven more difficult. In order to investigate whether voter attitudes are to blame for women's under-representation, researchers have compared the experiences of men and women candidates in state legislative and congressional elections. Their studies indicate that women and men candidates attract equal levels of support from voters once incumbency status is taken into account (e.g., Darcy and Schramm 1977; Burrell 1994; Seltzer, Newman, and Leighton 1997). As a result, some researchers called the idea that women have a more difficult time winning office a "myth" (Seltzer, Newman, and Leighton 1997: 90).

However, a newer set of studies suggests more complexity than is conveyed by the popular slogan, "When women run, women win." For example, female members of Congress attract more primary opponents than men (Lawless and Pearson 2008; Palmer and Simon 2012), and female congressional incumbents need to be of higher quality in order to yield the same vote share as male incumbents (Fulton 2012). Whether and to what extent voter attitudes are problematic remains the source of some academic debate (Sanbonmatsu 2002b; Dolan 2010; Brooks 2011), although voter stereotypes about the traits and abilities of female and male politicians are generally thought to alter the campaign choices of female candidates but not to prevent women from running and winning (Huddy and Terkildsen 1993b; Kahn 1996; Dittmar 2012). Stereotypes are believed to be most problematic for women in elections for high-level executive offices such as governor or president (Kahn 1996; Carroll 2009; Carroll and Dittmar 2010). To the extent that voter biases hinder women candidates, these biases are likely to be less consequential for women's bids for less visible and/or entry-level

offices such as state legislative seats. Moreover, party leader attitudes are probably more influential—and potentially more problematic—in shaping women's emergence and success as state legislative candidates than are voter attitudes (Sanbonmatsu 2006a, 2006b).

THE SOCIAL ROOTS OF POLITICAL INEQUALITY

Another set of explanations focuses on women's disadvantages in society and the resulting scarcity of women candidates. We can better understand this line of inquiry through the framework used to analyze women's mass political participation. Admittedly, becoming a candidate is an uncommon way to participate in America's democracy. Only one president, 100 U.S. senators, 435 members of the U.S. House of Representatives, 50 governors, and 7,382 state legislators are elected (with other officials elected depending on the state and locality) out of a population of more than 300 million Americans. Candidacy is uncommon, but it is a form of political participation nevertheless.

In a classic article from the 1970s, Susan Welch (1977) identified three possible explanations—situational factors, structural factors, and political socialization—for why women participated in a variety of political activities at lower rates than men. These explanations are as applicable to running for office as they are to other forms of participation. Situational factors are those related to women's private life responsibilities, especially caring for husbands and children. Women have traditionally borne greater responsibility than men for child rearing and household maintenance. According to this explanation, women's domestic responsibilities have led them to have less exposure to politics and less time to participate. Several studies have concluded that family responsibilities are a major consideration for women in deciding whether to run for office. Young children have been a deterrent; women have tended to wait until their children are grown before seeking office (e.g., Kirkpatrick 1974: 230; Lee 1977; Carroll and Strimling 1983; Carroll 1989). Similarly, spousal support of their political ambitions seems critical for women; few women have run for and been elected to office with less than fully supportive spouses (e.g., Stoper 1977; Carroll and Strimling 1983; Flammang 1997: 167).

Structural explanations focus on women's under-representation in demographic categories that are associated with high levels of participation among men. In the 1970s and 1980s, women in the general population were less likely than men to have advanced degrees and high incomes, and they were attorneys or business executives less often than men. Because

public officials tend to be well educated, have high incomes, and frequently have occupations in law or business, women less often than men were considered to have the background characteristics (and thus the resources and experiences) that might lead to candidacy (Kirkpatrick 1974; Darcy, Welch, and Clark 1994).

The third of Welch's explanations for participation differences focused on socialization differences between women and men. As she acknowledged, the socialization explanation—that women were socialized into a more politically passive role—was a common one in the conventional political science literature of that era (e.g., Githens and Prestage 1977; Lee 1977; Soule and McGrath 1977). However, Welch found little support for this explanation although she did not test it directly. Rather, she found that "women as a whole participate as much as men once structural and situational factors are considered" (1977: 726).

Two decades later another major study of gender differences in political participation came to similar conclusions, arguing that resources seemed to matter more than social learning or adult roles in accounting for participation differences. Kay Lehman Schlozman, Nancy Burns, and Sidney Verba (1994) found that women were disadvantaged with regard to the resources (e.g., money and civic skills) that facilitate political participation. They concluded that if women had political resources equivalent to those of men, gender differences in political participation would be notably diminished.

Although many researchers, like those above, have concluded that the socialization explanation has less validity than other explanations, a major recent study of women and men in the professions of business, education, law, and politics—the social eligibility pool from which candidates often emerge—has revived interest in this explanation, arguing that differences between women and men in political ambition are due largely to gender-role socialization. As Jennifer L. Lawless and Richard L. Fox explained, their "central argument" is "that the gender gap in political ambition results from longstanding patterns of traditional socialization that persist in U.S. culture" (2005: 6–7).

The implication of these accounts focused on the social roots of inequality is that once women are freed from disproportionate familial responsibilities, command the same economic resources as men, hold prestigious occupations at rates similar to those of men, and acquire political ambition similar to men's, the gender gap in participation—including women's office holding—will close. If women's lives were to become more like men's lives, in other words, the political participation gender gaps would be eliminated. In their study of political participation, Nancy Burns, Kay Lehman Schlozman, and Sidney Verba concluded that, were the agenda of

the women's movement to be fulfilled and gender equality realized, "then it would follow as the day the night: gender differences in political participation would disappear" (2001: 385). Similarly, in their account of gender differences among those in the social eligibility pool, Lawless and Fox suggested: "Women's full inclusion in our political institutions requires more than open seats and a steady increase in the number of women occupying the professions that most often precede political careers. It depends on closing the gender gap in political ambition" (2010: 166).

These scholarly accounts are premised on the idea that gender inequality in politics primarily stems from gender inequalities that can be found in society. The social roots of women's lesser political participation—family responsibilities, lack of personal resources and job opportunities, and socialization—receive heavy emphasis. The implication is that women and women's lives must change before political equality can be achieved. The disadvantages that women suffer in society by being women—having less ambition, fewer resources, less occupational status, and more family responsibilities compared with men—must first be remedied before the problem of women's under-representation in politics can be solved.

Unfortunately, inequalities for women in society—including within the family and the economy—persist owing to their structural nature. Despite dramatic changes in gender roles, women still provide a disproportionate share of unpaid domestic labor including the care of children, aging relatives, and veterans. Gender disparities in pay endure despite women's educational and occupational gains (Simon 2011). In its recent judgment on matters of sex discrimination, *Wal-Mart Stores v. Dukes*,[2] the Supreme Court has potentially undermined the ability of women to bring collective claims of pay discrimination in the future.

POLITICAL FACTORS

Explanations focusing on electoral arrangements and social factors leave little room for intentionality or agency to play a role in understanding women's election to office. There is little that women can do, according to these explanations, to increase their level of representation, and unfortunately there is no "invisible hand" at work that ensures that women will seek and be elected to office (Carroll 1994: 182).

However, a fourth explanation for women's under-representation, focusing on influences that can more readily be changed, does allow for greater

2. 131 S. Ct. 2541 (2011).

agency on the part of women. This explanation focuses on political factors, by which we mean the actions of parties and organizations and the role of issues and ideology. The idea that political factors might affect women's election to office has received much less attention compared with the explanations of societal factors and electoral arrangements.

Early studies were divided in their views and findings on the role of party leaders in recruitment. Several studies found that parties seemed to recruit women disproportionately as sacrificial lambs to run in hopeless races (Van Hightower 1977; Gertzog and Simard 1981; Deber 1982; Carroll and Strimling 1983; Ambrosius and Welch 1984; Carroll 1994). Other scholars—most notably R. Darcy, Susan Welch, and Janet Clark (1994)—came to the conclusion that women were not more likely to be recruited as sacrificial lambs and that party leader bias was not to blame for the dearth of women in elective office at the state legislative or congressional level. This conclusion was echoed and taken one step further by Barbara Burrell (1994), whose investigation of the role of parties in congressional elections led her to conclude that more party control over nominations can actually increase women's office holding because women have influence within the parties.

Some recent research has continued to examine the role of political parties, generally adopting a more skeptical stance toward the role of party leaders. David Niven (1998) has identified the bias of county party leaders as a source of women's under-representation, and Kira Sanbonmatsu (2006b) has argued that more party control over nominations negatively affects women's state legislative representation. However, Melody Crowder-Meyer (2010) has voiced optimism about party recruitment as an engine for increasing women's representation in local office.

Some studies have discussed the role of the modern women's movement and women's organizations in electing women to public office, although scholarly attention to this topic has been sporadic. Researchers have noted the important role of women's political action committees (PACs) such as EMILY's List in electing women to Congress in the contemporary era (Burrell 1994; Carroll 1994) and identified the role that women's organizations play in candidate recruitment and training (Rozell 2000). The role of national events has also been identified, particularly in studies of the so-called Year of the Woman election of 1992, in which the Anita Hill–Clarence Thomas hearings put a spotlight on the dearth of women seated in Congress (Carroll 1994; Wilcox 1994). Because the issue environment is dynamic, it can create more or less favorable electoral opportunities for female candidates depending on the year (Kahn 1996; Lawless 2004b; Dittmar 2012).

As others have observed, however, political factors such as parties and women's organizations have generally received much less attention in the women and politics literature compared with other explanations for women's under-representation (Baer 2003). In a stark contrast with the U.S. women and politics literature, the conscious efforts of political actors such as politicians and women's groups to promote women's candidacies through various means—including pressuring parties, enacting new laws, or revising constitutions—occupy a prominent place on the agenda of comparative women and politics scholars (Kittilson 2006; Krook 2009). No doubt, such scholarly emphasis is partly the result of cross-national differences in the existence of debates—often hotly contested—about whether gender quotas should be enacted and in what form. While such quota debates have generally not occurred within the United States, other debates have occurred, and continue to occur.

For example, the status of women candidates within the major parties remains a subject of debate within and outside the Democratic and Republican parties. Women's organizations continue to pursue a conscious strategy to elect more women to office—a strategy that dates back to the early 1970s. These efforts suggest that more attention to the role of political actors may be warranted in studies of women's candidacies. And while partisan polarization as a topic has dominated much of American politics scholarship in recent years, it has been much less discussed within the field of women and politics—no doubt the result of the field's relative neglect of political factors in understanding women's representation. As we will demonstrate, attention to party differences among women is critical to understanding contemporary patterns of women's representation.

GENDERED PATHWAYS TO POLITICS

In order to move the debate over the reasons for women's under-representation forward, we argue that it is necessary to reconsider some of the assumptions undergirding much of the literature. We contend that scholars and activists interested in increasing the numbers of women serving in elective office have generally operated with an underlying assumption that there is a single model of candidate emergence. This is most evident in research that focuses on the social roots of political inequality to account for women's under-representation. The socialization, situational, and structural explanations for differences in women's and men's levels of participation as candidates and officeholders are based on the idea that there is a single dominant model of office holding with scholars typically focusing on

the characteristics and experiences of male officeholders in order to explain women's under-representation.

We believe it is this commitment to a single model that has led scholars to argue that the origins of women's under-representation in politics are primarily sociological. The implication is that as societal changes provide more women with the backgrounds, resources, and experiences that men have long had, the numbers of women candidates and officeholders will increase. As women gain social equality and their lives become more similar to men's, more women will run for office, and if the political opportunities are present, more women will be elected. However, these expectations are based on the fundamental assumption that women's paths of entry into office, and the factors that affect those paths, will primarily be the same as men's—whatever works for the goose will also work for the gander.

Feminist scholars have long questioned political scientists' treatment of men as the norm in political life. For example, writing in 1974, Susan C. Bourque and Jean Grossholtz argued that political scientists have assumed that men's political behavior is the standard against which women should be judged. This assumption has led, in turn, to a focus on the deficiencies of women as compared with men. Bourque's and Grossholtz's critique, focused on mass political behavior and political socialization, is applicable to elite politics and office holding as well. Indeed, writing on the topic of political ambition, Barbara J. Burt-Way and Rita Mae Kelly observed:

> The assumption has long been that women's different, and usually lower, socio-economic status, different and less prestigious types of political experience, and different sex role attitudes are constraints not only in the development of ambition but also in deciding to run for higher office. Thus, the definition of what constitutes political ambition has typically been defined by male political career patterns and leads to the conclusion that women will be more ambitious and more successful when they attain the same characteristics as men. (1992: 23)

We suggest that a fruitful way to move forward in the study and practice of women and politics is to consider women on their own terms. Our approach is to analyze what has worked for women elected officials. By looking at officeholders—women who have successfully run for and been elected to the legislature—we try to understand if women must conform to the dominant model in order to achieve parity in office holding or if they are forging other pathways to office. We test the validity of the assumption that there is a single model of candidacy and consider the possibility that there are alternative models that better describe women's entry into office.

We also investigate the hypothesis that women's descriptive under-representation has political as well as social origins. As Jane Junn has advised, more scholarly attention in the field of gender politics is needed to discern "the public roots as well as the private roots of public action" (2007: 132). She has argued, "Rather than focus on the individual as the thing that needs fixing—more motivation, higher resources, stronger democratic values—a higher level of scrutiny should be directed at the institutions and practice of the democratic system itself" (2007: 131–132). Rather than prioritizing society as the primary way that gender matters, we consider the role of politics itself in creating and maintaining the gender gap in office holding.[3] Part of our investigation considers whether and how party affects women's pathways into office.

WHY STATE LEGISLATORS?

Much of the early research on women in elective office examined women state legislators, beginning with Emmy E. Werner's classic overview of women serving in the state legislatures in the mid-1960s (1968), Jeane J. Kirkpatrick's *Political Woman* based on interviews conducted in 1971 with fifty women state legislators (1974), Irene Diamond's study of women in New England legislatures (1977), and the nationwide surveys of women legislators conducted by the Center for American Women and Politics in 1975 and 1977 (Johnson and Stanwick 1976; Johnson and Carroll 1978). One of the major reasons for the early focus on state legislators was methodological; with so few women serving in Congress or statewide elected positions, the state legislatures were the highest level of office with a sufficient number of women to permit statistical analysis.

More recently, however, scholars have shifted their attention to the U.S. Congress. With the election of record numbers of women to Congress in 1992, the so-called Year of the Woman, the number of women serving in Congress almost doubled, from thirty-two to fifty-four, after decades of stagnation, and this number has usually increased incrementally with each subsequent election (Center for American Women and Politics 2013d). The election of more women to the U.S. House and Senate captured the attention of the public and the scholarly community but, perhaps more significantly, increased the number of women sufficiently to make systematic

3. For recent work by American political development scholars on the role of the state in shaping the category of gender, see Mettler (2005, 1998), Ritter (2006), and McDonagh (2009).

analysis feasible. Not surprisingly, feminist political scientists increasingly turned their attention to studying women in Congress (e.g., Burrell 1994; Gertzog 1995; Swers 2002; Dodson 2006; Palmer and Simon 2012), and research on women state legislators has waned.

Ironically, however, research on women state legislators has fallen out of fashion during the very era in which considerable responsibility for solving some of the country's most pressing domestic problems has shifted from the federal government to the states. Today the state legislatures play a more important role than in the past in governance and policy making on numerous issues critical to the lives of American citizens. In policy areas ranging from education to health care to the regulation of marriage to transportation to homeland security, the states bear more responsibility than ever and make decisions that dramatically affect the welfare of their citizens. According to 2007 estimates provided by the National Conference of State Legislatures (NCSL), the federal government shifted about $100 billion in costs to the states over the preceding four fiscal years (Tubbesing and Miller 2007).

Moreover, the state legislatures play a crucial role in the political pipeline that fuels women's representation at the national level. Activists and scholars alike refer to a pipeline of candidates and officeholders that runs from the local to the state to the national level. Women who serve in offices at the state level, most notably the state legislature, constitute a potential pool of candidates for seats in the U.S. Congress. The effectiveness of this pipeline is evident in statistics on the backgrounds of women who serve in Congress. Of the seventy-eight women who were members of the U.S. House in 2013, forty-three had previously served in the state legislature (Center for American Women and Politics 2013e). Similarly, of the twenty women serving in the U.S. Senate in 2013, eleven served as state legislators (Center for American Women and Politics 2013f).[4] Because so many of the women who seek and win election to Congress are drawn from the state legislatures, changes or developments in the backgrounds or experiences of political women may show up in the state legislatures years before they are evident among the women who serve in Congress.

Women continue to be represented in higher proportions in the state legislatures than in Congress. In 2013, women held 24.0 percent of the state legislative seats across the country, compared with 18.3 percent of

4. Of the women serving in the U.S. Senate, five served as state senators and seven as state representatives. Of the women in the U.S. House of Representatives, twenty served as state senators and thirty-seven as state representatives. These statistics include women who served in both state legislative chambers.

the seats in Congress (Center for American Women and Politics 2013b). Moreover, the number of women state legislators serving in 2013 was 1,769, compared with 98 women serving in Congress. So, clearly the much larger number of women at the state level permits much more extensive analysis than the relatively limited analysis allowed by the still relatively small number of women at the national level.

For all these reasons, then, research on women in the state legislatures is needed as much today as it was three decades ago. The women who serve in the legislatures are at the forefront of public policy in many issue areas, they constitute a major pool of potential future candidates for Congress, and statistically their numbers are large enough to allow for more in-depth analysis.

DATA

We analyze data from national surveys of women and men serving in state legislatures conducted by the Center for American Women and Politics. Our two main data sets are CAWP recruitment studies from 2008 and 1981. Data for each CAWP recruitment study were gathered through a survey instrument sent to legislators in all fifty states consisting primarily of questions concerning the decision to seek office, previous political experience, and personal background.[5] The 2008 CAWP Recruitment Study, funded in large part by the Barbara Lee Family Foundation with matching funds from the Susie Tompkins Buell Foundation, Wendy McKenzie, and other donors, was designed in large part to replicate the original, 1981 CAWP Recruitment Study, funded by the Charles H. Revson Foundation.

The 1981 study was based on four samples: the population of women state senators (N = 137); the population of women state representatives (N = 769); a systematic sample of men state senators, stratified by state and sampled in proportion to the number of women from each state in the population of women state senators (N = 136); and a systematic sample of men state representatives (N = 382), stratified by state and sampled in

5. See the Appendix for more details. Respondents were promised confidentiality. Our approach—which is to rely on self-reports—is commonly used to study recruitment; for example, Moncrief, Squire, and Jewell (2001) and Sanbonmatsu (2006b) surveyed state legislative candidates and Fox and Lawless (2010) surveyed potential candidates. Our approach treats state legislators as experts about their personal electoral experience and decision-making process. Because our data are self-reported, it is possible that there may be some inaccuracies in legislators' perceptions. However, perceptions are extremely important; legislators' perceptions of their electoral circumstances are critical to their candidacy decisions.

proportion to half the number of women from each state in the population of women state representatives.[6] A total of 789 legislators completed the survey for an overall response rate of 55.4 percent.[7] The survey was conducted by mail.

Our 2008 sampling strategy was modeled on the 1981 study.[8] We included the population of women state senators (N = 423); the population of women state representatives (N = 1,314); a random sample of men state senators, stratified by state and sampled in proportion to the number of women from each state in the population of women state senators (N = 423); and a random sample of men state representatives (N = 1,314), stratified by state and sampled in proportion to the number of women from each state in the population of women state representatives. A total of 1,268 legislators completed the survey for an overall response rate of 36.5 percent.[9] The survey was conducted primarily by mail and web, with a small number of completions by phone.

6. The men were sampled in this manner to ensure that we compared women and men who were elected and served in similar political and legislative environments since women legislators are distributed quite unevenly across the states. A list of men state legislators was constructed from a directory published by the Council of State Governments. The list of women state legislators was obtained from the Center for American Women and Politics. At the time of this study, women constituted 12.1 percent of state legislators (Center for American Women and Politics 1981).

7. The response rate was higher among women than men. The response rates were as follows: women state senators, 53.3 percent; men state senators, 50.0 percent; women state representatives, 58.1 percent; and men state representatives, 52.6 percent.

8. Samples were based on lists of legislators and women legislators serving in January 2008 provided by the National Conference of State Legislatures and the Center for American Women and Politics.

9. The response rate was higher among women than men. The response rates were as follows: women state senators, 40.7 percent; men state senators, 27.9 percent; women state representatives, 40.7 percent; and men state representatives, 33.6 percent. We had hoped for a higher response rate that was more similar to the 1981 CAWP Recruitment Study and invested significant time and resources to obtain the best response rate possible; our contracted survey research firm Abt/SRBI Inc. used multiple modes and contacted legislators repeatedly. Unfortunately, with the proliferation of state legislator surveys by scholars as well as political groups, it has become much more difficult since the early 1980s to persuade legislators to participate. Our response rate is not unlike that of other recent, major studies of state legislators. For example, the response rate was 40.1 percent for the 2002 National Survey of State Legislators, which was a joint project of three organizations well known and highly regarded by state legislators—the National Conference of State Legislatures, the Council of State Governments, and the State Legislative Leaders Foundation (Kurtz, Cain, and Niemi 2007). The state legislator survey portion of the 1998 Candidate Emergence Study conducted by L. Sandy Maisel, Walter J. Stone, and Cherie Maestas has a response rate of 32 percent (Fulton et al. 2006).

We also present evidence from in-depth, semistructured phone interviews conducted in the fall of 2009 with twenty-two women state legislators, twelve Democrats and ten Republicans, from fifteen states that varied in geography, partisan control, and level of professionalism of the legislature. The interviews, which were approximately thirty to sixty minutes in length, were intended to supplement and help us understand the survey results of the 2008 CAWP Recruitment Study. We selected women legislators for interviews based on their biographical information; those interviewed were diverse in their backgrounds and ideologies. Several had been actively involved in recruiting candidates to run for the legislature. We asked the women we interviewed for their general perspectives on women's election to the state legislatures and for their interpretations of some of our key survey findings.

CHAPTER PREVIEW

In the pages that follow, we investigate candidate emergence and political recruitment of women for state legislatures by focusing on those who have successfully run for and been elected to the legislature. In focusing on legislators—those who won—we are examining the paths to the legislature that have proven successful for women. In examining the factors that affect entry of women into state legislative office, we are particularly concerned with how these factors have (or have not) changed over the past two and one-half decades and what these changes over time suggest about the validity of the underlying assumption in the literature that there is a single model of candidate emergence and political recruitment. As societal changes have provided more women with the experiences that men have long had, have their pathways to office come more and more over time to resemble those of men? Or are women following alternative pathways into office? And how, if at all, do these pathways vary for women of different parties?

Throughout our analyses, our approach is primarily a consideration of the bivariate relationship between gender and pathways to office: we compare the pathways of women as a group with men's pathways. We are less interested in the individual as the unit of analysis than in the overarching patterns that emerge when we compare women state legislators with their male colleagues.[10]

10. On the difficulties of studying gender with individual versus aggregate data, see Burns (2007).

In chapter 2, we test the assimilation assumption that women's gains in politics will occur largely through the same pathways that men have traditionally taken to public office and explore whether there are other explanatory models that might better describe women's pathways into office. Using our survey data to assess the demographics, backgrounds, and prior experience of women and men legislators, we look for evidence of convergence, divergence, or the persistence of gender differences over time in the pathways that women and men have taken to political office. Based on our analysis in this chapter, we conclude that the pool of women eligible to run for office is much broader than is commonly believed.

In chapter 3, we examine the assumption that women's political careers conform to the traditional model of ambition and consider the possibility that an alternative model seems more often to characterize women's decision making. We argue for a model of "relationally embedded candidacy" that we believe better describes women's emergence as candidates than the traditional ambition framework.

In chapter 4, we begin an investigation of the role of political party in shaping women's election to office by analyzing possible explanations for the declining numbers of Republican women state legislators. In doing so, we emphasize the importance of recruitment and the role of politics itself, concluding that geographical and ideological changes in the strength of the Republican Party and its response to the women's movement have impeded growth in the numbers of Republican women legislators.

In chapter 5, we examine why Democratic women's numbers have continued to increase even as Republican women's numbers have declined, with an emphasis on the role that public policy seems to play in motivating Democratic women and the notable growth in the numbers of women of color. We also investigate some of the factors, especially party support and fund-raising, that may have kept Democratic women's numbers from increasing even further.

In chapter 6, we conclude and discuss implications for the status of women in politics and for the study of women in politics. We argue for enhanced scholarly attention to politics alongside analysis of women's social position and roles. While the absence of barriers to women's election is a necessary condition for gender parity in office holding, we conclude that increasing women's representation also depends greatly upon encouragement and support for women candidates.

CHAPTER 2

Can More Women Run? Reevaluating
Pathways to Office

Much has changed for women in politics since 1981. The term "gender gap" came into popular use for the first time following the 1980 election of Ronald Reagan when analysts observed a difference in the voting patterns and political preferences of women and men. On the heels of the gender gap, Reagan made history by nominating the first woman to serve on the U.S. Supreme Court. At that time only 23 women served in Congress, just 4.3 percent of its members (Center for American Women and Politics 2013b). Today the gender gap is widely recognized as an enduring feature of American politics, three of the nine justices on the Supreme Court are women, and ninety-eight women serve in the U.S. House and Senate (18.3 percent of all members of Congress) (Center for American Women and Politics 2013b).

Women still bear more responsibility than men for caregiving within the family (Sayer 2005; Sayer et al. 2009). However, women's status outside the home has changed considerably, and gender roles are much more flexible today than several decades ago. Women now earn a majority of postsecondary degrees. They also earn nearly half of law degrees compared with only about 30 percent in 1980 (U.S. Census Bureau 2011). In 2009, for the first time in U.S. history, women became a majority of employees (Mulligan 2010).[1] A Pew Research Center study found that 22 percent of married men

1. *The New York Times* reported that, according to the U.S. Department of Labor, women constituted a majority of nonfarm payroll employees for four months in 2009.

in 2007 compared with 4 percent in 1970 were married to wives whose education and income exceeded their own (Fry and Cohn 2010).

Surely we should expect these changes in the social and political landscape to have implications for how gender is related to office holding. Scholars have long observed that many women legislators take paths to office that differ from men's (Kirkpatrick 1974; Diamond 1977; Carroll and Strimling 1983; Burrell 1994; Thomas 1994; Dolan and Ford 1997; Thomas, Herrick, and Braunstein 2002). But over time, gains in women's educational and occupational status and the attenuation of traditional gender roles should have weakened the relationship between gender and pathways to office.

While we might expect to see changes in the relationship between gender and office holding over time, there are different models that may help to explain any changes that have occurred. The first possibility is an assimilation model, where men's pathways constitute the political norm and women's pathways into office come more and more over time to resemble this norm. Because women's lives outside politics have come in many ways to look more like men's lives over the past two and one-half decades, a similar pattern may be evident in the political sphere with women's routes to office conforming over time to the standard set by men. As we argued in the previous chapter, most existing accounts of women's election to office are premised on the assumption that gains in women's office holding will occur through such an assimilation process.

Alternatively, it is possible that change has been bidirectional rather than unidirectional; change may have occurred in men's as well as women's pathways into office. After all, the social changes that have occurred in gender roles since the emergence of the modern women's movement have affected both women and men. Although the changes have been less dramatic than for women, men's lives have been altered. Paralleling changes in society more generally, changes in pathways into office may be apparent for men as well as for women with a new norm emerging that reflects the convergence of what were formerly gender-based routes into office. Thus, changes in pathways into office may have followed a convergence model where men's pathways into elective office have come to look more like women's pathways at the same time that women's have come to more closely resemble men's.

While both of these explanatory models seem plausible, a third possibility presents itself: a persistent differences model. Gender differences in the pathways to office may not have narrowed over time. Perhaps the gender-related changes we have seen in the larger society have not been sufficient to lead to notable changes in the ways women and men enter office, or

perhaps social changes take a longer time frame to manifest themselves in the political arena than in other arenas of society. If so, women may continue to take distinctive pathways to office when compared with their male colleagues despite significant changes in gender roles.

In this chapter we examine the backgrounds of women and men state legislators in 1981 and 2008 to see how well these various models—the assimilation model, the convergence model, and the persistent differences model—help explain the changes that have, or have not, taken place over time in the pathways that women and men follow into office. By focusing on those who have won election to office, we are examining the paths to the legislature that have proven successful for women.

WHO IS "ELIGIBLE" TO RUN FOR OFFICE?

Writing in 1994, R. Darcy, Susan Welch, and Janet Clark predicted that women would constitute more than half of nonincumbent women state legislative candidates by the year 2006 (1994). Their model of women's office holding took into account the structural factors that they identified as the main impediments to women's election to office: incumbency and the social eligibility pool. Darcy, Welch, and Clark argued that sex discrimination and socialization created a gender imbalance in the occupations that typically precede a political career. The dearth of women in the social eligibility pool resulted from the highly sex-segregated nature of the workforce, especially the small numbers of women in the fields of law and business. They argued:

> ...a substantial part of the underrepresentation of women in public office in the United States is because of their underrepresentation in this eligible pool: the business and professional occupations [e.g., law] from which most officials are recruited.... [C]hanging the occupational distribution of women would influence their recruitment to public office (Darcy, Welch, and Clark 1994: 108).

Thus, when Darcy, Welch, and Clark predicted that women would come to compose a majority of nonincumbent state legislative candidates, they envisioned an almost automatic relationship between the rise of women in the fields of law and business and the rise of new women candidates. Of course, as we know with the benefit of hindsight, their prediction has not been realized and women today constitute only about one-quarter of nonincumbent candidates for the legislatures.

Despite the failure of Darcy, Welch and Clark's prediction, the eligibility pool is still viewed as an important cause of women's under-representation. Indeed, in their recent work on citizen ambition, Jennifer Lawless and Richard L. Fox (2005) used the eligibility pool approach. In order to identify those citizens who are "potential candidates," they constructed a sample of individuals working in occupations from which elected officials tend to be drawn—law, business, and education—as well as political activism.

Darcy and his coauthors recognized that at least some women officeholders had reached office as homemakers or with careers in female-dominated professions such as education and social work. But they did not believe that these backgrounds would be the source of future growth in women's representation. Arguing that "women's occupations and activities have not provided the same sort of gateway to political office as prestigious male occupations" (1994: 112), Darcy, Welch, and Clark excluded women's presence in female-dominated professions from their model of women's office holding.

Because of the continued importance of the social eligibility pool to theories about women's representation, we begin our analysis with an examination of the relationship between occupation and office holding. We seek to determine if women have assimilated to the routes that men tend to take to office, if women and men have converged to a common pathway, or if gender differences have persisted.

WHO SERVES?

Occupational Backgrounds

The story of pathways to office in the 1980s was one of gender difference. In 1981, when CAWP conducted its first recruitment study, significant differences in legislators' occupational backgrounds were apparent. Women state legislators were much less likely to reach the legislature from careers in traditionally male-dominated occupations such as law and business (Table 2.1).[2] In 1981 only 6.4 percent of women state representatives and 5.6 percent of women state senators were attorneys; their male colleagues were much more likely to practice law (Tables 2.1 and 2.2). Women were also less likely than their male counterparts to come to the legislature

2. For our comparisons of women state legislators with their male colleagues, we include tests of statistical significance within the tables. For comparisons of women and men state legislators that do not appear in tables, we use footnotes to indicate any gender differences that are statistically significant.

from business (Tables 2.1 and 2.2). Only 4.6 percent of women state representatives and no women state senators were business owners.

Instead, women were much more likely than their male colleagues to have occupations in female-dominated fields. Fully one-fifth of women state representatives and senators were elementary or secondary school teachers in 1981 compared to much smaller proportions of their male colleagues. Although the numbers were relatively small, women were also more likely than men to have jobs (other than physician and dentist) in the fields of health care and social work (Tables 2.1 and 2.2).

Fast forward to 2008, and perhaps surprisingly, these occupational differences largely remain intact. Despite two decades of social and economic change, the predominant pattern evident in occupational pathways to office is still one of gender difference. Women and men come to the legislature from a variety of occupations, but women and men legislators continue to hail from different fields on average.

Although women state legislators were more likely to be lawyers in 2008 than they were in 1981, they remain less likely to practice law than their male colleagues (Tables 2.1 and 2.2). Similarly, women continue to be less likely than their male colleagues to have backgrounds in business-related fields although more women now come from a business background. Similar proportions of female and male state representatives and senators identified as self-employed or business owners in 2008, but fewer women than men worked in other business-related occupations (Tables 2.1 and 2.2).

Women state legislators today continue to be much more likely than their male counterparts to come from the fields of education and health care. In 2008 almost one of every five women state representatives in both chambers were elementary or secondary school teachers, compared with about one of every ten of their male colleagues. Even more women were nurses or health care workers (other than physician or dentist) in 2008 than in 1981; meanwhile, only tiny numbers of men came to the legislature from these health-related occupations in either year (Tables 2.1 and 2.2).

While the predominant pattern in these occupational data is clearly one of continued gender difference, women have assimilated to men's pathways in at least one noteworthy way: there has been a decline over time in the proportion of women legislators who report never having an occupation outside the home. Whereas 16.7 percent of women state representatives reported that they had never been employed outside the home in 1981 and thus could be characterized as full-time homemakers, only 3.5 percent of women could be categorized in this way in 2008. This shift in the

Table 2.1. OCCUPATIONAL BACKGROUNDS OF STATE
REPRESENTATIVES

	1981		2008	
	Women %	Men %	Women %	Men %
Elementary or secondary school teacher	20.2**	6.4	17.5**	10.9
College professor	2.5	3.2	3.5	2.4
Educational administration	na	na	2.4	1.7
Other education	na	na	2.2*	0.5
Nurse or other health worker (excludes physician)	4.1**	0	8.3**	0.7
Physician or dentist	0**	1.6	0.4*	1.9
Other health care	na	na	2.2*	0.5
Social worker	1.6	0.5	2.2	1.2
Lawyer	6.4**	15.4	9.1*	13.9
Self-employed/ small business owner/ business owner	4.6**	14.9	7.3	8.7
Other business	na	na	7.1**	13.4
Real estate or insurance salesworker	3.7**	10.6	3.0	3.5
Farmer	1.6**	11.2	2.6*	5.7
Editor or reporter	1.1	0	2.0	0.9
Nonprofit	na	na	4.7**	0.9
All other occupations	37.4	36.2	22.2**	33.0
Homemaker/not employed outside the home	16.7	na	3.5**	0.2
N =	436	188	508	424

* $p \leq .05$, ** $p \leq .01$
Source: 1981 and 2008 CAWP recruitment studies.

occupational profile of women legislators parallels the significant increase
in women's labor force participation and the decline in the number of full-
time homemakers occurring in the larger society since the early 1980s.

On the one hand, the limited evidence of assimilation that we see in
our data is surprising given the rise in women's labor force participa-
tion, women's educational advances, and the increase in women lawyers.
On the other hand, though, perhaps we should not have expected to see

Table 2.2. OCCUPATIONAL BACKGROUNDS OF STATE SENATORS

	1981		2008	
	Women %	Men %	Women %	Men %
Elementary or secondary school teacher	20.8	9.1	20.0**	7.2
College professor	2.8	3.0	3.6	2.7
Educational administration	na	na	0.6**	6.3
Other education	na	na	0.6	0
Nurse or other health worker (excludes physician)	4.2	0	7.9**	0.9
Physician or dentist	1.4	7.6	1.8	3.6
Other health care	na	na	2.4	0.9
Social worker	1.4	0	3.0	0
Lawyer	5.6*	19.7	10.9	17.1
Self-employed/ small business owner/ business owner	0**	9.1	7.3	9.0
Other business	na	na	6.7	11.7
Real estate or insurance salesworker	4.2	3.0	1.8*	7.2
Farmer	1.4	7.6	1.2**	8.1
Editor or reporter	4.2	1.5	3.0	0.9
Nonprofit	na	na	6.1**	0
All other occupations	30.6	39.4	18.2	24.3
Homemaker/not employed outside the home	23.6	na	4.9*	0
N =	72	66	165	111

* $p \leq .05$, ** $p \leq .01$
Source: 1981 and 2008 CAWP recruitment studies.

dramatic change in legislator backgrounds. After all, despite the movement of women into nontraditional fields, the labor market remains quite segregated, with certain occupations largely populated with women while others are dominated by men.[3]

3. See Hegewisch et al. 2010; Coontz 2012; Cotter, Hermsen, and Vanneman n.d. <http://www.bsos.umd.edu/socy/vanneman/endofgr/matrix.html>. Accessed August 2, 2011.

The rise in women legislators over time has not been accompanied by a large increase in the share of women legislators who are lawyers. Instead, the occupational backgrounds of many women legislators continue to reflect those areas in which women have traditionally exhibited expertise: education and health. As a result, two important correctives to existing accounts of women's office holding seem merited. First, it does not appear that the numbers of women in the traditionally male-dominated fields of law and business are as important to explaining the under-representation of women in office as previously thought. The numbers of women entering law and business fields has increased substantially over the past two or three decades, and yet women officeholders remain far from parity with men in numbers and still are notably less likely than their male colleagues to have backgrounds in law and business.

As a second corrective, we suggest revisiting the notion that women have difficulty reaching office from female-dominated occupations. By implication, this means that we should expand our conception of the eligible pool of women candidates. Our occupational findings imply that the pool of women who can run for public office may be much larger than we have commonly assumed. After all, the number of women who work in traditionally female-dominated fields, such as education and health care, far exceeds the number of women lawyers. According to data from the U.S. Bureau of Labor Statistics, women were only 34.4 percent of lawyers in 2008 (U.S. Bureau of Labor Statistics 2009). But women were 74.0 percent of workers employed in education-related occupations—81.2 percent of elementary and middle school teachers and 56.0 percent of secondary school teachers (U.S. Bureau of Labor Statistics 2009). Although women constituted only 30.5 percent of physicians and surgeons, they were 91.7 percent of registered nurses. Simply considering the fields of education and health care as part of the social eligibility pool would greatly expand the number of potential women candidates.

Education

Darcy, Welch, and Clark view educational attainment, in addition to occupation, as an important determinant of who is eligible to run for office. Writing in the early 1990s, they argued that women were at a "definite disadvantage in terms of education" (1994: 108). Although women outnumbered men among college students at that time, fewer women than men in the general population had completed college or obtained some postgraduate training. Because "college seems to be nearly a prerequisite for

the modern legislator" (1994: 108), Darcy, Welch, and Clark concluded that education was another factor limiting women's presence in the eligibility pool and thus another critical factor contributing to their under-representation among officeholders.

Educational differences between women and men have continued to narrow over the past three decades. In contrast to 1980 when only 13.6 percent of women 25 and older, compared with 20.9 percent of men, had graduated from college, women are now almost as likely as men to hold a bachelor's degree. According to U.S. Census data, in 2009, 29.1 percent of women and 30.1 percent of men 25 and older had completed undergraduate school. Moreover, because women are a larger proportion of the American population than men, the sheer number of women holding bachelor's degrees is greater than the number of men (National Center for Education Statistics 2010).

Change is particularly evident among the younger generation. In April 2010, a U.S. Census Bureau press release predicted that "more women than men are expected to occupy professions such as doctors, lawyers and college professors as they represent approximately 58 percent of young adults, age 25 to 29, who hold an advanced degree" (U.S. Census Bureau 2010). In this young age cohort, 9 percent of women, compared with only 6 percent of men, had earned advanced degrees (U.S. Census Bureau 2010). Also, as widely reported in the media, women now frequently outnumber men among entering classes of law students.

Although legislators can be found at all educational levels, both women and men in state legislatures tend to be drawn from the better educated strata of society. For example, in 2008, 78.6 percent of women state representatives and 84.5 percent of women state senators had graduated from college, and 46.2 percent of women state representatives and 55.3 percent of women state senators had earned advanced degrees (i.e., a master's or a doctorate). Education levels of legislators have increased over time, and legislators of both genders were somewhat more educated in 2008 than in 1981.

Nevertheless, despite the fact that the education gap between women and men in the general population has greatly diminished over time (and even shows signs of reversing itself among the younger generation where women are now more educated than men), education gaps continued to be apparent among state legislators in 2008. These gaps, however, follow a curvilinear pattern, with women more likely than men to have master's degrees and men more likely than women both to have ended their formal education with high school and to have obtained doctorates, especially J.D.s (Table 2.3).

Table 2.3. STATE LEGISLATORS' EDUCATIONAL ATTAINMENT

	1981		2008	
	Women %	Men %	Women %	Men %
Representatives				
High school	8.9**	16.5	4.3	6.0
Some college	28.9	23.0	17.1	15.7
College graduate	37.1*	29.0	32.4	35.4
Master's degree	15.5	11.5	31.6**	21.2
Ph.D./Ed.D./M.D.	2.1	2.5	4.5	7.2
J.D.	6.8**	17.0	9.6*	14.5
Advanced degree (not specified)	0.7	0.5	0.4	0
N =	439	200	509	401
Senators				
High school	5.6*	17.9	1.9	4.6
Some college	25.0*	11.9	13.7	10.2
College graduate	38.9	26.9	29.2	34.3
Master's degree	20.8	16.4	39.1**	22.2
Ph.D./Ed.D./M.D.	2.8	6.0	5.6	7.4
J.D.	6.9*	20.9	10.6*	21.3
Advanced degree (not specified)	0	0	0	0
N =	72	67	161	108

* $p \leq .05$, ** $p \leq .01$
Source: 1981 and 2008 CAWP recruitment studies.

Comparing the educational levels of state legislators in 1981 and 2008, there are some signs of convergence, but the main pattern is one of persistent gender differences. The proportion of men with law degrees decreased just slightly from 1981 to 2008 among state representatives while remaining the same among state senators. In contrast, the proportion of women with law degrees increased for women legislators in both chambers, offering some evidence of both convergence (for state representatives) and assimilation (for state senators). Nevertheless, we see gender differences in 2008 with women in both houses of the legislature less likely than men to have been trained as attorneys; in fact, among state senators only half as many women (10.6 percent) as men (21.3 percent) had law degrees. Thus, despite some evidence of convergence and assimilation, the dominant pattern over time with regard to law degrees is one of persistent gender differences.

In 1981 women were notably more likely than men to have ended their formal educations upon earning a bachelor's degree and just slightly more likely than men to have master's degrees. By 2008 this pattern had shifted upward with women equally or just slightly more likely than men to have a bachelor's as their highest degree but notably more likely to have earned a master's degree.

Thus, while some changes over time are evident, gender differences in educational levels among legislators remain. These findings on education reinforce the findings of gender differences in occupational pathways to office. Although most of the women who gain election to state legislatures are very well educated, they are less likely than men to have formal legal training and law degrees. Women have managed to run successfully for legislative office without having the same educational credentials as men. Being well educated seems to help, but a law degree certainly is not a prerequisite.

Family Factors

As women's educational attainment, occupational status, labor force participation, and income have risen, their domestic lives have changed as well. These changes in women's lives have been accompanied by changes in men's domestic lives. But the changes in men's lives have been smaller, and women remain the primary caregivers within the family.

The persistence of traditional gender roles, especially women's disproportionate responsibility for caregiving, helps explain our findings on the impact of family-related factors on women's political careers. Consistent with previous research (e.g., Blair and Henry 1981; Carroll 1989), we do find that family considerations are often important to the political decisions of men as well as women. We also find some evidence of convergence between women and men as a result of changes that have occurred among men legislators since the early 1980s. Nevertheless, despite the passage of several decades, family continues to have different implications for women's and men's candidacies.

While family considerations affect both women and men, they still play a larger role in women's candidacies. Analyzing the results of the 1981 CAWP Recruitment Study, Susan J. Carroll and Wendy S. Strimling observed that the differences they found between women and men who held public office "suggest that considerations about children's needs and spouse's attitude affect a woman's decision about seeking elective office more often than they affect a man's" (1983: 7). Although much has changed since 1981, we find that the gendered division of labor within the home continues to have powerful implications for women's decisions to seek state legislative office and the timing of women's political careers.

Table 2.4. SPOUSE/PARTNER APPROVAL AS A FACTOR IN THE
DECISION TO RUN

	1981		2008	
	Women %	Men %	Women %	Men %
Representatives				
Very important	84.3	77.8	76.0	82.0*
N =	306	162	371	383
Senators				
Very important	87.5	78.0	77.8	80.4
N =	48	59	117	97

Question wording: "Below are various factors that have been suggested to be important in influencing decisions to run for office. Please indicate how important each factor was in affecting your decision to run the first time for the office you now hold.... Approval of my spouse or partner."
* $p \le .05$, ** $p \le .01$
Note: This table is limited to those state legislators who are married or living as married.
Source: 1981 and 2008 CAWP recruitment studies.

We asked legislators to rate the importance of various factors in influencing the decision to run the first time for their current office.[4] In both time periods, overwhelming majorities of married legislators in both state senates and houses responded that "approval of my spouse or partner" was "very important" to their decision (Table 2.4). One important change between 1981 and 2008 is that male legislators in both chambers are more likely now than in the past to identify spousal approval as very important. A statistically significant difference has emerged among state representatives, and interestingly, it is men in 2008 who are slightly more likely than women to rate this factor as "very important."

While married legislators regardless of gender see spousal support as very important, it is noteworthy that women in both chambers were much less likely than their male counterparts to be married in both 1981 and 2008 (Table 2.5). Women also tend to be more likely to be divorced, separated, or widowed compared with their male colleagues.

We also asked about the level of spousal support for the legislator's office holding, and here gender differences are more apparent and in the expected direction. Among both state representatives and state senators who were currently married or living as married, women in both 1981 and 2008 were

4. Response options were "very important," "somewhat important," "not important," or "not applicable."

Table 2.5. MARITAL STATUS OF STATE LEGISLATORS

	1981		2008	
	Women %	Men %	Women %	Men %
Representatives				
Married	72.1**	84.0	67.9**	87.0
Divorced or separated	11.0**	4.0	12.9**	4.6
Widowed	8.2*	3.0	11.6**	1.4
Single, never married	8.7	9.0	4.6	5.7
Living as married	na	na	3.0	1.4
N =	437	200	527	437
Senators				
Married	68.1**	89.4	68.1**	82.1
Divorced or separated	13.9	7.6	15.4*	7.7
Widowed	15.3**	0	8.3	3.4
Single, never married	2.8	3.0	6.5	3.4
Living as married	na	na	1.8	3.4
N =	72	66	169	117

$* p \leq .05, ** p \leq .01$
Source: 1981 and 2008 CAWP recruitment studies.

more likely than men to say that their spouse or partner was "very supportive" of their office holding (Table 2.6). Few legislators of either gender reported that their spouses were indifferent or resistant to their holding office, but men were more likely than women to acknowledge that their spouses were only "somewhat" supportive.

Levels of spousal support were very similar for women in both time periods, but some change in the direction of convergence with women is evident among men. Men—especially among state representatives—were notably more likely to report a "very" supportive spouse in 2008 than in 1981 (although still less likely to do so than women) and less likely to report that their spouses were indifferent or somewhat resistant to their office holding (Table 2.6). These findings suggest that family considerations are playing a greater role in men's career decisions today than in previous decades.

Parenting, another important aspect of legislators' family lives, has typically presented a more complex set of calculations for women in politics than for men as documented by a sizable body of research (e.g., Lee 1977; Carroll and Strimling 1983; Carroll 1989). Gender differences are strikingly

Table 2.6. SPOUSAL SUPPORT AMONG STATE LEGISLATORS

	1981		2008	
	Women %	Men %	Women %	Men %
Representatives				
Very supportive	82.7**	58.2	83.2**	74.2
Somewhat supportive	14.3**	27.9	12.8**	22.0
Indifferent	1.0**	5.5	2.4	1.8
Somewhat resistant	2.0**	8.5	1.6	2.1
N =	307	165	376	387
Senators				
Very supportive	87.8**	62.7	88.1**	69.7
Somewhat supportive	8.2*	23.7	6.8**	21.2
Indifferent	2.0	5.1	1.7	4.0
Somewhat resistant	2.0	8.5	3.4	5.1
N =	49	59	118	99

Question wording: "If currently married or living as married, would you say that your spouse/partner is [very supportive of/somewhat supportive of/indifferent toward/somewhat resistant toward] your holding public office."
* $p \le .05$, ** $p \le .01$
Source: 1981 and 2008 CAWP recruitment studies.

apparent in the extent to which considerations around children enter into the political decision-making calculus of legislators, and these gender differences have been remarkably consistent over time. We asked legislators about the importance of the following factor to their decision to run: "My children being old enough for me to feel comfortable not being home as much." In both 1981 and 2008, a majority of women state legislators in both chambers—and a much larger proportion of women than men—rated this factor as "very important" to their decision to run the first time for their current office (Table 2.7).

In keeping with this evidence about the role that considerations about children played in legislators' decisions to seek office, women representatives and senators were less likely than their male colleagues in both 1981 and 2008 to have young children (Table 2.8). In both years, almost no women, but a few men, had children under the age of 6, and the vast majority of women, and a smaller majority of men, had no children

Table 2.7. AGE OF CHILDREN AS A FACTOR IN THE DECISION TO RUN

	1981		2008	
	Women %	Men %	Women %	Men %
Representatives				
Very important	57.3**	37.7	56.7**	41.9
N =	426	191	526	437
Senators				
Very important	69.4**	35.8	50.9**	34.8
N =	72	67	171	115

Question wording: "Below are various factors that have been suggested to be important in influencing decisions to run for office. Please indicate how important each factor was in affecting your decision to run the first time for the office you now hold.... My children being old enough for me to feel comfortable not being home as much."
* $p \leq .05$, ** $p \leq .01$
Source: 1981 and 2008 CAWP recruitment studies.

under the age of 18. Interestingly, while the proportions of both women and men with children under the age of 6 were similar in 1981 and 2008, the proportions of state representatives with children under the age of 18 declined noticeably for both women and men over the past quarter century. For example, while one of every three women state representatives serving in 1981 had a child under 18, only about one of every seven women serving in 2008 had a child that young (Table 2.8).

The decline in the proportion of legislators with children under the age of 18 is likely a reflection of the "graying" of state legislatures. The NCSL has found an increase in the age of legislators in recent years. The average age for a contemporary legislator is 56, with almost three-fourths of legislators (71.5 percent) age 50 or older (National Conference of State Legislatures n.d.). This "graying" of legislators reported by NCSL is also evident in the CAWP studies. The mean age of women representatives in 2008 was 57, up from a mean age of 48 in 1981, and the mean age of women senators similarly increased from 50 in 1981 to 59 in 2008. The mean ages for the women's male colleagues (57 for both representatives and senators in 2008) were similar to those for women. As Table 2.9 makes clear, there were relatively few women or men under the age of 40 serving in either chamber in 2008, and fewer in 2008 than in 1981. The vast majority of women legislators and their male counterparts serving in 2008 were 50 or older.

Although legislators of both genders are now less likely to have young children than in 1981, reflecting the higher age of legislators in 2008, the gender

Table 2.8. PARENTAL STATUS OF STATE LEGISLATORS

	1981		2008	
	Women %	Men %	Women %	Men %
Representatives				
Child under 6	3.7**	11.9	3.0**	8.2
Child under 18	33.3	39.9	14.5**	22.4
N =	429	193	531	438
Senators				
Child under 6	2.9	9.1	1.2	2.6
Child under 18	21.4**	54.6	13.5*	23.1
N =	70	66	170	117

* $p \leq .05$, ** $p \leq .01$
Source: 1981 and 2008 CAWP Recruitment Studies.

differences apparent in 1981 were still evident in 2008. In both time periods women legislators were less likely than their male colleagues to have young children at home. This pattern suggests both that women still are more likely than men to wait until their children are older to run for office and that family responsibilities remain a greater impediment for women than for men.

Political Experience

In 1981, women arrived in the state legislatures with more experience than men on a host of dimensions. Women legislators were more likely to have had campaign and staff experience. For example, 82.3 percent of women representatives compared with 74.5 percent of their male colleagues had worked on a political campaign before seeking office themselves. Among senators, 83.3 percent of women compared with 71.6 percent had worked on one or more campaigns. Similar differences were evident for staff experience. In 1981, 23.4 percent of women state representatives compared with 15.9 percent of their male colleagues had worked on the staff of a public official before seeking office themselves. Among state senators, 24.2 percent of the women but only 12.1 percent of the men had experience working on the staff of an officeholder.[5]

5. These gender differences are statistically significant ($p \leq .05$) for state representatives. Differences among state senators are not significant at conventional levels ($p \leq .10$).

Table 2.9. AGE OF STATE LEGISLATORS

| | 1981 | | 2008 | |
	Women %	Men %	Women %	Men %
Representatives				
Less than 30 years old	6.1	8.1	0.8*	2.5
Between 30 and 39 years old	15.8*	22.3	5.5	6.0
Between 40 and 49 years old	31.9**	19.8	12.8	15.7
Between 50 and 59 years old	32.1	26.9	37.2*	30.2
60 and older	14.2**	22.8	43.8	45.6
N =	430	197	514	434
Senators				
Less than 30 years old	4.4	0	1.8	0
Between 30 and 39 years old	10.1	20.9	1.8	5.2
Between 40 and 49 years old	29.0	26.9	12.8	16.4
Between 50 and 59 years old	34.8	35.8	39.6	32.8
60 and older	21.7	16.4	43.9	45.7
N =	69	67	164	116

* $p \leq .05$, ** $p \leq .01$
Source: 1981 and 2008 CAWP recruitment studies.

The same pattern exists today. In 2008, women state representatives were more likely than their male counterparts to have worked both on the campaign of a candidate (73.6 percent compared to 60.3 percent), and on the staff of an elected public official (21.8 percent compared to 17.1 percent).[6] The experiences of state senators in 2008 largely mirror those of state representatives, except that women and men had more similar levels of staff experience.

We also find that women legislators are somewhat more likely than men to have been active in their political parties although we do not have

6. The gender difference in campaign experience is statistically significant ($p \leq .01$).

comparable data for 1981. Women and men serving in the lower chambers in 2008 had similar levels of experience at the level of the local party; about 42 percent of both women and men served as members or chairs of their local party committees before running for the legislature. But women were somewhat more likely than men (12.4 percent of women compared to 7.1 percent of men) to have served as members or chairs of their party's state or national committees and slightly more likely (33.4 percent of women compared to 29.3 percent of men) to have attended a party convention.[7]

Women state senators were about equally likely as men state senators (11.1 percent compared to 11.4 percent) to have served as chairs of state or national committees, but they were more likely than their male colleagues to have been members or chairs of their local party committees before running for the legislature (43.3 percent compared to 36.8 percent) and to have attended a party convention (41.5 percent compared to 36.0 percent).

Women are also more likely than their male colleagues to have attended a campaign training program or workshop. In 1981, 57.8 percent of women state representatives compared with 43.4 percent of their male colleagues had attended at least one training. By 2008 larger proportions of both women and men reported having participated in a campaign training program, but gender differences were as apparent as they were in 1981. In 2008, 75.0 percent of women state representatives had attended at least one campaign training compared to 59.6 percent of their male colleagues.[8] Like their female colleagues in the state house, women state senators were also more likely to have attended a campaign training workshop than were male state senators in both 2008 and 1981.

The greater experience levels among women compared with men raise the question of whether women need so much experience to reach the legislature. It may be that women acquire more experience in order to bolster their confidence and feel sufficiently qualified while men more often feel qualified without a great deal of experience. Some of the women legislators we interviewed suggested this might indeed be the case. One woman legislator thought that women may have more experience because women want "to feel solid about their credentials before they put themselves out there." Another legislator suggested it was "an act of self protection"—that having more experience helped women feel more secure. But it may not just be that women are not as confident about their qualifications as men; the flip side is that men may be overconfident. Several of the legislators we interviewed

7. The gender difference in state/national party committee experience is statistically significant ($p \leq .01$).

8. These gender differences are statistically significant ($p \leq .01$).

expressed the view that men often do not feel they need much experience to run. As one legislator suggested, "I think sometimes women are more honest about their abilities—and maybe a little more realistic and practical."

An alternative explanation for the finding that women have more political experience is that there may be a double standard in which more is expected of women candidates. Women may need more experience than men in order to be viewed as equally qualified. As one legislator explained, "when women come on the scene, they have to prove themselves whereas men are given the presumption of competence until they disprove it." Another woman legislator, observing that a woman "is going to have to have more qualifications and work harder," went on to explain that party leaders "won't even look at a woman unless she's got some experience, but they will look at a man without the same qualifications if he is a warm body and he can work hard and raise money." These sentiments were echoed by another woman legislator who suggested, "because we are women, a minority, . . . we have to appear a little smarter and have a little more experience to better our male opponents. Unfortunately sad but true—the reality of it." Although we are not able to distinguish between explanations and say with confidence why it is that women acquire more experience than men, the pattern of women being more qualified is clearly evident. And it is a persistent pattern across more than two decades.

IMPLICATIONS FOR RECRUITMENT

We have found only limited evidence for the assimilation and convergence models as explanations for patterns we observe over time in the pathways to office taken by women and men. Perhaps the strongest evidence for an assimilation model is the fact that few women legislators today report that they are full-time homemakers. In this respect, women officials have come over time to resemble their male colleagues. Women also are more likely today than they were in 1981 to work in law or business, the two most common occupations for male legislators, providing some additional evidence for an assimilation model.

We also find some evidence consistent with a convergence model of women's and men's pathways to office. The proportion of women legislators with law degrees has increased since 1981, offering some evidence of convergence in the case of state representatives, where the proportion of men who are attorneys has declined somewhat. In addition, we find that family considerations play a greater role in men's political career decisions today than they did a quarter century ago with men coming to look more like women in terms of the importance they attach to their spouse's

approval of their political involvement. This finding also is more consistent with the convergence hypothesis.

However, despite these findings suggesting that some modest assimilation and convergence have occurred, the majority of evidence in this chapter is consistent with a model of persistent gender differences in pathways into office. The differences in the backgrounds of women and men serving in legislatures in 2008 were stunningly similar to the differences that were apparent in 1981. Despite widespread societal changes over the past quarter century, our findings for 1981 and 2008 are remarkably consistent. What is most striking and in many ways surprising is the lack of evidence of change.

Unlike their male colleagues, many women legislators in 2008 continued to come from occupations in the female-dominated fields of health care and education. Similarly, women in 2008 were less likely than their male counterparts to have only high school educations or doctorates, especially law degrees, just as they were in 1981. They were more likely than men to be concentrated in the middle of the educational range: more likely to have bachelor's degrees in 1981 and more likely to have master's degrees in 2008. Relative to men, women in both years were more likely to report that their spouses were very supportive of their office holding, less likely to have young children, and much more likely to report that having older children was very important to their decisions to seek office. Finally, women in 2008 as in 1981 were more likely than men to have political experience before seeking office themselves, including working on campaigns, serving as staff to an elected official, and attending campaign training. In all these respects the pattern we find is one of persistent gender differences in the pathways to public office.[9]

Moreover, despite some recurrent patterns in women legislators' pathways into office (the tendency to have occupations in traditionally female-dominated occupations, to be college-educated or have master's degrees, to have supportive spouses and grown children, to have acquired considerable political experience before running), their backgrounds also reveal remarkable variability. As the tables in this chapter show, women come to the legislature from a variety of occupations and educational levels. While most are older and do not have children at home, some women legislators are younger and some do have young children. Although women are more likely than men to have political experience before running for office, some women do run successfully without campaign experience and party involvement. Just as women do not follow the same pathways into office

9. These gender differences are not a product of differences in electoral circumstances faced by women and men. For example, women and men were equally likely to have faced a primary opponent and to win a seat previously held by their party.

as men do, so too it is impossible to identify a single dominant pathway that women take into office. There is no "women's pathway" to office with respect to occupational and educational backgrounds. Rather, there are a variety of pathways women follow.

Our in-depth telephone interviews reinforce this conclusion. We asked the women legislators we interviewed, "What kinds of qualifications and experience, if any, do you think women need to have before they run for the legislature?" Their answers are very revealing. Some legislators seemed initially to be stumped by this question because they did not perceive that there were particular qualifications or experiences that women needed to have.

Remarkably few pointed to education or occupation as a qualification, and when they did, they generally were not referring to advanced degrees. The legislator who most strongly emphasized education and occupation said the following: "I certainly think that education—a college educa-tion...is very important these days....We have female colleagues who have come to the table as attorneys....[T]hat adds value...in terms of how people perceive them."

Others who mentioned education treated it as a baseline qualification and then went on to emphasize personal qualities as being equally or more important. One legislator observed, "I think anyone needs to have an education....Other than that I think honesty, integrity, willingness to serve are all you need." And another made clear that while education was important, the educational bar was low. She explained, "I think you need to be educated enough...like at the newspaper level, like at the sixth grade level....[Y]ou need to be educated but not [necessarily] well educated. And I think you have to like people."

The legislators did not perceive that political experience per se was an important prerequisite, although one legislator from a state where par-ties play a particularly strong role in the recruitment process explained, "I don't think there is a clearly defined path of how you get there. But to satisfy the party—in other words, to get endorsed—which is a very, very powerful thing...you have to pay your dues to the party." While she was the only legislator who mentioned party involvement as criti-cal, several of the legislators did emphasize community involvement and civic activism as important assets for women who want to run for the legislature. One legislator explained, "I think the main qualification is just to be engaged in city affairs and have a commitment to improv-ing your community and maybe a bit of a track record in working with people in organizations." She went on to explain that this activism was more important than any "technical or professional qualifications."

Another legislator agreed, "a well-rounded candidate is one who exposes themselves to a variety of interest groups and issues and concerns....So I think it behooves female candidates to kind of get out and about in their community and have a wide network of folks from a diverse set of groups." A third legislator explained that what women need in order to be a candidate is "ideally a base in the electorate where you are going to run, based on work you've done in the community, whether it is PTA or civic leadership, neighborhood involvement, an important voice on an issue, or service." Yet another legislator explained how women's civic activism can lead to a run for the legislature:

> ...[women] need to be involved in their community, whether PTA president or community association president or on the board of a community organization or non-profit. Get the exposure with issues that they will be confronting with the legislature....It should be that they are so involved in these issues in their community that when they decide to run, it is like, yes, that is the next logical step.

The women legislators who responded to our survey manifested a strong level of civic activism before running for office the first time, indicating that their involvement in their communities may well have helped pave the way for their candidacies, just as our in-depth interviews with legislators suggested.[10] Among women state representatives, for example, the proportions reporting in 2008 that they had been active or very active in various types of organizations was 53.8 percent for women's organizations, 51.4 percent for children's or youth organizations, 51.2 percent for church-related or other religious groups, 51.2 percent for business or professional groups, and 42.6 percent for service clubs such as Rotary.

Beyond civic activism and community involvement, the women legislators we interviewed tended to emphasize personal qualities—not occupation, education, or experience—as the major prerequisites for running for the legislature. One woman legislator who "didn't have any political background, just my nursing background" before running and who initially got involved in legislative activities through a nursing

10. Our interview evidence echoes Sanbonmatsu's (2006b) findings about state legislator qualifications as perceived by state legislative and state party leaders from the fifty states. Party leaders rated community involvement as the most important qualification for a state legislative candidate, higher in importance than political or party experience or legal or other occupational experience.

organization suggested, "I think anybody who really wants to [run] can, but it helps to have good organizing skills, good computer skills...a profession, a claim to fame if you will, and a reason to get involved." Another legislator who was involved in recruiting candidates for the citizen legislature in her state explained, "We look for people who are going to be likeable by the public, who are going to work hard, who have some background in their community...there is no one thing you need other than some interest in doing it and some willingness to work hard to get elected." When asked what qualifications and experience women need to run for the legislature, one of the legislators we interviewed answered bluntly and simply, "None." However, she then went on to elaborate, "It is a willingness, and once you have that willingness and desire, then it is a commitment to give it everything you've got." She felt this level of commitment was especially important for women, "Because it is a lot harder to raise money; it is a lot harder to convince voters that you are just as good if not better than your male counterparts."

CONCLUSION

Women's representation in the legislatures increased between 1981 and 2008 despite our finding of persistent gender differences in backgrounds and experience. We therefore can conclude that women need not assimilate to a model of pathways into office based on the experiences of men. Of course, women remain far from parity with men in office holding, and women's movement into legislative office might be further enhanced if more women followed the routes into office that many men have traditionally followed (e.g., using careers in law or business as launching pads). However, women and those who recruit women to run for office need not restrict themselves to these traditional pathways. Rather, women have found success over the years, even if more limited than many advocates would like, by forging new pathways into state legislatures. Achieving parity will likely require the use of multiple pathways.

The persistence of gender differences over time and the fact that there seem to be few, if any, prerequisite qualifications or experiences a woman needs to have before running for the state legislature leads us to conclude that many more women could run. The desire to serve and a commitment to working hard may be more important than years of political

experience. Women candidates need not come from traditionally male candidate pools or occupations. Female-dominated occupations such as education, health care, and social work offer rich potential recruiting grounds for those interested in increasing the number of women in office. And while more young women officeholders might be desirable, women whose children are older might be more open to the idea of seeking a legislative seat. Our analysis of who serves clearly suggests a need to think more broadly and less conventionally about the women who might serve in the future.

CHAPTER 3

Gender and the Decision to Run for Office

Political scientists have generally adopted the framework of political ambition theory in studying candidacy for public office, typically assuming that a long-standing interest in public life precedes office holding (e.g., Schlesinger 1966). But ambition theory may not be an adequate framework for understanding how individuals decide to run for office. The traditional view that ambition precedes the decision to run may not always apply. For starters, political careers may not be planned, making them more difficult to predict. The process of candidate recruitment, in which potential candidates are approached and encouraged to run, can create candidates from individuals who had never before contemplated running for office. Meanwhile, a community concern or issue may attract a citizen's attention, spur activism, and eventually lead to a bid for elective office although a political candidacy was not something this citizen had previously considered.

We analyze state legislators' decisions to seek elective office in this chapter. Where possible, we compare state legislators in 2008 with state legislators in 1981. Our analysis reveals that a traditional model of ambition, in which candidacy is self-initiated, offers a less adequate account of how women reach office than of how men do so. We argue for an alternative model of candidacy, one that seems to apply more often to women than to men, that recognizes running for office as a relationally embedded decision.

The study of political careers has focused on the ambitious politician (Schlesinger 1966). The decision to enter a given electoral contest can be understood as an individual, rational calculus in which a politician assesses the relative costs and benefits of running for a given office and the probability of winning (Black 1972; Rohde 1979; Jacobson and Kernell 1981; Brace 1984; Abramson, Aldrich, and Rohde 1987; Maisel et al. 1990; Stone, Maisel, and Maestas 2004). Gender has generally been thought to interact with the traditional ambition model, leading certain factors to weigh more heavily in women's decision making than in men's. For example, using the ambition model, Sarah Fulton and her colleagues (2006) have found gender differences in how state legislators reached a decision about pursuing a seat in the U.S. Congress. Similarly, Kathryn Pearson and Eric McGhee (2004) have argued that women congressional candidates are more likely to be strategic than men because of the hurdles that women face in electoral politics. Palmer and Simon (2003) have also used the ambition framework to understand changes over time in women's congressional office holding.

As Linda Fowler (1993) has observed, however, the ambition literature takes the ambitious politician as given. For this reason, ambition theory is better able to explain the decision calculus of those who already hold office than that of first-time candidates. This deficiency in the literature led scholars Richard L. Fox and Jennifer Lawless (2004) to focus on the origins of political ambition, studying women and men in those occupations from which officeholders most often emerge and distinguishing between two forms of political ambition, nascent and expressive. In their view, candidate emergence proceeds in two stages:

> In order to leave the pool of eligible candidates and run for office, potential candidates undergo a two-stage process that serves as a precursor to the strategic side of the decision to run. First, they must consider running for elective office; potential candidates will never emerge as actual candidates if the notion of launching a campaign and what that entails does not enter into their frame of consciousness. Only after the notion of a candidacy crosses a potential candidate's mind can he/she determine that the benefits to entering the electoral arena outweigh the costs. (Fox and Lawless 2004: 267)

Fox and Lawless contend that the lower rate of ambition found among women in the eligibility pool is problematic for the future of women's office holding because "nascent ambition—or the inclination to consider a

candidacy" (2005: 644) is a precursor to expressive ambition, or interest in a specific electoral contest.

Yet, women's pathways to politics, in particular, do not always seem to conform to a linear process in which nascent ambition precedes the candidacy decision. Instead, ambition and candidacy may arise simultaneously; recruitment for a specific race can spark interest in running for office. Rather than preceding political involvement, ambition may be a product of a political opportunity or the recruitment efforts of political parties or other actors (Fowler 1993; Aldrich 1995). For example, Sanbonmatsu's (2006b) study finds that political parties can create state legislative candidates: a potential candidate who has never thought about running can become a candidate because the party taps him or her for a given race. It may not be necessary for women (or men) to harbor political ambition in order to run for public office. And Fox and Lawless (2010) argue that recruitment affects political ambition, implying that recruitment can be causally prior to nascent ambition.

Research conducted by Gary Moncrief, Peverill Squire, and Malcolm Jewell (2001) also casts doubt on whether the framework of ambition theory adequately captures the experiences of women candidates.[1] In a survey of nonincumbent state legislative candidates in eight states, Moncrief and his coauthors found that women were much more likely than men to seek a state legislative seat after receiving the suggestion to run. Women were much less likely than men to be what the authors call "self-starters" who reached the decision to run for the legislature entirely on their own. Meanwhile, women were more likely than men to be "persuaded" candidates who decided to run for the legislature after receiving the suggestion to run from someone else. Women were also more likely than men to be "encouraged" candidates, who reported a mix of their own thinking and the suggestion of someone else.

Based on this earlier research as well as the findings of our own research presented in this chapter, we question whether existing accounts of candidacy that are premised on the idea of ambition are as applicable to women's pathways to office as they are to men's. The ambition framework envisions individuals with a long-standing interest in politics who run for office under the right electoral conditions. We do not wish to argue that there is a "male" or "female" way of making the decision to seek office, but we do advance an alternative view of candidacy that may more often characterize women's decision-making process than men's.

1. See Squire and Moncrief (2010) for additional evidence.

We argue that for women more than for men, candidacy is a "relationally embedded decision." By relationally embedded decision, we mean that women's decision making about office holding is more likely to be influenced by the beliefs and reactions, both real and perceived, of other people and to involve considerations of how candidacy and office holding would affect the lives of others with whom the potential candidate has close relationships. The candidacy decision-making process takes place in the context of a network of relationships and is deeply influenced by relational considerations. This view is consistent with the findings of research on gender differences in both leadership styles and decision making in other contexts. For example, social-psychological research by Alice Eagly and others has found that men are viewed as more agentic (e.g., assertive, ambitious, confident, and competitive), while women are viewed as more communal (e.g., nurturant, sensitive to the needs of others, helpful, and supportive), and these differences seem to affect their leadership styles. Eagly and Johannesen-Schmidt (2001) have found that women managers have a more transformational leadership style, with the greatest gender differences evident on a scale of "individualized consideration," which focused on mentoring followers and attending to their individual needs. This pattern of women being more relational and other-oriented is evident in other research on gender differences in leadership, such as that of Judy B. Rosener (1990), who found women managers to have an "interactive leadership" style. And, of course, women's relational orientation has also been evident in research on gender differences in moral decision making, most notably the work of Carol Gilligan (1993) who found the concepts of care and responsibility figured centrally in women's resolution of moral dilemmas.[2]

There are clear reasons to expect that women's decision making about running for office will be more influenced by relationships with other people. The candidate emergence process occurs within larger gendered social and political contexts. The gender gap in candidacy is often attributed to gender differences in social roles, and we, too, believe that gender differences in social and economic roles and in the household division of labor give rise to different patterns of decision making about candidacy. The home front holds consequences for how a woman juggles a career—including a career in politics—with family life. Although gender roles are changing, women still bear disproportionate responsibility for child care and household maintenance (Sayer 2005; Sayer et al. 2009). And the

2. See also England (1989) and Driscoll and Krook (2012) on feminist challenges to theories premised on an autonomous rational actor.

traditional division of labor in the home affects the resources, education, and skills available to women for political participation (Burns, Schlozman, and Verba 2001). We therefore would expect that women's decision making about running for office is more likely to include considerations about how other family members feel about the decision and how their lives might be affected.

Our analysis suggests this is the case. As we saw in chapter 2, the candidacy decisions of women legislators are very much affected by their relationships with other family members, especially their children. We found few women served in legislatures while their children were young, and much larger proportions of women than men reported that the fact that their children were older was a very important factor in their decision to run for their current legislative office.

Our interviews with women legislators were filled with references to the important role that family relationships played in women's decisions to seek elective office. One state representative explained her own decision and the timing of her candidacy this way:

> I do think it is harder for women to make that decision to spend a lot of time away from their kids....I decided to do this when my kids were about three and six, but I put it off until they graduated high school. That is because I represent a rural district, and their whole school life I would have been in [the state capitol], and it wasn't a cost I wanted to pay....And for men...if they are married, they have someone at home who can tend to the home fires....If we had a wife, it would be better, but we don't have wives.

Another woman legislator who is very involved in candidate recruitment in her state observed:

> We very often encounter women who say, "Well, I have young kids; I definitely can't do it." I've seen women with young kids in the legislature who have had a hard time serving. So there really is a reality to it being difficult for women with young children, whereas men with young children don't seem to have much of a problem at all.

And she went on to explain that relationships with spouses strongly affect decisions as well:

> ...we've tried to get some specific women to run with husbands who are not supportive, and they don't do it. I have never seen them decide to do it over that objection when I've known about it.... [T]he spouse thing can go either way, but

often when the male spouse doesn't want the female spouse to do it, ... it does not happen.

Yet another state representative perhaps best explained how and why family relationships are more important to women's decisions to run:

> I think women and men weigh considerations about children and spouses differently. And I also think it is much harder for women, and here is why. First of all, I believe most women view themselves as the primary parent. ... It is the mom who starts the dinner in the crock pot if she is not going to be home to make dinner. It is the mom who calls and says, "Did you do your homework?" If she is not there, she replaces herself: "Honey, can you pick up Joey from scouts tonight? I am going to be late getting home." It is mom who actually has primary responsibility for all those things involving children and husbands and houses. Now the husband can help, but he is usually helping. He is not the one who remembers that Joey needs to be picked up from football. ... So to accept a job that actually has tremendous time demands is a harder choice for women because she has [to do] so much more to replace herself. And maybe she doesn't want to miss it either. ... The time demands of a political job are way more than most other jobs a woman can take. ... And not just the job, but there are also the other things. In the legislature we are ... always running. So you are always attending a Boy Scout function or a fire company function or knocking on doors. ... So if you are the primary parent, and most women are the primary parent, it is a harder decision to make and you need a lot of support.

It is not just women's roles in the home and family that may lead to differences in the way that women and men emerge as candidates. In our view the decision to run takes place in a political as well as a social context. While gender scholars tend to privilege social factors over political factors in accounts of gender inequalities in politics, we contend that gender is a political category as well as a social category. By political category, we mean that the formal, and informal exclusion of women from the right to vote and run for public office historically has had long-term consequences for women's relationship to electoral politics. Both political elites and the public see inequalities for women in contemporary electoral politics (CBS 2008; Sanbonmatsu 2006b). While the public voices support for the idea of electing more women to public office, the public is also comfortable with men occupying a majority of elected positions (Dolan and Sanbonmatsu 2009). Politics is a highly masculinized space, and women are still viewed as intruders whose presence disrupts the traditional order (Puwar 2004; Duerst-Lahti 2005). Meanwhile, women have internalized this sense of

themselves as outsiders to political life. For example, one effect of the under-representation of women in politics is that women potential candidates are less likely than men to view themselves as qualified for holding public office (Lawless and Fox 2005).

Because women traditionally have not had an equal role in political life, the dynamics of the candidate emergence process may be quite different for women than for men. In the remainder of this chapter we explore the decision to run for office, finding gender differences that provide evidence for a relationally embedded model of candidacy and seem to reflect the effects of women's historical exclusion from electoral politics.

THE INITIAL DECISION TO RUN FOR ELECTIVE OFFICE

Because of the masculine nature of mainstream politics and women's history of marginalization in the electoral arena, one might well expect women to be less likely than men to view elective office holding as an appropriate career choice or even a realistic aspiration. As a result, women more often than men might need encouragement to toss their hats into the ring and run for office.

The state legislature is the first foray into public office holding for many individuals. A majority of the women and men legislators we surveyed in 2008 ran for the legislature as their very first elective office (61.3 percent of women and 55.6 percent of their male colleagues), and we begin our analysis with these legislators whose first bid for office was for a legislative seat (see Figure 3.1).

A large gender gap is evident in how these state legislators made the decision to run for office the very first time.[3] The most striking gender differences are apparent among "pure recruits"—those who responded that they had never thought seriously about running until someone else suggested it. A majority of the women, 55.9 percent, had not seriously thought about running for the legislature before someone else suggested that they run. Although this was the most common response for women, it was the least common of three responses for men. Only 29.7 percent of men had never considered becoming a state legislative candidate until someone else suggested they run.

3. Our question is modeled on that of Moncrief, Squire, and Jewell (2001), although we queried legislators about the decision to run for their first elective office regardless of whether state legislative office was the first office sought. The Moncrief, Squire, and Jewell survey question concerned the decision to run for the legislature.

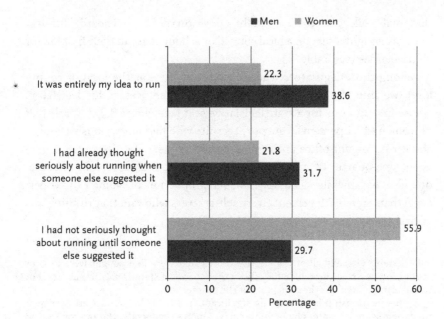

Figure 3.1
The Decision to Seek First Elective Office (among those who ran for the legislature first)
Source: 2008 CAWP Recruitment Study.

While women were much more likely than men to be pure recruits, they were much less likely to be "self-starters." Less than one-quarter of women (22.3 percent) said that running for the legislature was entirely their idea in contrast to their male colleagues for whom this was the modal response (38.6 percent). Finally, 21.8 percent of women and 31.7 percent of their male colleagues chose the middle or hybrid response, saying that they had already seriously thought about running when someone else suggested it.[4] This gendered pattern holds when we analyze Democrats and Republicans separately.[5]

What about those legislators whose first bid for office was for a position other than a state legislative seat? Almost all began their foray into elective politics with a run for local or county office, with women more likely than

4. A chi-square test indicates that the relationship between gender and recruitment is statistically significant ($p \leq .01$).
5. Among Democrats who sought state legislative office first, for example, 57.3 percent of women and 30.6 percent of men were pure recruits and 21.7 percent of women and 41.3 percent of men were self-starters. Among Republicans, 50.9 percent of women and 29.1 percent of men were pure recruits and 25.0 percent of women and 35.8 percent of men were self-starters. These relationships between gender and recruitment are statistically significant ($p \leq .01$).

their male colleagues to have sought a position on a school board.[6] The vast majority sought a seat on a local council or school board in their first bid for elective office (see Table 3.1).

Among those legislators who first ran for office at the local or county level, we find the same pattern of gender differences as for legislators whose first run was for a state legislative seat (see Figure 3.2).[7] Nearly half of women (44.1 percent) were pure recruits who had not seriously thought about running for office until someone else suggested it. In contrast, only about one-quarter of men (25.8 percent) ran at the suggestion of someone else. Meanwhile, a notably smaller proportion of women (33.0 percent) than men (47.9 percent) were self-starters who said that running was entirely their idea.[8]

6. Because virtually all of the elective offices that were first sought were local or county, we describe these bids for office other than the state legislature as "local or county candidacies" for the remainder of the chapter.

7. This relationship is statistically significant ($p \leq .01$). The results are similar if we disaggregate legislators by political party. Among Democrats who ran for local or county office first, 45.1 percent of women and 22.1 percent of men were pure recruits and 32.6 percent of women and 51.3 percent of men were self-starters. This relationship is statistically significant ($p \leq .01$). Among Republicans, 40.9 percent of women and 29.8 percent of men were pure recruits and 34.4 percent of women and 44.4 percent of men were self-starters, although the relationship between gender and recruitment is not statistically significant.

8. Although women were more likely than men to be pure recruits and less likely to be self-starters regardless of the office they first sought, we do find one interesting difference between those who first ran for the legislature and those who first ran for local and county offices. Comparing Figures 3.1 and 3.2 reveals that the likelihood that candidacy was the legislator's own idea—rather than an idea posed by someone else—is somewhat greater among those legislators who first ran for local or county office than among those who first ran for the legislature. However, this difference is due in part to variations among the states in levels of professionalism of their legislatures and the way that legislative professionalism affects political career paths. In states with more professional legislatures, legislators generally have higher pay, spend more days in session, and have legislative staff; usually it also costs more to run for the legislature in such states. As a result, holding legislative office is considered more prestigious and desirable in these states than in states with less professionalized legislatures, especially the least professionalized "citizen" legislatures, where the gap between holding local and legislative office may be less pronounced. Legislators in our study, both women and men, from the states with the least professionalized citizen legislative institutions were more likely to run for the legislature than another position as their very first elective office. In these states with what the NCSL has called "blue legislatures," 69.2 percent of women and 61.3 percent of men ran for the legislature as their very first elective office. In contrast, less than half of legislators from the states with the most professionalized legislatures (NCSL's "red legislatures") ran for the legislature as their first office (43.0 percent of women and 38.9 percent of men). Meanwhile, 60.6 percent of women and 54.4 percent of men from states with hybrid legislatures (NCSL's "white legislatures")—or legislatures that combine elements of the more professionalized and more citizen legislatures—ran for the legislature as their first office. Thus, the legislature is much more likely to be an entry point for elective office-seeking

Table 3.1. FIRST ELECTIVE OFFICE SOUGHT (AMONG THOSE WHO RAN FOR A FIRST OFFICE OTHER THAN THE LEGISLATURE)

	Women %	Men %
Town or city council	32.8*	43.3
School board (local or county)	37.1**	19.9
County legislator	10.9	11.7
Board or commission (local or county)	9.0	10.4
Executive (local or county, including mayor)	7.0	10.4
Other	3.1	4.3
N =	256	231

* $p \leq .05$, ** $p \leq .01$
Note: This table is limited to those state legislators who sought an office other than the legislature as their first elective office.
Source: 2008 CAWP Recruitment Study.

For the large proportions of women (and smaller proportions of men) in our study who were pure recruits, the traditional ambition framework does not appear to be applicable. These individuals did not harbor ambition to run for office; a long-standing interest in politics was not activated by the existence of a political opportunity. Rather, for those who had never before considered running for office, ambition and candidacy appear to have occurred more or less simultaneously. Their political ambition was ignited when someone persuaded them to run for office.

Rather than conforming to the ambition model, the decisions to run made by these pure recruits seem more consistent with a relationally embedded model of candidacy where relationships with other people figure importantly in decision making. If we consider all legislators together regardless of whether or not they ran for the legislature as their first elective office, a majority of women, 51.2 percent, compared with 28.0 percent of their male colleagues, attributed the idea of candidacy to someone else.[9] So clearly, although some men's decisions to run for office came about because of the encouragement they received from others, such encouragement was far more commonly important for women. Consequently,

in those states which have citizen legislatures. Legislators from states with more professionalized legislatures were more likely to get their start running at the local or county level. NCSL categories available at <http://www.ncsl.org/legislatures-elections/legislatures/full-and-part-time-legislatures.aspx>. Accessed January 19, 2013.

9. This gender difference is statistically significant ($p \leq .01$).

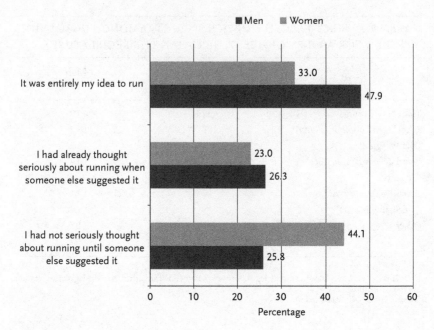

Figure 3.2
The Decision to Seek First Elective Office (among those who ran for a first office other than the legislature)
Source: 2008 CAWP Recruitment Study.

women's decision making much more often than men's seems to take place in relationship with other people and to fit the embedded candidacy model. In contrast, men's decisions more frequently are consistent with a self-initiated notion of candidacy and thus more often seem consistent with the ambition framework. And given the sizable proportions of women and men who said they had already thought seriously about running when someone else suggested it, the decisions of many women and men seem to fit neither the embedded nor the ambition model of candidacy but rather are best described as having elements of both.

Our interviews with women legislators underscored the importance of encouragement and recruitment to women's decisions to run for office and the relationally embedded nature of their decision-making process. A Democratic state representative explained:

> Well, it never occurred to me that I could run for office....I started out as planning commissioner, then city council [member], then mayor, then state legislator. But each time someone else had to suggest that I do that....It never occurred to me to...boost myself....I had to have other people, whom I respected, encourage me and tell me I was capable.

Similarly, a Republican state senator observed:

> …women generally have to be talked into running.… [W]e who believe in bringing more women into public life work to help spread the word that women can run and can help make a difference when they get in. I don't think that has historically been the message that society sends to females.… I have spent a lot of time talking women into running, and I had to be talked into running myself.

A Democratic woman legislator also echoed the main finding of our survey data on decision making:

> Men are more often likely to say, "I always wanted to be a state legislator; I am a good business person." And they step up and say, "I am going to run." They step up on their own whereas women very rarely do it on their own. It takes someone talking them into it.

POLITICAL PARTIES AND ORGANIZATIONS

In the previous chapter we found that on several different measures women were more likely than men to be active in their political parties before running for office. The relationships that women develop through these partisan activities may well prove critical in helping them decide to run for office.

About half of women state representatives in both 2008 and 1981 reached office after receiving encouragement for their candidacies from their party's leaders (see Table 3.2). Slightly higher proportions of women state representatives than their male colleagues said that their party encouraged their candidacy (54.9 percent of women and 49.9 percent of men). Similarly, among senators, more women than men reported party encouragement (56.6 percent of women compared with 43.5 percent of their male colleagues).

Gender differences were more apparent when legislators were asked to evaluate the importance of the support they received with women notably more likely than men to rate party support as very important to their decision to run. Among state representatives in 2008, 34.9 percent of women compared with 25.3 percent of their male colleagues rated "having the support of my party" as very important.[10] A similar gender difference was apparent among state senators.

10. This difference is statistically significant ($p \leq .01$).

Table 3.2. PARTY ENCOURAGEMENT FOR FIRST BID FOR
CURRENT OFFICE

	1981		2008	
	Women %	Men %	Women %	Men %
Representatives				
Yes	46.5	47.7	54.9	49.9
N=	428	197	530	439
Senators				
Yes	54.4*	33.9	56.6*	43.5
N=	68	62	168	115

Question wording: "Think back to the first time you ran for the legislative office you now hold. Did leaders from your party actively seek you out and encourage you to run for this office?"
* $p \leq .05$, ** $p \leq .01$
Source: 1981 and 2008 CAWP recruitment studies.

To the extent that women may be less likely to envision themselves as candidates, the support of party leaders may help counter this perception and bolster political confidence. One legislator we interviewed explained that party support shows a candidate "that somebody important thinks she is qualified.... That certainly helped me. I didn't think I was qualified. It wasn't until the party was recruiting me and investing in me." Another legislator noted:

> You do hear that story a lot where a woman has worked a lot on other people's campaigns and been a real reliable player in her political party. And on the basis of that, she is approached to run, and lots of times it is the first time the woman ever dared dream she could be the candidate. So the party...backing...goes a long way towards sending the right message to a woman that she is competent, capable, and ready to lead.

The fact that party leaders play a more prominent role in women's decisions to run than in men's is consistent with the contention that an embedded candidacy model, in which relationships with others play critical roles in the decision to run, is more applicable to women's decisions than to men's.

Evidence about the importance of relationships formed through organizational involvement is even more clear-cut than our findings about the role of parties. Although parties are more active and important in encouraging candidacies than organizations, the role of organizations is nevertheless significant.

As Table 3.3 indicates, large proportions of both women and men among state legislators were active in a variety of different types of civic, community, and professional organizations before seeking public office for the first time. Women were somewhat less likely than men to be involved in professional or business groups and labor organizations, and they were somewhat more likely than men to be active in children and youth organizations. The most dramatic difference is that women legislators were much more likely than their male counterparts to participate actively in women's organizations.

Despite the fact that both women and men serving in state legislatures had high levels of involvement in organizations, in both 2008 and 1981, and for legislators in both chambers, organizations played a larger role in the candidacies of women than men (see Table 3.4). More than one-quarter of women state representatives, compared with just under one-fifth of their male colleagues, said that an organization played a particularly important role in getting them to run the first time for their current office. Similar gender differences were apparent among state senators.

Table 3.3. ACTIVITY IN CIVIC ORGANIZATIONS PRIOR TO RUNNING FOR THE LEGISLATURE

	Representatives		Senators	
	Women %	Men %	Women %	Men %
Business or professional group	27.9**	38.9	37.1	43.0
Service club (e.g.,Rotary)	23.2*	28.3	24.5	31.7
Teachers'organization	10.2	11.0	11.8	7.5
Labor organization	7.8**	11.8	12.2	8.1
Children or youth organization	28.0	30.5	40.8**	22.6
Women's organization	29.3**	4.8	37.6**	2.2
A church-related or other religious group	27.9**	36.9	33.9	33.3
Civil rights or race/ethnic group	12.3	12.0	17.1**	8.6
N =	982	643	245	186

Question wording: "Prior to becoming a candidate for the first time, how active were you in any of the following organizations?" (percentage very active or active)
* $p \leq .05$, ** $p \leq .01$
Source: 2008 CAWP Recruitment Study.

Table 3.4. ORGANIZATION IMPORTANT TO FIRST BID FOR
CURRENT OFFICE

	1981		2008	
	Women %	Men %	Women %	Men %
Representatives				
Yes	33.9**	16.3	28.4**	19.1
N =	434	196	528	439
Senators				
Yes	31.5	23.9	31.0**	17.9
N =	73	67	168	112

Question wording: "Excluding your political party, was there an organization that played a particularly important role in getting you to run the first time for the office you now hold?"
* $p \leq .05$, ** $p \leq .01$
Source: 1981 and 2008 CAWP recruitment studies.

Women's organizations were especially important for women legislators. We asked women legislators a specific question about whether or not one or more women's organizations actively encouraged them to run the first time for their current office. Among state representatives, 21.4 percent of women state representatives reported that a women's organization actively encouraged them to run in 2008, slightly fewer than the 27.3 percent of women who reported similar encouragement in 1981. In contrast, more women senators were encouraged by women's organizations in 2008 (30.2 percent compared with 26.0 percent in 1981).

So, as with parties, many legislators of both genders had forged relationships with organizations through their participation in those groups prior to running for legislative office. Consistent with an embedded model of decision making, these relationships proved important in the decision to run for substantial proportions of women and men. However, relationships with organizations, especially women's organizations, more often figured importantly in women's decisions to run than in men's, consistent with the idea that a relationally embedded candidacy model is more applicable to women.

We can also see the important role that parties and organizations play among those legislators who attributed the candidacy idea to others or who described their initial decision to seek elective office as a combination of their thinking with encouragement from someone else. The idea for candidacy can derive from the political or personal lives of legislators. We asked those legislators who ran because they were encouraged

or recruited to run to indicate the actor most influential in encouraging them. For the state legislators for whom the legislature was the first elective office sought, the single most influential source of encouragement of both women and men was a party official and/or legislative leader (see Table 3.5). The second most influential source of recruitment was an elected or appointed officeholder. Thus, political sources appear to be most influential in suggesting the idea of candidacy. Next most frequent after political sources were personal sources: the respondent's spouse or partner; another family member; or a friend, coworker, or acquaintance. Least common among both women and men was an organizational source of encouragement, but women were more likely than men to credit a member of an organization.

Many races for local office are nonpartisan, and thus it is not surprising that party sources were less influential for bids for local and county office than for state legislative bids. Nevertheless, for legislators who first ran at the local or county level, women were less likely than men to identify a party source and more likely to report an organizational source as the most influential source of encouragement (Table 3.5). Beyond this difference, however, women's and men's responses mostly overlapped, and in general, the pattern of gender differences we find overall holds for respondents from both major parties.[11]

Thus, women and men who ran because they were recruited or encouraged to do so gave credit to a range of actors for presenting them with the idea to run. While family relationships can often pose hindrances to women's political careers, here we see some limited evidence of a more positive role: that a family member can be the most influential source of recruitment. Also, as we will see in more detail in the next chapter, political actors play a large role in spurring legislators to seek office. Such recruitment is especially important for understanding how women reach the legislatures (Figures 3.1 and 3.2).

11. For example, 52.1 percent of Democratic women and 52.7 percent of Democratic men who ran for the legislature first (who were non-self-starters) credited a party or elected official with the recruitment idea; 48.3 percent of Republican women and 57.0 percent of Republican men did so. Compared with Republican men, Republican women were slightly less likely to cite a political source and somewhat more likely to cite a spousal source (26.4 percent of Republican women compared with 10.5 percent of Republican men). Among those who ran for local or county office first and listed a recruitment agent, 38.3 percent of Democratic women compared with 33.3 percent of Democratic men said a party or elected official was the most influential, compared with 45.0 percent of Republican women and 56.5 percent of Republican men. A similar spousal difference emerged among Republicans in this group, as well, with 16.7 percent of Republican women compared with 8.7 percent of Republican men citing their spouse.

Table 3.5. MOST INFLUENTIAL SOURCE OF ENCOURAGEMENT FOR INITIAL DECISION TO SEEK ELECTIVE OFFICE

	State Legislative Office First		Local/County Office First	
	Women %	Men %	Women %	Men %
Political				
A party official and/or legislative leader from my party	29.4	31.9	15.8	21.8
An elected or appointed office holder	22.3	23.8	24.3	24.2
Personal				
My spouse or partner	17.1	13.5	14.7	11.3
A family member (other than spouse)	6.1	4.9	3.4	6.5
A friend, coworker, or acquaintance	13.5	15.7	24.9	26.6
Organizational				
A member of a women's organization	3.7	0.5*	6.2	2.4
A member of another organization or association	6.4	8.1	7.9	5.7
Other	1.5	1.6	2.8	1.6
N =	327	185	177	124

Question wording: "Who was the most influential person in encouraging you to run?"
Note: Data are presented for those legislators who ran because they were encouraged or recruited (not self-starters).
* $p \leq .05$, ** $p \leq .01$
Source: 2008 CAWP Recruitment Study.

MAIN REASON FOR RUNNING

Gender differences are evident, as well, in the responses by legislators to a question asking about the main reason they ran for their current state legislative office (see Table 3.6). These differences provide additional evidence

that women's decisions to run are more consistent with a relationally embedded candidacy model while men's are more consistent with ambition theory.

In 2008, we asked legislators a closed-ended question: "Other than your desire to serve the public, what was the single most important reason that you decided to seek the office you now hold?" The most frequent reason given by women representatives and senators was a concern about one or more specific public policy issues. This was also the most frequent response for male senators and the second most frequent response for male representatives although women legislators in both chambers were notably more likely than men to choose this response.

While a public policy motivation for seeking public office is not directly relevant to either ambition or embedded candidacy models, the

Table 3.6. MOST IMPORTANT REASON LEGISLATOR SOUGHT CURRENT OFFICE

	Representatives		Senators	
	Women %	Men %	Women %	Men %
My concern about one or more specific public policy issues	35.9**	26.7	45.8	35.7
A party leader or an elected official asked me to run or serve	23.8**	14.8	14.9	7.8
My long-standing desire to be involved in politics	16.2**	28.9	15.5*	26.1
My desire to change the way government works	11.0*	16.6	12.5	20.0
Dissatisfaction with the incumbent	6.1	5.7	7.7	2.6
It seemed like a winnable race	1.9	1.6	0.6	2.6
Other	5.1	5.7	3.0	5.2
N =	526	439	168	115

Question wording: "Other than your desire to serve the public, what was the single most important reason that you decided to seek the office you now hold?"
* $p \leq .05$, ** $p \leq .01$
Source: 2008 CAWP Recruitment Study.

two other responses most commonly given as reasons for running are. The second most frequent reason why women representatives sought their current office was a relational one—that a party leader or elected official asked them to run—and this reason was offered by substantially more women than men at both state house and state senate levels. The sizable percentage of women state representatives who sought a seat in the legislature because they were recruited by a party leader or officeholder (23.8 percent) is particularly striking. This finding not only highlights the importance of relationships to the decision to run for many women but is also consistent with the idea that ambition may not always precede, but rather may in some cases be a by-product of, recruitment.

A long-standing desire to be involved in politics, which is, of course, a direct expression of political ambition, was cited considerably less frequently by women than men as the most important reason for seeking their current office. More than one-fourth of the male representatives and senators, compared with only 16.2 percent of women representatives and 15.5 percent of women senators, ran for their current office primarily for this reason.[12] Thus, consistent with our earlier finding that men were more likely than women to be self-starters, self-initiated candidacy is less likely to characterize women's bids for state legislative office. Because women do not necessarily aspire to office, the women who reach the legislature are more likely to do so because they received a suggestion to run. As one woman state legislator explained:

> ...perhaps men automatically think about a professional career in politics whereas women may not. But I think that once you introduce that idea to women, they recognize that absolutely [they should run], because when it comes to issues that are addressed in the legislature, those are issues that they are very in tune with—be it education, health care, family.... [I]t is just [a matter of] changing the mindset that historically... [politics] is not a profession that women automatically gravitate towards.

12. This is true of both parties. For example, among Democratic state representatives, 15.5 percent of women compared with 28.0 percent of men cited their long-standing desire to be involved in politics. Among Republican state representatives, 17.4 percent of women compared with 30.0 percent of men did so. These gender differences are statistically significant ($p \leq .01$).

CONCLUSION

We have found that the way that women reach office does not necessarily follow the linear pattern suggested by the ambition framework in which a long-standing interest in office-seeking leads to candidacy. While the pathway of some women legislators can be explained by an ambition framework, we have argued for an alternative conceptualization of relationally embedded decision making about running for office that moves beyond the individual, rational calculation of the ambitious politician. Our alternative view recognizes that candidacies can be initiated through recruitment and encouragement by others in the context of a specific political opportunity even in the absence of prior ambition. And our view argues that candidacy may be equally, or even more, dependent on the consequences of that candidacy for *others* than on the personal costs and benefits to the *candidate*.

Men's pathways to politics may not always follow a linear trajectory either. Nevertheless, we find that this alternative embedded model of candidacy is more likely to be found among women than among men.

Women's decision making about running for office takes place in both a social and a political context. Women's traditional gender roles and the persistence of the division of labor within society and the family have political consequences. In particular, these features of the social context lead women to give more weight in the decision-making process to the opinions of others and the effects of their decision upon others, especially family members.

But the political context matters as well. Politics traditionally has been and is still a masculinized domain. In turn, women more often seek support and encouragement before they enter what is far from gender-neutral territory. Encouragement from those in their political and personal networks—party leaders, elected officials, spouses, family members, friends, coworkers, organization members—often figures critically in women legislators' decisions to run. In fact, a majority of the women in our study attributed the candidacy idea to someone else.

Political science and politics itself have privileged the ambition model over the alternative embedded candidacy model we propose. But we would argue that either candidacy framework can successfully produce democratic self-governance. Indeed, embracing the relationally embedded notion of candidacy alongside the ambition model might actually enhance American democracy by making American government look more like the people.

Acknowledging the relationally embedded nature of women's candidacies can expand our ideas about who could emerge as candidates. Talented legislators need not have aspired to a political career from a young age.

The value of politics and public service may become clearer in the context of a specific race. A phone call from the house majority leader or the local district leader may be necessary for a person to realize that she (or he) could lead.

Taking a less linear path to public office is not an inherently inferior path. Nor is it problematic for officeholders, and particularly women, to take a range of relationships into account when considering candidacy. Because people are embedded in familial and other social and political relationships, it is only natural for people to be responsive to the viewpoints and needs of others. It is also logical that the pathways that under-represented groups take to elective office may depart from those taken by the dominant group.

The relationally embedded candidacy model suggests that organizations, elected officials, political parties, and even family members can persuade a woman to enter a race, regardless of whether she has previously thought about candidacy. By implication, then, widespread cultural changes in socialization patterns need not occur first in order to improve women's descriptive representation in the medium term.

As we will see in the coming chapters, the relationally embedded candidacy model has important implications for the level of women's office holding overall and for how political factors intersect with gender to promote or inhibit office holding for subgroups of women. Recognizing that women state legislative candidates need not have the same backgrounds as men (chapter 2) and that more than one model can explain candidate emergence (chapter 3), we turn next to understanding how party interacts with gender and candidacy.

CHAPTER 4

Republican Women State Legislators: Falling Behind

For the first three decades following the emergence of the contemporary women's movement in the late 1960s and early 1970s, progress for women in American politics seemed inevitable. Changes in women's social roles and advances in their economic and educational status were accompanied by increases in women's political representation. Although women's political gains were incremental, many observers assumed that the changes occurring in women's lives would eventually lead more and more women to seek and win election to public office. Social change would lead to political change, and we would eventually reach parity if we were just patient enough.

Data on women's office holding from the 1970s, 1980s, and 1990s seemed to support this claim. At the state legislative level with each successive election, more women ran for office and more women were elected (see Figure 4.1). Similarly, at the statewide level, the trend over time was clearly upward.[1] Although progress was less evident at the congressional level, that changed with the 1992 elections and the so-called Year of the Woman. The number of women increased dramatically from thirty-two in the 102nd Congress (1991–1992) to fifty-four in the 103rd (1993–1994), and subsequently the numbers have continued to climb incrementally, reaching ninety-eight in the 113th Congress (2013–2014). Over the past two decades, the pattern of slow but steady

1. <http://www.cawp.rutgers.edu/fast_facts/levels_of_office/statewide.php>. Accessed September 6, 2011.

Figure 4.1
Women Major Party State Legislators
Source: Center for American Women and Politics.

increases apparent in the states in earlier decades has become evident at the congressional level.

However, while the numbers of women in Congress grew during the first decade of the twenty-first century, a troubling new pattern was becoming evident at the state level, revealing the fallacy of any assumption that progress toward parity was inevitable. At both statewide and state legislative levels, the numbers and proportions of women officeholders have stagnated and declined since the turn of the century. At the statewide level, women's representation peaked at 27.6 percent of all statewide officeholders in both 1999 and 2001 and subsequently decreased to 21.9 percent in 2011. It rose slightly to 23.4 percent following the 2012 election (Center for American Women and Politics 2013a). Among state legislators the proportion of women has stagnated since the late 1990s (Figure 4.1), increasing by only two percentage points (from 22.5 percent to 24.5 percent) from 2000 to 2010, and then actually declining to 23.6 percent following the 2010 elections; in 2013, women are 24.0 percent (Center for American Women and Politics 2013c). The leveling off and years of decline evident in women's representation in statewide and state legislative office over the past decade clearly defy the conventional wisdom that changes in women's social roles, such as gains in educational and occupational status, will automatically lead to increases in the proportions of women in elective office.

A closer look at the data suggests that there is a distinctly partisan character to the lack of recent overall growth in numbers of women at the state legislative level. Except for a notable drop-off following the 2010 elections, the number of Democratic women serving in state legislatures has continued to increase since the late 1990s (Figure 4.2). In contrast, although they regained some ground following the 2010 elections, Republican women legislators decreased in numbers throughout the first decade of the twenty-first century. Thus, for most of the past decade Republican women appear to be the primary source of the stagnation and decline apparent in the trend line for women state legislators overall.

In 1981 when the first CAWP Recruitment Study was conducted, Republicans were a clear minority among legislators overall, holding only 37 percent of state senate seats and 40 percent of state house seats (Center for American Women and Politics 1981). And while the numbers of women who held state legislative office were small, the proportions of women among the legislators of each party were similar (even higher in the case of state senators) to the proportions of Republicans and Democrats among legislators overall. Republicans comprised 37 percent of all women state

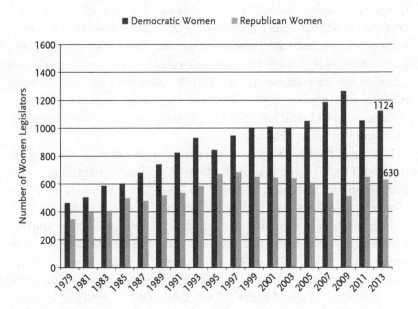

Figure 4.2
Numbers of Women State Legislators by Party
Source: Center for American Women and Politics, Council of State Governments, National Conference of State Legislatures.

senators and 45 percent of all women representatives (Center for American Women and Politics 1981).

Throughout most of the 1990s and 2000s the Republican Party gained strength and numbers within state legislatures, moving from the minority to the majority in many states, but women did not share proportionately in its success. Republican women fell behind. In this chapter we examine several possible explanations for why Republican women have not benefited equitably from their party's success and have not kept pace with Democratic women. We build on the findings from our previous chapters and examine how party politics have intersected with the gendered pathways to office. Regional changes in Republican Party strength play a role as does the rightward shift in the ideology of the party. We also find that the parties' recruitment practices and receptivity to women candidates are critical to understanding women's presence as state legislators.

TRENDS IN REPUBLICAN WOMEN'S OFFICE HOLDING

The history of women's office holding in the United States reveals a strong Republican tradition. Indeed, the first woman ever elected to the U.S. Congress, Jeannette Rankin, was a Republican. For most of the twentieth century, Republican women constituted a larger percentage of their party's state legislators than did Democratic women (Cox 1996: 27). However, Democratic women today far outnumber Republican women in elective office. In the state legislatures in 2013, for example, Democratic women make up 64.1 percent of all women state legislators from the two major parties, compared with just 35.9 percent who are Republican (Center for American Women and Politics 2013b).

Looking at the two groups of women in recent decades reveals stark differences. In 1981—the year of the first CAWP Recruitment Study—just 399 Republican women served as state legislators (Center for American Women and Politics 1981). That number had increased to 536 by 2008 (Center for American Women and Politics 2008) (Figure 4.2). By contrast, Democratic women held almost as many seats, 503, in 1981 as Republican women held in 2008. By 2008, 1,201 Democratic women served in the legislatures, far exceeding the number of Republican women (Center for American Women and Politics 2008). Democratic women's office holding more than doubled between the 1981 and 2008 CAWP recruitment studies—an increase of 139 percent—compared to an increase of just 34 percent for Republican women.

The decline in the Republican share of women legislators is not a simple function of changes in Republican office holding in general. Although the Democratic Party has traditionally dominated state legislatures, the Republican Party became increasingly competitive toward the end of the twentieth century. In 1994, in addition to winning the U.S. Congress, Republicans gained twenty state legislative chambers (Jacobson 2010).[2] Although Democrats became more competitive in subsequent election cycles, Republicans experienced another important election in 2010, a particularly historic year for the Republican Party. Not since 1928 had the Republicans won such a large number of seats nationwide in state legislative elections (National Conference of State Legislators 2010). As a result of these elections, Republicans in 2011 held a majority of seats in state houses and senates nationally. Yet, Republican women did not share equally with men in the Republican Party's success. In 2011 only 16.5 percent of Republican state legislators were women, and Republicans comprised even smaller proportions of women legislators (35 percent of women senators and 39 percent of women representatives) than in 1981 when their party was clearly in a much weaker position nationally![3] Even when the total number of seats held by each party is considered, Democratic women were still advantaged over Republican women (Figure 4.3). This pattern continues in 2013.

The level and partisan nature of women's state legislative office holding has long-term consequences not only at the state level but also for women's access to higher-level offices. Because state legislators are a pool of talent for federal offices, the party gap among women in state legislatures has helped shape the distribution of women by party in Congress (Elder 2008). Indeed, Elder (2008) found that a majority of women in the U.S. Congress previously served in the state legislatures, and of the women serving in the 113th Congress, 55.1 percent have been state legislators (Center for American Women and Politics 2013d, 2013e). Mirroring the partisan distribution of women state legislators, Democratic women in 2013 make up the vast majority—75.5 percent—of all women in Congress; just 24.5 percent of women in Congress are Republicans (Center for American Women and Politics 2013b).

2. http://www.governing.com/blogs/politics/2010-state-legislatures-democrats-wild-ride.html. Accessed July 28, 2010; Jacobson 2010.
3. As of 2011, fifty-seven state legislative chambers were controlled by Republicans and thirty-nine by Democrats, with two chambers equally divided between the two parties (NCSL 2011). <http://www.ncsl.org/documents/statevote/2010_Legis_and_State_post.pdf>. Accessed February 2, 2011.

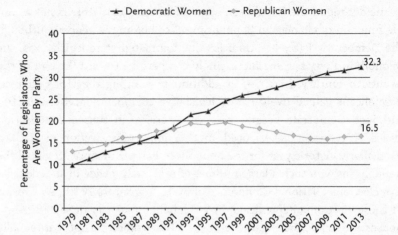

Figure 4.3
Percentage of Women State Legislators by Party
Source: Center for American Women and Politics, Council of State Governments, National Conference of State Legislatures.

GENDER AND THE DECISION TO RUN AMONG REPUBLICANS

What explains the shortfall of Republicans among women state legislators in recent years? One potential explanation is that there is something unique about Republican women's approach to the decision to run for office. We saw in the previous chapter that the way women reach the state legislatures is better characterized by a relationally embedded model of decision making than a self-initiated model. However, because most women state legislators are Democrats, our analysis may have better captured the experiences of Democratic women than Republican women. The first question we must address, then, is whether Republican women depart from our findings for women legislators overall.

When we analyze the pathways to office for Republican women, we find that they are indeed consistent with the relationally embedded candidacy model that we proposed in the last chapter. For example, Republican men state representatives were more likely than their Republican female counterparts to cite prior ambition as an explanation for why they sought their current seat: a "longstanding desire to be involved in politics" was more likely to be identified by Republican male state representatives as the "single most important reason" for seeking their current office. This explanation was given by 30.0 percent of Republican men state representatives but only 17.5 percent of their

Republican female counterparts.[4] Meanwhile, recruitment by a party leader or elected official was more likely to be mentioned by Republican women (19.8 percent) than by their male counterparts (15.5 percent).

The gender gap among Republican legislators is even larger when we consider their decisions to run for elective office the very first time. While 46.4 percent of Republican women state legislators ran for their first elective office because someone else suggested it, only 29.3 percent of their male counterparts did so. The modal response option for Republican male legislators (39.9 percent) was that running was entirely their idea; meanwhile, only 29.2 percent of Republican women characterized their decision this way.[5]

Thus, gender differences in the approach to candidacy are apparent in both of the major political parties. External encouragement and support play a larger role in Republican women's decision making compared with that of Republican men, and the same is true of Democratic women when we compare them with Democratic men. Yet, Democratic women have fared far better than Republican women in reaching state legislative office.

A SHRINKING POOL OF POTENTIAL REPUBLICAN WOMEN CANDIDATES?

Another possible explanation for the shortfall of Republicans among women state legislators in recent years focuses on shifts in the partisan preferences of voters. The gender gap is a well-documented phenomenon in American politics that has been evident in voting behavior and party identification since the early 1980s (Wirls 1986; Mueller 1988; Kaufmann and Petrocik 1999). Women voters are more likely than men to vote for Democratic candidates and to identify with the Democratic Party whereas Republican partisan attachments are stronger among men. According to this explanation, the flagging numbers of Republican women state legislators may simply be a logical consequence of the reduced numbers of women citizens who see themselves as Republicans.

Although this explanation has some intuitive appeal, upon closer examination it is clearly flawed. Survey evidence suggests that women have not changed their partisan affiliations over time nearly as much as men

4. This difference is statistically significant ($p \leq .01$).
5. A chi-square test indicates that the relationship between gender and recruitment is statistically significant ($p \leq .01$).

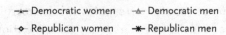

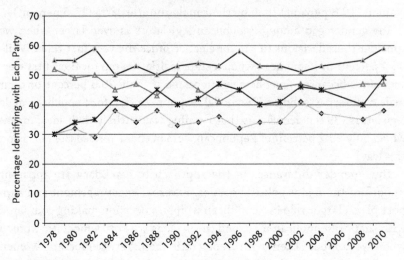

Figure 4.4
Party Identification in the Electorate (ANES Data)
Source: American National Election Studies.

have. Women's levels of identification with the two parties remained very similar from the late 1970s into the 1980s; it was men whose partisan loyalties shifted notably during this time period (Wirls 1986; Kaufmann and Petrocik 1999). Women did not become less Republican (or more Democratic); rather, men became more Republican, creating a gap in party identification between the genders (see Figure 4.4).[6] Thus, over time there is no evidence of a notable decline in those who in the very broadest sense might constitute the pool of potential female Republican candidates—women in the electorate who identify as Republicans.

And while women are less likely than men to vote for Republican candidates, the number of women who do so is very large. For example, in the 2008 presidential election, although fewer women than men cast their ballots for the Republican candidate, nevertheless 43 percent of women voted for John McCain. This means that over 30 million women voted Republican in 2008 (Center for American Women and Politics 2008; File and Crissey 2012). As we saw in chapter 2, many more women could be considered eligible to seek office than is commonly believed—including Republican women. The sheer number of Republican women in the electorate suggests

6. Data are from the American National Election Studies (n.d.) and DeBell et al. 2011.

that the pool of Republican women who could potentially launch bids for state legislative seats remains large despite the existence of the gender gap in the electorate. Women have a long tradition of activism within the Republican Party (Freeman 2000; Rymph 2006).

And the pool remains large despite the plausibility of two other explanations for the shortfall of Republican women offered by the state legislators we interviewed. We asked all the women legislators why they thought that Democratic women state legislators outnumbered Republican women. Some women legislators suggested that the more traditional gender-role and family-oriented attitudes of many Republican women keep them from running for office. As one Republican woman representative explained when asked why more Democratic than Republican women serve in state legislatures:

> Republican women are still more traditional, more conservative, and I think they are more oriented to the family [in] the old traditional... [way] of our families come first.... They have a little more old-fashioned value about the importance of family and dedicating themselves to that.

A Democratic representative from a state in a different region of the country agreed "the more traditional attitude of [Republican] women" accounted for the shortfall. She explained that for many Republican women their "goal would be to stay in the home and take care of their family, even if the family is grown up. Then there are grandchildren and taking care of males."

While it undoubtedly is the case that women with more traditional attitudes about women's role within the family probably are less likely than other women to run for office, the number of women with traditional gender role attitudes has declined over the years according to survey research (Sanbonmatsu 2002a). Moreover, the visible examples of conservative Republican women such as Sarah Palin and Michele Bachmann suggest that traditional attitudes and complicated family responsibilities may not now be as much of a deterrent to women running as they were in the past.

In explaining why the number of Republican women legislators had not kept pace with their Democratic counterparts, other legislators we interviewed pointed to the decline of full-time homemaking and the civic involvement that often accompanied full-time homemaking for affluent women. One legislator offered a fairly elaborate explanation of what had happened in her state as she saw it. She described how several decades ago the Republican Party in her state did a better job than the Democrats in recruiting women for the legislature. She explained that "Republican women...at that point were not doing a whole lot in the regular workforce"

and that the women in the legislature at that time "came from fairly afflu-
ent areas." Legislative salaries were "lousy" and so a number of women
served in the legislature "...as a kind of extension of a notion of giving
back and giving to the community. So, if you are not running the gala for
the symphony benefit or running the local League of Women Voters, an
extension of that is you are going to ... [the state capitol] to help make pub-
lic policy."This legislator went on to explain that over time "the legislature
has become a different kind of place from what it had been, and the idea of
women ... serving this larger goal of a civic responsibility has become less
contained within Republican party notions. And the culture has changed."

In 1981, 16.7 percent of women state legislators were full-time home-
makers while in 2008 virtually none of them were full-time homemak-
ers. More than half of the homemakers were Republicans, so the decline
to which the aforementioned legislator refers is a real one. The civic do-
gooder, full-time homemaker woman state legislator so evident in some
of the studies of women legislators in the 1970s (Diamond 1977; Johnson
and Carroll 1978) is largely a relic of the past.

The claims of these legislators about women's gender roles have validity.
Women with more traditional views of their role in the family are more
likely to be Republican and probably less likely to run for office, and the
old model of Republican women legislators who were full-time homemak-
ers with considerable volunteer experience no longer seems applicable.
Nevertheless, these explanations are inadequate in accounting for the
shortfall in Republican women legislators in recent years. With 30 million
women voting Republican in 2008, the Republican Party does not have to
rely on women whose own gender-role views make them unlikely candi-
dates or full-time homemakers to fill its legislative ranks. There are vast
numbers of Republican women who could run if encouraged to do so.

REGIONAL SHIFTS IN PARTY STRENGTH

Another possible explanation for the shortfall in Republican women leg-
islators, based on the congressional literature, has to do with regional
shifts in Republican Party strength. Laurel Elder (2008) has argued that
the party gap in women's congressional office holding, with Republican
women greatly outnumbered by Democrats, stems partly from the fact
that Republican gains in congressional seats have disproportionately
occurred in the south—a more traditional region of the country that has
not historically produced a large number of women candidates or office-
holders. It is possible that changes in Republican women's state legislative

office holding could similarly be a simple reflection of regional changes in Republican Party strength since the southern states, where the Republican Party has been ascendant, have traditionally ranked among the very lowest in the representation of women in their state legislatures (Center for American Women and Politics 2013c).[7] Meanwhile, while the Republican Party has made gains in the South, in recent years the Republican Party has lost strength, as measured both by partisan loyalties among the electorate (Reiter and Stonecash 2011) and by congressional office holding (Elder 2008), in the Northeast where the proportions of women in state legislatures have frequently been above the national average (Center for American Women and Politics 1981, 2013c).[8]

As Figure 4.5 demonstrates, there has been a fairly dramatic shift in regional representation among Republican legislators nationally. In 1981, 29.4 percent of Republican legislators were from the Northeast and only 10.3 percent were from the South. By 2013, the Northeastern share of Republican legislators had declined to 18.0 percent while the Southern share had grown dramatically to 28.8 percent.

These regional shifts in Republican Party strength do seem to have played some role in producing the shortfall among Republican women legislators although the shifts cannot fully account for it. As Figure 4.5 makes clear, Republican women, like women legislators in general, have fared worse in terms of numerical representation within their party in the South, where their party has made major gains, and better in the Northeast, where their party has lost seats. However, since the late 1990s, the decrease in the presence of women among Republican legislators overall has not been apparent among Republican legislators in the South (Figure 4.5).[9] Similarly, since 1999, after a slight decline, the proportion of women among Republican legislators in the Northeast has remained steady. In contrast, the proportion

7. In 2013 the four states with the lowest proportions of women in their legislatures are southern states—Louisiana, South Carolina, Oklahoma, and Alabama.

8. In 2013, Connecticut, New Jersey, Maine, New Hampshire, Rhode Island, and Vermont were all above the national average in the proportion of women in their legislatures. In 1981 four of the six states with the highest proportions of women in their legislatures were northeastern states—New Hampshire, Connecticut, Maine, and Vermont—and in three of these states (the exception being Vermont), Republicans outnumbered Democrats among women in the lower house.

9. The strength of region as an explanation for the deficit of Republican women is also diminished when we examine the pattern of Democratic women's office holding over time. Democratic women's share of Democratic state legislators has increased in both the South and the non-South. For example, Democratic women were 5.8 percent of southern Democratic state legislators in 1981 and 27.8 percent in 2013; outside the South, Democratic women were 13.9 percent of Democratic state legislators in 1981 and 33.4 percent in 2013.

Figure 4.5
Women Among Republican State Legislators in the Northeast and the South
Source: Center for American Women and Politics, Council of State Governments, National Conference of State Legislatures.

of women among Republican legislators nationwide has declined over the same period with a slight uptick in 2011. This pattern suggests that the regional realignment of the Republican Party cannot fully account for the decline in Republican women legislators in the first decade of the twenty-first century.

REPUBLICAN PARTY SUPPORT FOR WOMEN LEGISLATORS

The dwindling presence of women among Republican legislators cannot be explained by changes in the candidate pool, and regional shifts in Republican Party strength offer only a partial explanation. Another possible explanation for changes in Republican women's office holding is that Republican Party support for women legislators has declined over time. Perhaps Republican women are less likely than men to reach the legislature with backing from their party and less likely to do so than they were in the past.[10] Such support

10. We use gender, party, and over-time comparisons to draw inferences about the obstacles that inhibit higher levels of Republican women's office holding. Because our data come from legislators and we do not observe Republican women who did not win

is important because, as we saw in the previous chapter, external encouragement and support play a larger role in women's candidacies—both Democratic and Republican—than in men's.

Looking at the 1981 and 2008 CAWP recruitment studies, we can see that a large majority of Republican women legislators were supported by party leaders in their bids for the legislature, and they have levels of party support similar to those of their Republican male counterparts (Table 4.1).[11] We find little evidence that the relationship between gender and party support among Republicans has changed over time although Republican women in 1981 were slightly less likely than their male counterparts to receive party support. Compared with 1981, in 2008 Republican state representatives of both genders were less likely to have faced supportive party leaders and more likely to have faced divided, opposed, or neutral party leaders in their first bid for their current office. However, there are no clear gender differences here. The main conclusion to be drawn from Table 4.1 is that it is unusual for either Republican women or Republican men to reach the legislature by overcoming party leader opposition. Those women who are successful in winning election to the legislature are perhaps there at least in part because they were supported by their party. Republican women are not frequently or disproportionately winning office as party outsiders.

The extent to which legislators say that party leaders sought them out and encouraged them to run for their current office is similar, as well, for Republican women and their male counterparts in both 1981 and 2008. About half of women state representatives in both time periods were encouraged to run by party leaders (Table 4.2). Again on this measure, party support figures importantly in the candidacies of a substantial proportion of the Republican women who made it through the process and were elected to office.

office, our evidence about the dearth of Republican women is necessarily indirect. In our analysis, we primarily consider state representatives because the lower chamber is more likely than the upper chamber to be the entry point for the legislatures. The N of Republican women state senators is small. For example, only 120 Republican women served in state senates in 2008.

11. In the analysis that follows, we use the word "counterparts" rather than "colleagues" to describe Republican women and men to acknowledge the nature of our samples of state legislators. The male legislators included in our study were selected by stratifying on the state and chamber in which women legislators serve. Because the 1981 CAWP Recruitment Study was not stratified by party, we did not stratify by party in the 2008 study. Therefore, the Republican women in our study may or may not be serving in the same states as the Republican men.

Table 4.1. PARTY SUPPORT OF REPUBLICAN STATE REPRESENTATIVES

	1981		2008	
	Women %	Men %	Women %	Men %
Party leaders generally supported my candidacy.	72.0	85.4**	65.5	66.7
Party leaders generally opposed my candidacy.	3.4	0	4.1	7.3
Party leaders neither supported nor opposed my candidacy.	11.6	6.7	14.0	15.0
Party leaders were divided in their reactions to my candidacy; some were supportive, but others were opposed.	13.0	7.9	16.4	11.1
N=	207	89	171	207

Question wording: "Again, think back to the first time you ran for the office you now hold. Which of the following statements best characterizes the reactions of your party's leaders to your candidacy?"
* $p \leq .05$, ** $p \leq .01$
Source: 1981 and 2008 CAWP recruitment studies.

In the previous chapter we found that women legislators in general were more likely than men to identify the role of party support as "very important" in their first bid for the legislature. This gender difference is apparent among Republican state representatives just as it is for all legislators, with Republican women more likely than Republican men (33.3 percent compared to 27.1 percent) to rate party support as very important, although the difference is not statistically significant. This is yet another indicator of the importance of party support to many of the women who won election.

Thus, we find little evidence to support the idea that the shortfall in Republican women's office holding is due to a decline in Republican Party support for women legislators' candidacies over time. Of course, we only have data for the women who were successful in winning election to office, so we cannot assess levels of party support among unsuccessful candidates. However, relatively few Republican women ran for office and were elected without the support and often the active encouragement of their party's leaders, and party support is viewed as important by substantial proportions of Republican legislators. Republican women are as likely as men to reach the legislature with backing from their party and about as likely to do so as they were in the past.

Table 4.2. PARTY ENCOURAGEMENT OF REPUBLICAN STATE
REPRESENTATIVES

	1981		2008	
	Women %	Men %	Women %	Men %
Yes	53.9	56.7	50.3	47.3
N =	208	90	171	207

Question wording: "Think back to the first time you ran for the legislative office you now hold. Did leaders from your party actively seek you out and encourage you to run for this office?"
* p ≤ .05, ** p ≤ .01
Source: 1981 and 2008 CAWP recruitment studies.

SHIFTING IDEOLOGY OF THE REPUBLICAN PARTY

Although most of the women in the legislatures have won election with the support of their parties, party gatekeepers and primary electorates may make it more difficult for some types of candidates to win election than others. Indeed, in the past two to three decades, there has been much attention to the rightward shift of the Republican Party. This shift began with the election of Ronald Reagan in 1980, continued with the increasing influence of the Christian right and the Gingrich revolution and takeover of Congress in the 1990s, and has been evident most recently in the rise and political clout of the Tea Party movement (Himmelstein 1990; Pierson and Skocpol 2007; Critchlow 2011; Skocpol and Williamson 2012).

The rightward shift of the Republican Party has made it more and more difficult for moderates within the Republican party as many moderate office-holders and polling experts have observed. In an op-ed piece in the *New York Times* reacting to the decision of moderate U.S. Senator Arlen Specter in 2009 to leave the Republican party and become a Democrat, Senator Olympia Snowe of Maine proclaimed, "It is true that being a Republican moderate sometimes feels like being a cast member of 'Survivor'—you are presented with multiple challenges, and you often get the distinct feeling that you're no longer welcome in the tribe" (Snowe 2009: A23). Similarly, a few weeks before the 2010 elections, Tom Jensen of Public Policy Polling explained, "I think it's virtually impossible anymore to be a moderate in the Republican Party and survive politically" (Woodward 2010). Following those elections, Connie Morella, former Republican congresswoman from Maryland, suggested, "Moderates were an endangered species, and now it's just about an extinct species" (Rawls 2011).

Several of the legislators we interviewed echoed these sentiments about changes in the Republican party. One Democratic woman legislator suggested:

> ...the Republican party has taken a sharp turn to the right, and the voice of religious fundamentalists is a significant part of the base. And the fundamentalist voter is guided by religious convictions.... [T]here are factors within the Republican base that really don't look kindly on women being in the forefront as leaders. They belong to churches that have issues with women being leaders, being pastors, and being ordained. They may be reflecting a very fundamentalist view of the family that the woman is a step behind, that the woman's place is in the home.

This legislator further explained:

> There have been a lot of moderate women that have been defeated by candidates to the right in their own party. I know personally moderate Republican women who have been pretty much given the cold shoulder...moderate Republican women in office are somewhat of a vanishing species. They are not there in the numbers they used to be.

Similarly, another Republican woman legislator observed, "you are labeled too moderate if you get too close to the other side, and then you get eaten by your own." And a Democratic woman legislator added:

> I've known Republican women legislators who felt uncomfortable with the kind of positions they took and not getting the flexibility to have those positions in the Republican party. Specifically for Republican women who are pro-choice or more moderate on social issues, that has often times put them in conflict with their party.

This rightward shift in the Republican Party has posed problems for moderate men who wish to run for office as well as for moderate women. As Dolly Madison McKenna, a Republican who ran for a congressional seat in Texas in 1996, explained about her party, "They're not interested in moderate women.... They're not interested in moderate anybody" (McCarthy 2000).

However, there are reasons to believe that Republican women candidates have been disproportionately affected by this ideological shift. Most important, despite salient exceptions such as Congresswomen Michele Bachmann and Helen Chenoweth, Republican women legislators, as a considerable body of research conducted over the past thirty-five years has shown, have tended

to come disproportionately from the moderate wing of the party. Republican women legislators at both state and national levels have tended to take more moderate to liberal positions on a variety of issues and to be more moderate in their voting behavior than their male counterparts (Frankovic 1977; Leader 1977; Johnson and Carroll 1978; Welch 1985; Dodson and Carroll 1991; Carey, Niemi, and Powell 1998; Center for American Women and Politics 2001; Swers 2002; Carroll 2003; Dodson 2006). If, as this evidence would seem to indicate, there is a bias in the selection process and Republican women who seek legislative office, or at least those who traditionally have been successful in doing so, more often than men are moderates, then it may have become more difficult for these women to run and win as the primary electorate and party gatekeepers moved to the right.

Evidence from the CAWP recruitment studies suggest that the more moderate ideological tendencies of Republican women legislators, relative to their male counterparts, were as evident in 2008 as they were in earlier research. Figure 4.6 demonstrates that the Republican shift to the right apparent nationally is also apparent among state legislators. Republican legislators became more conservative in their self-identified political ideology over the course of our two studies. Women legislators and their Republican male counterparts in both chambers were more likely to describe themselves as conservative or very conservative in 2008 than in 1981. Yet, in both chambers in both years a gender gap is apparent. In 2008 Republican women were almost twice as likely as Republican men to describe themselves as middle-of-the-road, liberal, or very liberal—41.8 percent of female Republican representatives, compared with only 20.2 percent of their male counterparts, and 43.9 percent of female Republican senators, compared with only 24.1 percent of their male counterparts. These are sizable and statistically significant gender differences in political ideology.[12]

These ideological differences are also evident in attitudes on public policy issues. We asked legislators in 2008 about their views on several issues, ranging from free enterprise to school vouchers to abortion (Table 4.3). On each of these issues Republican women were significantly less likely than their male counterparts to take conservative positions.

We have already seen that Republican women who make it through the selection process and become state legislators are as likely as their male colleagues to have received party support and encouragement. But perhaps women legislators are more moderate than men not just because of gender, but because they ran in very different electoral circumstances

12. These differences persist even if region (South) is taken into account.

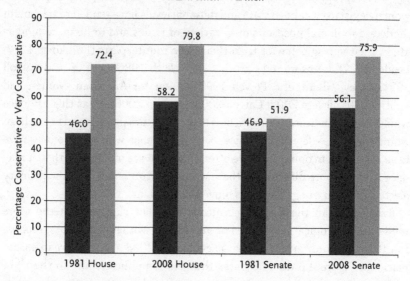

Figure 4.6
Ideology Among Republicans
Source: 1981 and 2008 CAWP recruitment studies.

and districts, ones that were more favorable to moderate candidates. We asked legislators in 2008 several questions about their districts and the electoral circumstances surrounding their initial bids for their current offices. On these questions we find little evidence of gender difference. Republican women state representatives were about equally as likely as their male counterparts to report that the voters in their district favored the Republican Party (63.7 percent versus 65.2 percent) as opposed to being equally divided between the two parties (20.8 percent versus 20.8 percent) or favoring the Democratic Party (15.5 percent versus 14.0 percent). Thus, there is no evidence that Republican women representatives were elected from more competitive districts than the men. Similarly, Republican women representatives were equally likely as their male counterparts to have run for an open seat (71.6 percent versus 71.2 percent), to have faced a serious primary opponent (60.2 percent versus 63.3 percent), and to hold a seat previously held by the Republican Party (75.8 percent versus 77.2 percent).[13] There was no

13. The same was true in 1981. For example, in 1981, 63.6 percent of Republican women state representatives compared with 60.0 percent of their Republican male counterparts faced a serious opponent. 62.6 percent of Republican women state representatives and 60.2 percent of their male counterparts held a Republican seat.

Table 4.3. GENDER DIFFERENCES IN REPUBLICAN STATE
REPRESENTATIVES' ISSUE POSITIONS

	Women %	Men %
If left alone, except for essential regulations, the private sector can find ways to solve our economic problems.	1.88**	1.58
Minors should be able to obtain a legal abortion without parental consent. (reverse coded)	1.94**	1.31
The death penalty should be an option as a punishment for those who commit murder.	2.10**	1.74
The women's movement has gone too far in pushing for equality between the sexes.	2.89**	2.49
Government-funded school vouchers should be available to parents for tuition at the public, private, or religious school of their choice.	2.28*	1.99
I would like to see the U.S. Supreme Court overturn the *Roe v. Wade* decision which made abortion legal during the first three months of pregnancy.	2.65**	1.90
Affirmative action programs are needed to help women and minorities overcome discrimination. (reverse coded)	2.29**	1.87
N =	*139 to 162*	*168 to 200*

Cell entries are mean values with higher values representing more liberal and/or more feminist responses.
Question wording: "Please indicate your degree of agreement or disagreement with each of the following
statements by placing a number from 1 to 5 in the blank provided." Response options: 1 = strongly agree,
2 = agree, 3 = disagree, 4 = strongly disagree, 5 = don't know ("don't know" omitted from the analysis).
* $p \leq .05$, ** $p \leq .01$
Source: 2008 CAWP Recruitment Study.

relationship between the ideology of women legislators and their responses
on any of these measures. In other words, Republican women who were mod-
erate to liberal were no more likely than those who were conservative to be
from competitive districts, to have challenged an incumbent, or to have faced
serious primary opposition.

The only notable difference in electoral circumstances between Republican
women and men had to do with the gender of the previous incumbent of
the seat. While Republican women representatives were just as likely as
men to report holding a seat previously occupied by a Republican, they were
significantly more likely to report holding a seat last occupied by a woman

(28.8 percent versus 16.2 percent).[14] This is a notable change from 1981 when Republican women representatives were no more likely than Republican men to be occupying a seat last held by a woman (14.6 percent versus 14.5 percent), and it is a different pattern from that among Democrats where women representatives in 2008 were not notably more likely than men to be serving in a seat last held by a woman (31.9 percent versus 28.8 percent). The majority of the Republican women holding a "woman's seat" in 2008, 68.2 percent, were serving in districts that could be considered safe for Republicans in that more voters identified with the Republican party. Only 15.9 percent of Republican women holding a woman's seat reported that they served in districts where more voters were Democrats and 15.9 percent reported that they served in swing districts where the voters were about evenly divided between the parties.[15] The fact that there tends to be a greater tendency for Republican women than men to fill seats previously occupied by a woman does suggest that Republican women may be more likely to run successfully where a Republican woman has served before and that the range of districts in which women can run may be more constrained than for men.

Except for the greater tendency of women to serve in a seat previously held by women, then, Republican women and men serve in similar situations, and the ideological differences between Republican women and men serving in state legislatures are not due primarily to differing districts or electoral circumstances. Rather, it appears that even in this very conservative era, the Republican women who manage to circumnavigate the system and win election to office more often than the men are moderate to liberal. Party support is clearly critical to large proportions of the Republican women who win election—those from the more moderate end of the party as well as those from the more conservative end. Few legislators win without party support. But the relatively small numbers and proportions of Republican women legislators suggest that too few are making it through the party's selection process. As Republican primary electorates have become more conservative, one can imagine that party leaders and gatekeepers, who are motivated first and foremost by a desire to win, may not often be looking for moderate candidates to run for legislative office and may often not offer support for those who choose to do so. The desire to win might lead party gatekeepers to overlook otherwise capable candidates who happen not to be conservative enough to be deemed electable (Koch 2000, 2002; King and Matland 2003; Sanbonmatsu and Dolan

14. This difference is statistically significant ($p \leq .01$).
15. Moderate-to-liberal women were no more likely than conservative women to be holding a seat previously occupied by a woman.

2009). Liberal to moderate Republicans might also be more hesitant to run knowing that they have to face more conservative primary electorates. To the extent that ideological differences among women and men in office are mirrored among Republicans who might run for office, these kinds of conservative biases in the candidate selection process would likely have a disproportionately adverse effect on women, keeping the numbers of women candidates lower than they otherwise might be.

THE WOMEN'S MOVEMENT AND WOMEN STATE LEGISLATORS

The Democratic and Republican parties have taken different positions in response to the modern women's rights movement. Because electing more women to office is one goal of the women's movement, party positions on the women's movement itself may have shaped the level of women's representation. Included in the constellation of women's movement issues is abortion. The parties' abortion positions have significantly polarized since the 1970s with potential implications for the ability of Republican women to win party support as well as organizational support from women's groups.

The Democratic and Republican parties' responses to the modern women's movement have been characterized by Jo Freeman (1987, 1999) as an elite party realignment. Beginning in the 1970s, the parties arguably switched places with the Democratic Party replacing the Republican Party as the party most strongly in favor of women's rights. Neither major party had been very supportive of the Equal Rights Amendment (ERA) for most of its history, but the Republican Party had been more supportive than the Democratic Party from the 1920s through the 1960s due largely to labor's opposition to the amendment. In the early 1970s, with the efforts of feminist activists and with labor no longer opposed, both Republicans and Democrats supported passage of the ERA in their party platforms and offered voters similar women's rights promises at their national conventions (Freeman 1987; Sanbonmatsu 2002a). However, the ERA failed to be ratified during the 1970s as antifeminist activists mobilized to defeat the amendment and became more closely aligned with the Republican Party (Mansbridge 1986). Feminist and antifeminist organizations became more closely affiliated with different political parties and helped drive the party platforms, the parties in Congress, and the presidential nominees further apart on women's rights policies (Freeman 1987, 1993; Wolbrecht 2000; Young 2000).

Changes in the parties' abortion positions have been the most notable (Adams 1997; Sanbonmatsu 2002a; Karol 2009). Some have also argued that the parties' shifting positions on women's rights, including abortion,

have contributed to the dearth of Republican women officeholders (Melich 1996). There is little doubt that among the ideological litmus tests that are likely to be employed by Republican Party gatekeepers, abortion is an important one. As with ideology in general, attitudes on abortion differentiate Republican women and men state legislators (Table 4.3).

The stronger alliance of feminist groups such as NOW (National Organization for Women) with the Democratic Party and the emergence of new women's political action committees (PACs), such as EMILY's List, that primarily back Democratic women candidates, may help explain why Democratic women have been more successful in reaching office than Republican women (Cooperman 2006; Burrell 2010). Indeed, the 1981 and 2008 CAWP recruitment studies reflect these differences in party relationships with women's organizations. Women state representatives were more likely to identify a women's organization as important to their candidacies if they were Democrats rather than Republicans. In 1981, 30.8 percent of Democratic women compared with 23.6 percent of Republican women said a women's organization actively encouraged them to run the first time for their current state legislative office. In 2008, 23.8 percent of Democratic women compared with 16.1 percent of Republican women reported active encouragement by a women's organization, and this party difference was significant.[16]

The associational activities of women state representatives (prior to entering state legislative office) also reflect national party differences on women's rights (Table 4.4). While Democratic and Republican women were about equally likely to be a member of a business and professional women's organization, Democrats were much more likely to belong to groups with more feminist inclinations. One-third of Democratic women representatives surveyed in 2008 were members of a feminist group such as NOW before running for the legislature, compared with only about one of every ten Republican women. In contrast, almost one-tenth of Republican women, compared with only 1.5 percent of Democratic women, belonged to a conservative women's organization such as the Eagle Forum or Concerned Women for America—groups that frequently line up in opposition to feminist organizations.

At first glance these differences between Democratic and Republican women appear to be consistent with Freeman's elite realignment hypothesis. Recall that in 1981 Republican women were somewhat better represented among Republican legislators compared with Democratic women. What began as comparable levels of representation for women in the

16. This difference is statistically significant ($p \leq .05$).

Table 4.4. WOMEN STATE REPRESENTATIVES' ORGANIZATIONAL
MEMBERSHIPS PRIOR TO RUNNING FOR OFFICE

	Democratic Women %	Republican Women %
A feminist group (e.g., NOW, Women's Political Caucus)	34.2**	12.0
A women's PAC (e.g., EMILY's List, WISH List,Susan B. Anthony List)	21.5**	5.7
A conservative women's organization (e.g.,Concerned Women for America, Eagle Forum)	1.5**	8.1
League of Women Voters	29.0**	16.1
Other women's civic organization	40.0	43.2
A business or professional women's organization	38.6	36.3
An organization of women public officials	3.2	5.6
A sorority	23.1*	31.1
N =	337 to 352	157 to 162

Question wording: "Have you ever been a member of the following organizations? If yes, please indicate whether you were a member before you ran the first time for any elective office or whether you joined later."
* $p \leq .05$, ** $p \leq .01$
Source: 2008 CAWP Recruitment Study.

two parties' state legislative caucuses changed simultaneously with the Republican Party's increasing opposition to the agenda of feminist organizations through the 1980s and 1990s.

However, if we look more closely at the 1981 and 2008 CAWP recruitment studies, it is evident that the realignment hypothesis receives only partial support. One problem for the realignment hypothesis is that even in 1981, Democratic women were more likely than Republican women to have been affiliated with feminist organizations either at the time they ran or at some other point (see Table 4.5). In 1981 Democratic women state representatives were much more likely than Republican women to belong to a feminist group such as NOW (64.6 percent of Democratic women compared with 36.1 percent of Republican women). In 2008, a large party gap among women persisted, although membership had declined substantially for both Democratic and Republican women. But because a large difference already existed regarding feminist organization membership in 1981, it is difficult to attribute changes in Republican women's office holding, relative to the trend for Democratic women, to a diminishing

Table 4.5. WOMEN STATE REPRESENTATIVES' ORGANIZATIONAL
MEMBERSHIPS OVER TIME

	1981		2008	
	Democratic Women %	Republican Women %	Democratic Women %	Republican Women %
League of Women Voters	57.2	48.7	45.2**	26.5
A feminist group (e.g., NOW, Women's Political Caucus)	64.6**	36.1	48.2**	19.0
An organization of women public officials	57.1**	43.6	46.2	42.9
N =	205 to 215	179 to 197	344 to 352	158 to 162

Question wording: "Have you ever been a member of the following organizations?" (2008 question wording)
* $p \leq .05$, ** $p \leq .01$
Source: 1981 and 2008 CAWP recruitment studies.

association with feminist organizations due to the realignment of the two political parties.[17]

Our data indicate that women's organizations do appear to provide Democratic women with a stronger base of support than Republican women. To the extent that women's organizations such as NOW use abortion as a litmus test in their decisions to support candidates, some Republican women may be at a disadvantage with respect to attracting electoral resources from women's groups (Burrell 1994; Crespin and Deitz 2010; Elder 2012). But, as we saw in chapter 3, women's organizations are not the most influential source of recruitment when women are making decisions about running for office. Political parties and elected officials were much more likely to be the leading source of the candidacy idea among those officeholders who ran at least in part because they received the suggestion to run from someone else. Among Democratic women state representatives in 2008 who first ran for office because they were encouraged to do so, for example, only 3.8 percent cited a women's organization as the most influential source of recruitment.

Before drawing any conclusions about the effect that elite party positions on women's rights have had on Republican women's representation,

17. See also Rymph (2006) who argues that feminist influence within the Republican Party began to decline in the mid-1970s.

however, it is important to reflect on the growing role of social conservatives in the party and how attitudes about the women's movement may have influenced the level of Republican women's representation. As some have argued, the Republican Party's shift to the right on women's rights issues may have affected the ability of the party to attract women candidates and the ability of women to win party support. Electing more women to public office is one goal of the women's movement. And the abortion issue has been particularly pivotal, with the Republican Party becoming more allied with pro-life forces over the past few decades and with pro-choice Republican women often facing intense resistance within the party (Melich 1996; Whitman 2005). Given this shift to the right, what electoral context and climate has greeted Republican women? What are Republicans' views about the women's movement?

In both 1981 and 2008, CAWP asked legislators if they agreed or disagreed with the following statement: "The women's movement has gone too far in pushing for equality between the sexes." This question is a less than ideal measure because it queries legislators about the women's movement broadly rather than the election of women specifically. At the same time, and with the caveat that it is an indirect measure, it is the best indicator we have to assess legislators' attitudes.

Republican women representatives and their male counterparts differed greatly in their reactions to the women's movement when surveyed in 1981. Most Republican women in the lower chambers disagreed with this statement—with one-quarter strongly disagreeing (Figure 4.7). In contrast, almost half of Republican men in the lower chambers agreed that the women's movement had gone too far (43.2 percent). Meanwhile, Democratic legislators in 1981 were much more supportive of the women's movement than Republican legislators.[18]

When we fast-forward to 2008, gender differences among Republicans persist. Many more Republican men than women agree with the statement about the women's movement (Figure 4.7).[19] While 50.0 percent of Republican men state representatives in 2008 believed the women's movement had gone too far in pushing for equality, only 28.2 percent of Republican women state representatives thought the same. As in 1981, a

18. In 1981, 56.1 percent of Democratic male state representatives and 84.6 percent of Democratic female state representatives disagreed with the statement that the women's movement had gone too far in pushing for equality. In 2008, virtually all Democratic state representatives disagreed (92.4 percent of men and 93.3 percent of women).

19. The survey response options to this question changed slightly across the two surveys (with the neutral response option eliminated in 2008).

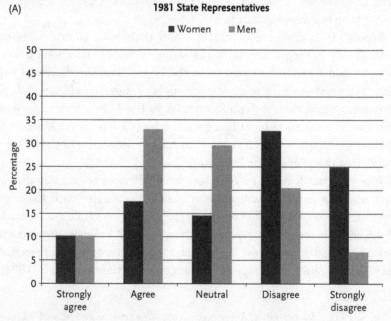

(B) **2008 State Representatives**

■ Women ■ Men

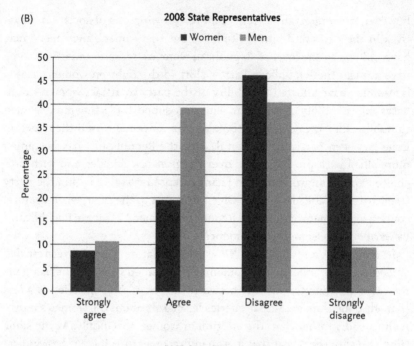

(A) **1981 State Representatives**

■ Women ■ Men

Figure 4.7
Attitudes Toward the Women's Movement Among Republicans
Source: 1981 and 2008 CAWP recruitment studies.
Note: Question wording: "The women's movement has gone too far in pushing for equality between the sexes."

large majority of Republican women disagreed with the statement, about a quarter of them strongly.

As we saw earlier in this chapter, differences in opinion between Republican women and their male counterparts extend beyond attitudes toward the women's rights movement to political ideology and attitudes on a range of issues. Nevertheless, attitudes toward the women's movement merit special attention. The persistent objections to the women's movement that are evident among Republican male legislators are likely to create a less than ideal environment for the emergence of new Republican women state legislative candidates given that most Republican state legislative leaders—many of whom are involved in candidate recruitment—are men. We believe that state legislative recruitment patterns may have interacted with changing party positions on women's rights. The lesser support for the women's movement that can be found among Republican Party elites, compared with Democratic Party elites, is likely to mean that the Republican Party has less of an ideological commitment to take steps to remedy inequalities in women's descriptive representation.

Although we lack comparable data for 1981, we find that Democratic and Republican women legislators in 2008 report different recruitment experiences that may be related to the parties' attitudinal responses to the women's movement. Democratic women are outpacing Republican women in terms of the extent to which they report recruitment by the party itself. Democratic women state representatives are somewhat more likely (25.3 percent) than Republican women (19.8 percent) to cite party recruitment as the single most important reason they ran for their current office (Figure 4.8). This suggests that more recruitment of women is occurring on the Democratic side than on the Republican side, and it is consistent with the overall pattern of greater representation among Democratic women compared with Republican women. We can infer, then, that more Republican women would hold state legislative office were the Republican Party to recruit more women.

Consistent with this finding, some of the women legislators we interviewed expressed the view that the Democratic Party had done a better job recruiting women than the Republican Party. A few suggested that the Republican Party was less open to women's candidacies. For example, one Democratic female legislator argued that she was advised to run as a Democrat rather than a Republican:

A lot of people assumed I was going to run many years before I did because I was very active. And I remember, without naming names, one Republican woman [who] . . . didn't know what [party] I was . . . said to me, "Be a Democrat. It is really hard to be a woman in the Republican party."

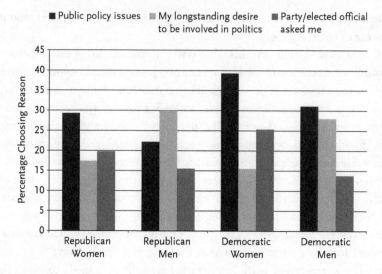

Figure 4.8
State Representatives' Single Most Important Reason for Seeking Current Office
Source: 2008 CAWP Recruitment Study.
Note: Question wording: "Other than your desire to serve the public, what was the single most important reason that you decided to seek the office you now hold?"

A Republican woman legislator we interviewed argued that male leaders will look to replace themselves and naturally gravitate to men when in need of a candidate:

> I actually think that the men who are in charge tend to be middle-aged or older, and they suffer from the same prejudices as the rest of their generation. So they don't think of women unless one presents herself.... Whereas with a young man, they would look and think, "Oh, he reminds me of myself when I was young. I used to be that kind of guy. He is a go-getter," even if he has not proven himself to be a go-getter.

Previous research has indicated that the gender of party leaders is likely to be consequential to candidate recruitment (Sanbonmatsu 2006b). Although women are underrepresented in the leadership of local and state party organizations of both parties, women occupy fewer leadership positions in the Republican Party than in the Democratic Party (Shea and Harris 2006; Sanbonmatsu, Carroll, and Walsh 2009). And Democratic women have usually been more likely than Republican women to occupy leadership roles in the legislatures (Center for American Women and Politics 2011b). Women and men party leaders are likely to know different sets of potential candidates because of gender differences in networks and because party leaders tend to look for candidates who resemble themselves

(Niven 1998; Sanbonmatsu 2006b). Thus the greater representation of Democratic women in party leadership positions, both inside and outside legislatures, means that more Democratic women than Republican women are in a position to recruit other women to the legislature. As one legislator we interviewed argued:

> It is not that men in leadership don't recruit women. They just don't recruit as many, and they don't put the extra effort into recruiting women who are sometimes harder to get to get to run. I think there are fewer women in the legislature because much more often men are in charge.

Some of the Republican women legislators we interviewed expressed the view that the Democratic Party had been more successful in recruiting both women and minorities as candidates. For example, this Republican woman argued that her party could do better:

> I would say that Democrats seem to throw a little wider net at catching minorities, whether it is ethnic or gender minorities, and giving them a place in the party. To be quite honest, I think this is a failing in the Republican party. I think we're going to have to get off the image that we are a white male party with the little wife at home. We are going to have to embrace these minorities, whether they are ethnic or gender....I really think our efforts have been to recruit good candidates, and through that some women have surfaced. But I don't think we've been as diligent as we [need to be] to try to recruit women.

In sum, the Democratic and Republican parties' distinctive positions on women's rights policies and sympathy toward the women's movement likely contribute to the deficit in Republican women's office holding. Because encouragement and recruitment are critical to spurring women to seek office, a candidate recruitment strategy aimed at remedying gender inequality is more likely to occur on the Democratic than Republican side of the aisle. And because more women have reached office as Democrats, more Democratic women than Republican women are positioned to help identify and encourage women's candidacies.

CONCLUSION

Although party differences have generally been overlooked in accounts of women's descriptive representation, the evidence presented in this chapter suggests the recent stasis in women's state legislative office holding

has much to do with party. While Republican women's presence among Republican state legislators has been declining, the presence of women among Democratic state legislators has been increasing. The Republican Party has made dramatic gains in state legislative office holding over the past several decades, but Republican women have not shared equally in their party's success.

Our analysis suggests that the shortfall in the number of Republican women state legislators does not stem from party differences in the pathways that women take into office or a shortage of Republican women who could become legislative candidates. However, we did find evidence suggesting that region can partly explain the current situation of Republican women. Republican state legislators are now more likely to be elected from the South—a region that historically has not been conducive to women's office holding—and less likely to be elected from the Northeast—one of the regions most conducive to women's office holding.

Our analysis also pointed to ideological changes in the Republican Party as a factor that has contributed to the shortfall. Most Republican women reach office with party support. Because Republican women legislators have been much more likely to hail from the moderate wing of the Republican Party, the increasing difficulty that moderates face in reaching office has disproportionately affected women. Any movement of the Republican Party back toward the more moderate center of the ideological spectrum would likely have a positive effect on Republican women's representation.

Finally, the parties' differing responses to the women's movement itself, with Republicans less supportive than Democrats, is likely related to the party imbalance in women's office holding. The reason for this disparity is intimately connected to the argument we advanced in the previous chapter about the decision to seek elective office. Because women's candidacies are more likely to take the form of a relationally embedded decision-making process, women's ascension to office depends more on external encouragement by others, including fellow partisans, and Republican men in particular exhibit low levels of commitment to remedying existing gender inequalities. With fewer women serving in party leadership positions in the Republican than Democratic Party, Republican Party recruitment is likely to yield fewer women candidates. The addition of more women to Republican Party leadership ranks as well as more intensive recruitment efforts by Republican Party leaders could help to remedy the flagging numbers among women state legislators.

CHAPTER 5

Democratic Women State Legislators: On the Rise

Democratic women's record of state legislative office holding stands in sharp contrast with that of Republican women. While Republican women's numbers declined throughout the first decade of the twenty-first century, Democratic women's numbers continued to increase as they had in previous decades. Even after the 2010 elections in which Republican women made gains and Democratic women experienced losses, Democrats continued to substantially outnumber Republicans among women state legislators.

In this chapter we examine two factors that help explain why Democratic women's representation has followed a different trajectory than that of Republican women. The first is the strong and increasing role that public policy has played in motivating the candidacies of Democratic women, especially when compared with Republican women. The second is the increase in the number of Democratic women of color serving in elective office. Without the advance of women of color, notably fewer women would be counted among the ranks of Democratic state legislators today.

Despite the fact that Democratic women occupy many more seats in state legislatures than do Republican women, their numbers fall far short of those for Democratic men. Why have Democratic women failed to achieve parity with the men in their party? While we cannot provide a comprehensive answer to this question, in the second half of this chapter we do investigate some of the challenges that remain for Democratic women's representation.

First, we examine the pathways of Democratic women of color. Because women of color have been a growing share of Democratic women

legislators, we argue that the prospects for increasing Democratic women's office holding depend significantly on continuing to expand opportunities for minority women. The fact that women of color tend to be elected from majority-minority districts, the numbers of which are no longer increasing as they did over the last couple of decades, means that minority women's ability to continue to fuel an upward trajectory in Democratic women's representation may be limited.

Second, we examine party recruitment as one possible problem area for Democratic women. While we find similarity in the relationship that women and men have with the Democratic Party, we also uncover evidence, consistent with our relationally embedded model of candidacy, that Democratic women's representation is more reliant on party support. Finally, we also find that fund-raising remains a hurdle for Democratic (and Republican) women in politics. Despite the conclusion of some studies—typically based on congressional elections—that women and men are equally successful in campaign finance, women and men in both parties have dramatically different perceptions of potential gender differences in fund-raising. Attracting campaign resources and party support are challenges that confront women of color and white women alike, although they appear to present somewhat greater challenges for women of color.

The existence of gender barriers in the world of campaign finance helps to explain why women's PACs such as EMILY's List are so popular among women. As we saw in the previous chapter, these women's PACs are more likely to be helping Democratic women than Republican women, contributing to the party gap among women legislators.

PUBLIC POLICY AS A MOTIVATION FOR OFFICE HOLDING

There are reasons to expect public policy may have played an increasing role over time in motivating the candidacies of Democratic women, especially when compared with Republican women. The growth and maturation of the contemporary feminist movement over the past three decades has occurred simultaneously with the increasing conservatism of the Republican Party as evident in the success of Ronald Reagan and his conservative agenda in the 1980s, the influence of the Christian Right in the 1990s, and the widespread adoption of Grover Norquist's Taxpayer Protection Pledge and the election of Tea Party candidates since the 2000s. While the growth of feminism on the left and conservatism on the right have exerted countervailing pressures on moderate Republican women, these developments have

provided liberal Democratic women with a sizable agenda of new issues to pursue and enacted policies to defend.

As would be expected given the Republican Party's shift to the right, we found in the previous chapter that the proportion of Republican women who identify as moderates has decreased since 1981. Nevertheless, Republican women who were elected to the legislature in 2008 were more likely to describe themselves as moderate than were their male counterparts. Because of their more moderate leanings, Republican women may be less likely than Republican men to experience a comfortable fit between their own political ideologies and the dominant ideological tendencies of their party.

A similar gender gap in political ideology exists in the Democratic Party with Democratic women more likely than their male counterparts to identify as liberals. In 2008, 61.2 percent of Democratic women state representatives compared with 50.5 percent of Democratic men described themselves as liberal or very liberal.[1] Yet, because Democratic Party elites and primary electorates tend to be more liberal than the electorate as a whole, there is no reason to expect that left-leaning Democratic women feel out of synch with the dominant ideological tendencies of their party.

As noted in chapter 3, the candidacies of women more often than those of men are motivated by public policy issues. Women overall are more likely than men to cite their concern about one or more policy issues as their single most important reason for running for the legislature; this gender difference occurs within both parties (see chapter 4, Figure 4.8, in this volume). However, Democratic women are considerably more likely than Democratic men and Republican women to have run for the legislature primarily because of their policy-related concerns (chapter 4, Figure 4.8, in this volume).

In both parties it was the more left-leaning women who reported that public policy issues were the most important factor motivating their candidacies. On the Republican side of the aisle, 37.7 percent of women state representatives who identified as moderate or liberal in 2008 were motivated first and foremost by public policy, compared with 22.8 percent of conservative women—a statistically significant difference. Among Democrats, 43.0 percent of liberal women state representatives, compared with 32.6 percent of moderate and conservative legislators, ran for the legislature primarily for policy-related reasons.[2]

1. This difference is statistically significant ($p \leq .01$).
2. This difference is statistically significant ($p = .05$).

While we did not ask legislators to name the specific issues that moti-
vated them, one possibility is that the more left-leaning legislators have
been influenced by the women's movement and have in many cases been
motivated to run for office to advance the policies associated with that
movement. If so, those legislators who identify with the movement more
often than other legislators should be motivated to run for policy-related
reasons. We asked legislators in 2008 whether they did or did not identify
with the label "feminist" (in a list of three different labels). Not surpris-
ingly, Democratic women were significantly more likely than Republican
women (55.6 percent versus 20.4 percent among state representatives)
to adopt this label. Republican women who identified as feminists were
no more likely than those who did not (27.3 percent versus 28.1 percent)
to cite their concern about one or more policy issues as the major reason
they ran for office, suggesting that the issues associated with the women's
movement by and large were not motivating the candidacies of Republican
women. However, the pattern was different for Democratic women rep-
resentatives, where the candidacies of almost half (45.1 percent) of those
who identified as feminists were motivated primarily by policy concerns
compared with only less than one-third (29.6 percent) of those who did
not call themselves feminists.[3] While we cannot be certain that some of the
policy concerns that motivated the candidacies of these Democratic femi-
nists were issues associated with the women's movement, it nevertheless
seems likely.

Studies of women of color often identify the important role that pol-
icy plays in minority women's politics. Indeed, we find in 2008 that
Democratic legislators from both chambers who were women of color were
slightly more likely than white Democratic women legislators to cite their
concern about one or more policy issues as the major reason they ran for
office (46.2 percent versus 41.2 percent), although this difference is not
statistically significant. Historically, the drive to overcome racial subor-
dination has played an important role in the activism of both minority
men and minority women in the United States (Giddings 1996; Williams
2001). Indeed, scholars have found that the intersection of race and gen-
der inequality has given African American women a singular legislative
agenda compared with other Democratic state legislators. For example,
Edith Barrett (2001), who surveyed Democratic state legislators in 1992,
found that African American women state legislators feel the responsibility
of representing both women and minorities.

3. This difference is statistically significant ($p \leq .01$).

One additional piece of evidence allows us to extend our analysis further back in time. The 1981 CAWP Recruitment Study did not include a question asking legislators about their single most important reason for running as the 2008 study did. However, both the 1981 and 2008 studies did ask legislators in a battery of items to rate the importance of "my concern about one or two particular public policy issues" as a factor that influenced their decisions to run for their legislative seat. In 1981 virtually identical proportions of Democratic and Republican women state representatives—about one-third—rated public policy issues as "very important" in their decisions to seek office (Table 5.1). Gender differences in both parties were small and statistically insignificant.

However, the pattern for 2008 on the importance of public policy in the decision to run is dramatically different compared with 1981. Between the early 1980s and 2008, issues of concern to women received greater and greater public attention with, for example, increasing efforts to restrict abortion rights, enhanced attention to sexual harassment fueled by high-visibility events like the 1992 Clarence Thomas confirmation hearings and the 1991 Tailhook scandal where women were sexually assaulted by

Table 5.1. STATE REPRESENTATIVES: IMPORTANCE OF PUBLIC POLICY IN DECISION TO SEEK CURRENT OFFICE

	1981		2008	
	Democratic Women %	Democratic Men %	Democratic Women %	Democratic Men %
Very important	32.6	29.1	45.8*	35.8
N	221	110	354	226

	1981		2008	
	Republican Women %	Republican Men %	Republican Women %	Republican Men %
Very important	32.2	27.8	40.5*	28.3
N	205	90	168	205

Question wording: "Below are various factors that have been suggested to be important in influencing decisions to run for office. Please indicate how important each factor was in affecting your decision to run the first time for the office you now hold. . . . My concern about one or two particular public policy issues."
* $p \leq .05$, ** $p \leq .01$
Source: 1981 and 2008 CAWP recruitment studies.

Navy and Marine Corps pilots, and greater public awareness of the need for research and services focusing on breast cancer and other women's health issues. Although issues such as these certainly were not the only ones of interest to women active in the public arena, one might expect that the increasing salience of these issues would lead more women over time to run for office for policy-oriented reasons. In the 1970s and through the 1980s, the mobilization to ratify the Equal Rights Amendment and the amendment's subsequent defeat had led many issue-oriented women's organizations and activists to turn their attention increasingly to electoral politics (Hartmann 1996). For many women, activism during this time shifted from a focus largely on protest outside institutions to mobilization to bring about change within institutions (Katzenstein 1998), including the institutions of government.

Indeed, our data seem to reflect an increasing recognition of the importance of government as an arena for social change in that public policy was a motivational factor for more of the women who served in 2008 than in 1981. Women state representatives of both parties were notably more likely to rate their concern with one or two policy issues as very important in 2008 than they were in 1981, and gender differences (with women more likely to evaluate policy as important in their decisions to run) were statistically significant. Moreover, in 2008 almost half of Democratic women rated public policy concerns as very important to their decisions to run, outpacing not only Democratic men but also Republican women. Among Republican women, only those who identified as moderates or liberals—a declining proportion of all Republican women from 1981 to 2008—showed an increase in the proportion rating policy concerns as a very important influence on their decisions to become a candidate. In contrast Democratic women across the ideological spectrum attributed more importance to policy concerns in 2008 than in 1981 (Table 5.2).

While policy is important in motivating the candidacies of women of both political parties, the foregoing evidence suggests it is particularly significant for Democratic women. The increasing importance of policy in motivating candidacies over time may thus be one factor that helps explain why the numbers of Democratic women state legislators have trended upward.

THE RISE OF WOMEN OF COLOR

The growth in Democratic women's office holding can also partly be attributed to the rise in the presence of women of color—a rise that is one of

Table 5.2. WOMEN STATE REPRESENTATIVES: IMPORTANCE OF PUBLIC POLICY IN DECISION TO SEEK CURRENT OFFICE

| | 1981 Democratic Women | | 2008 Democratic Women | |
	Moderates and Conservatives %	Liberals %	Moderates and Conservatives %	Liberals %
Very important	29.6	34.5	42.5	47.9
N	88	119	134	213

| | 1981 Republican Women | | 2008 Republican Women | |
	Conservatives %	Moderates and Liberals %	Conservatives %	Moderates and Liberals %
Very important	33.0	31.7	34.4	47.8
N	88	104	93	69

Question wording: "Below are various factors that have been suggested to be important in influencing decisions to run for office. Please indicate how important each factor was in affecting your decision to run the first time for the office you now hold.... My concern about one or two particular public policy issues."
$* p \leq .05, ** p \leq .01$
Source: 1981 and 2008 CAWP recruitment studies.

the most notable changes in women's office holding since the early 1980s.[4] The combined effects of gender and racial inequality arguably put women of color candidates at a greater disadvantage compared with white women or minority men. Consistent with the social science literature of the time that emphasized the additive effects of race and gender, Jewel L. Prestage,

4. In this chapter we use the terms "Anglo" and "white" interchangeably to indicate non-Hispanic white women; we use "women of color" and "minority women" interchangeably to refer to African American, Asian American, Latina, and Native American women collectively. Because nearly all women of color state legislators are Democrats, we focus our discussion in this chapter on Democratic women of color; we simply have too few cases of Republican women of color for analysis. For example, in the 2008 CAWP Recruitment Study, 84 percent of women of color respondents were Democrats. Although the term "women of color" fails to capture important differences in the experiences, resources, and political histories of African American women, Latinas, Asian American women, and Native American women, our data do not permit analyses by racial/ethnic subgroup. Because the N of Democratic women of color is small, and because we wish to preserve legislator confidentiality, we analyze women of color as a group rather than separately by race/ethnicity. Among the Democratic women of color in our study, 67.9 percent are African American, 19.8 percent are Latina, 6.2 percent are Asian American, 3.7 percent are Native American, and 2.5 percent are mixed race.

in the first study of African American women state legislators, conceived of African American women as a "double minority" (1977: 415). More recent scholarship has continued to recognize the distinctive situation of women of color but has moved away from the additive models of the 1970s and 1980s in favor of an intersectionality approach. Black feminists and other women of color have argued that inequalities are interlocking and mutually constitutive and that the effects of race and gender oppression are not separable (e.g., Giddings 1984; Mohanty 1984; King 1988; Crenshaw 1989; Hill Collins 1990; Smooth 2001, 2006; Hancock 2007).

There has been remarkably little research examining how the intersectional identities and histories of women of color affect their pathways into elective office. Nevertheless, in a CAWP study that compared black women legislators with other legislators, Susan J. Carroll and Wendy Strimling found evidence that African American women in some respects had stronger credentials than men or women in general—evidence that the authors believe suggested that black women were held to higher standards. They argued, "If gaining entry as a woman into a traditionally male-dominated field such as politics requires having as good or better an education and equal or stronger professional background than men, being both black and female in politics may require even stronger educational and occupational credentials" (1983: 203). A few years later Gary Moncrief and Joel Thompson (1991) also found black women state legislators to have higher education levels and more prestigious occupations than white women, black men, and white men although the differences were large only between black women and white women.

While little research has been conducted, there are good reasons to expect women of color to face distinctive obstacles with respect to office holding. The existence of racial and gender inequalities means that minorities and women are typically excluded from the formal and informal networks that lead to office holding; are confronted with discrimination on the part of voters, donors, political parties, and the media; and lack access to needed campaign resources as well as role models for politics (Takash 1997; McClain, Carter, & Brady 2005; Philpot and Walton 2007; Lien, et al 2008).

America's racial diversity is reflected in the ranks of women state legislators although neither women nor men of color are represented in elite politics in proportion to their presence in the population. Among the most significant changes in American politics over the past half-century is the transformation of the racial composition of both the electorate and elected officials. The civil rights movement and the 1965 Voting Rights Act enfranchised African Americans in what has appropriately been called the "Second Reconstruction." At the same time, changes in U.S. immigration

policy and immigration patterns have given rise to an increasingly diverse population. Fully 36 percent of the U.S. population identifies as nonwhite or Hispanic, or both; the proportion of U.S. residents whose racial identification on the 2010 Census was nonwhite was 28 percent, and 16 percent of U.S. residents identified as Hispanic (Humes, Jones, and Ramirez 2011). Yet office holding by Latinos and Asian Americans lags behind their numbers in the population due to obstacles to citizenship, language barriers, and resource limitations (Jones-Correa 1998; Lien, Conway, and Wong 2004; Wong 2006; Junn and Haynie 2008; Schmidt et al. 2010). In part, the failure of American politics to more fully incorporate Latinos and Asian Americans—two communities that consist of a high proportion of immigrants—lies with the political parties themselves, the Democratic as well as the Republican Party (Wong 2006).

In proportion to their presence in the U.S. population, white women are better represented in the state legislatures than are women of color (Hardy-Fanta et al. 2006).[5] However, African American, Latina, and Asian American women are better represented among state legislators of color than are white women among white state legislators (Hardy-Fanta et al. 2006; Bratton, Haynie, and Reingold 2008). Scholars have also observed that women of color comprise a larger share of minority members of Congress than white women do of all white members of Congress (García Bedolla, Tate, and Wong 2005).

Office holding by women of color—and particularly by African American women—is at an historic high. Together, women of color constitute 20.5 percent of all women state legislators (Center for American Women and Politics 2013g). African American women, who represent the vast majority of minority women legislators, constitute 13.5 percent of all women legislators in the states (Center for American Women and Politics 2013g). In 1981—the year of the first CAWP Recruitment Study, African American women were only 7.0 percent of women state legislators (Carroll and Strimling 1983: 141).

As Figure 5.1 shows, between 1991 and 2013, the presence of African American women legislators rose incrementally. The numbers of Latinas and Asian American women progressed as well, although they occupy

5. This relationship holds in 2013 when one compares CAWP data on women's office holding with the 2010 U.S. Census. Women of color are 4.9 percent of state legislators but 18.4 percent of the population, giving them a ratio of legislative office holding to population size of .27. Meanwhile, white women are 19.1 percent of legislators and 32.4 percent of the population, giving them a ratio of .59. Among women of color, African American women are represented in legislatures in a similar proportion to their share of the population, but Asian American women and Latinas are not.

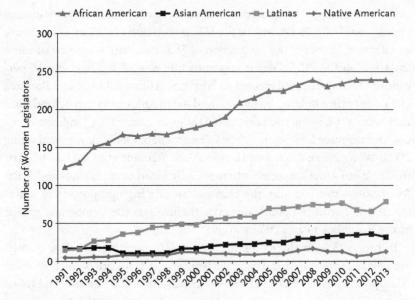

Figure 5.1
Women of Color State Legislators, 1991–2013
Source: Center for American Women and Politics.

fewer legislative seats than do African American women. While only fifteen Latinas held state legislative office in 1991, that number had more than quintupled to seventy-nine by the year 2013. Meanwhile, thirty-two Asian American women held state legislative office in 2013, an historic high. Trailing behind other women of color are Native American women whose tiny numbers declined in the 2010 elections; a mere thirteen Native American women served as state legislators in 2013.

The increases in the number of women of color have occurred almost exclusively on the Democratic side of the aisle. In fact, women of color made up 28.0 percent of all Democratic women state legislators in 2008 (Center for American Women and Politics 2008). In contrast, in 1991—the earliest year of CAWP's data on minority women's office holding—women of color were 19.2 percent of all Democratic women state legislators.[6] In the span of less than two decades, then, the share of minority women among Democratic women legislators increased by almost 50 percent. At the time of the 2008 CAWP Recruitment Study, 361 women of color held state legislative office and the overwhelming majority of them—336 or 93.1 percent—identified as Democrats.

6. Data provided by CAWP.

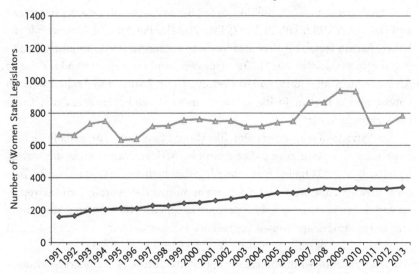

Figure 5.2
Democratic Women State Legislators by Race, 1991–2013
Source: Center for American Women and Politics.

Following the 2010 elections, which proved to be historic for the Republican Party, the ranks of Democratic state legislators across the country shrank dramatically. Nevertheless, as a result of the 2010 elections, the share of minority women among all Democratic women state legislators increased, reflecting the fact that minority women are more likely than Anglo women to represent safe Democratic seats. In 2013, women of color composed nearly one-third of all Democratic women state legislators (30.3 percent). Women of color, therefore, contribute even more than before to explaining why the number of Democratic women legislators is as large as it is (Figure 5.2).

THE PATHWAYS OF DEMOCRATIC WOMEN OF COLOR

Although office holding by women of color has increased dramatically, only 4.9 percent of all state legislators in 2013 are women of color (Center for American Women and Politics 2013g). Why are the numbers not greater? What then are the challenges that women of color continue to confront in their bids for state legislative office?

Minority officeholders tend to hail from districts with substantial—if not majority-minority populations; indeed, it is the creation of

majority-minority districts that has fueled the substantial growth in African American office holding over the past several decades (Grofman and Davidson 1992; Lublin 1997; Tate 2003). Like African American legislators, Latino legislators are also likely to represent predominantly Latino populations (Casellas 2011). The stronger Democratic partisan loyalties of African American voters, and to a lesser extent, Latino and Asian American voters, means that majority-minority districts tend to be safe districts for the Democratic Party.

The districts of women of color, like those of men of color, usually include large minority populations. For example, African American women state legislators in 2004 hailed from state legislative districts that were 52.9 percent African American and 64 percent nonwhite overall; Latinas represented districts that were 44.9 percent Latina and 57.2 percent nonwhite; and Asian American women represented districts that were 38.1 percent Asian and 57.2 percent nonwhite (Hardy-Fanta et al. 2006).

Racial differences in the electoral circumstances of Democratic women are evident in the 2008 CAWP Recruitment Study, reflecting these larger patterns in the types of districts that elect legislators of color. The vast majority of Democratic women of color serving in state legislatures (85.9 percent) describe their districts as composed of a majority of Democratic voters, compared with 48.7 percent of Democratic women who are of Anglo background. Anglo women Democrats are more likely than minority women to say that they represent districts in which voters are equally divided between the two parties (33.1 percent) or that more voters identify with the Republican Party (18.2 percent).[7]

Although Democratic women of color are more likely to have faced friendly general election voters, they confronted heightened primary competition compared with white Democratic women. Minority women state legislators in 2008 were more likely to have had a primary opponent the very first time they ran for the legislature (77.2 percent of Democratic women of color compared with 48.0 percent of Democratic white women). When a party primary is the main contest, party leaders may be less likely to remain neutral. Perhaps because of this, women of color are more likely than their white female colleagues to have faced divided or opposed party leaders (27.5 percent of women of color compared with 16.5 percent of white women) rather than supportive party leaders (53.8 percent of women of color versus 72.8 percent of white women).[8]

7. The relationship between race and district characteristics is statistically significant ($p \leq .01$).

8. All comparisons in this paragraph are statistically significant.

Racial and ethnic differences among women are evident in other assessments of the Democratic Party. Women of color are significantly less likely than Anglo Democratic women to cite party support as having been "very important" to their candidacies (26.3 percent compared with 37.1 percent) and less likely to say that party leaders sought them out and encouraged them to run for their first legislative race (38.5 percent compared with 59.8 percent).[9] Finally, only 15.4 percent of Democratic women of color cited recruitment by a party leader or elected official as the single most important reason they sought their current office, compared with 24.2 percent of Democratic white women. We cannot say with certainty why these differences occur although parties do play a different role in safer, more Democratic state legislative districts such as the majority of those that have elected women of color to date, and these differences may be evident here. Nevertheless, we can say with certainty that the "recruited" pathway is less likely to characterize minority women's entry into elective office; women of color are less likely than white women to arrive at the legislature because of party recruitment.

On the one hand, these patterns demonstrate that women of color can run successfully in safe Democratic districts and can reach the legislature without encouragement or recruitment by their party. On the other hand, this means that minority women are less likely than white women to experience any benefits that accompany strong party support.

At the congressional level, scholars have argued that the strategy of creating majority-minority districts has probably been exhausted, which may make it more difficult for women of color to win office in the future (Williams 2001). Certainly there are limits to the number of majority-minority districts that will exist at the state legislative level as well. The ceiling posed by racial redistricting severely affects the opportunities for African American women, but it has implications as well for other women of color, who tend to represent racially and ethnically diverse districts. In the short term, additional gains in office holding by Latinas and Asian American women are likely to be geographically limited because of candidate recruitment patterns. Over the long term, however, the growth of the Latino and Asian American population and the growth of minority voting power should lead to increased office holding by Latinas and Asian American women.

Even in districts where people of color are a minority of voters, women of color might have wider electoral appeal than white women because

9. The racial difference in experiences with party recruitment is statistically significant ($p \leq .01$).

minority women can appeal to both minority voters and women voters of all backgrounds (Smooth 2006). Indeed, Luis Fraga et al. contend that Latina state legislators benefit from "strategic intersectionality" (2008: 157) arising from their position at the intersection of class, gender, and ethnic politics. Meanwhile, Christina Bejarano believes that Latina candidates may be advantaged over Latino candidates, and cites the "diminished electoral disadvantage" of Latinas (2007: 1). Women of color may be less racially threatening to white voters than candidates who are men of color (Bejarano forthcoming).

Although the intersection of race and gender can advantage minority women in some ways, the combined effects of race and gender can also place them at a disadvantage. For example, in the 2008 CAWP Recruitment Study, we found that Democratic women of color state representatives faced greater obstacles compared with their Anglo counterparts (Table 5.3). Democratic women of color state representatives were somewhat more likely than white women Democratic state representatives to report having faced efforts (from a variety of sources) to discourage their candidacies (42.3 percent of women of color compared with 28.3 percent of white women). While Democratic women of color state representatives were significantly more likely than their Anglo women counterparts to have encountered efforts to discourage them from running, there was no significant difference between Democratic men state representatives and white Democratic women state representatives.[10]

No doubt the openness of Democratic Party leaders to candidates who are racial/ethnic minorities, especially in districts that are not majority-minority, will partially determine if office holding by people of color—male and female—continues to increase. However, the obstacles that women of color confront mean that the future of women of color in state politics will continue to depend as well on the tenacity of the minority women who seek office.

RELATIONSHIPS WITH THE DEMOCRATIC PARTY

Democratic women have not achieved anything close to parity with Democratic men; in 2008, women were 29.8 percent of all Democratic state legislators. Yet, compared to Republican women, Democratic women legislators, with their upward trajectory in numbers, appear to represent a

10. We lack a sufficient number of men of color to permit an analysis of male state legislators by race.

Table 5.3. EXPERIENCES WITH EFFORTS TO DISCOURAGE
CANDIDACY, DEMOCRATIC STATE REPRESENTATIVES

	Women of Color %	Anglo Women %	Men (all) %
Encountered efforts to discourage very first candidacy	42.3[a]	28.3	29.0
N	52	300	221

[a] The difference in the means of Democratic women of color state representatives and Anglo women is significant at $p \leq .05$. The difference in the means of all Democratic women state representatives and Democratic men state representatives is not significant.
Question wording: "When you were making your initial decision to seek elective office the very first time, did anyone try to discourage you from running?"
Source: 2008 CAWP Recruitment Study.

success story. It would therefore seem likely that women legislators' relationship to the Democratic Party is a positive one. We saw in the previous chapter that Democratic women are more likely than Democratic men, Republican women, or Republican men to cite recruitment by a party leader or elected official as the single most important reason for seeking their current office. And Democratic women and men reported similar levels of party support and encouragement to run as well as similar levels of party organizational involvement.

However, we have yet to consider if women and men legislators receive a similar reception from the Democratic Party when they run under the same circumstances. Do women and men have similar experiences with the Democratic Party once we consider the role of electoral factors and legislator backgrounds? Our 2008 data enable us to analyze the relationship between state legislators and the party in two respects. We examine the influence of Democratic Party leaders on legislators' entry into difficult electoral situations, and we study the effect of legislators' backgrounds on attracting party support and encouragement. Throughout, our focus is on whether the patterns that predict party support are similar or different for women and men.

The 1981 CAWP Recruitment Study found evidence that more women than men legislators had been recruited to run as "sacrificial lambs" in districts where their odds of winning were low (Carroll and Strimling 1983). However, much may have changed for women candidates since that time, and at first glance today's Democratic women legislators do not appear to be more likely to have reached office after beginning as so-called sacrificial lambs. For example, similar proportions of both genders—23.6 percent of 2008 Democratic women state representatives compared with 23.5 percent of their male counterparts—faced a Republican incumbent the very first

time they ran for their legislative office. Nevertheless, this bivariate relationship does not pinpoint the exact extent and nature of the Democratic Party's involvement in the candidacy decision. Consequently we turn to a multivariate analysis, focusing on Democratic state representatives from the 2008 CAWP Recruitment Study.[11]

In order to determine if women legislators were more likely than men to be urged by the Democratic Party to enter a difficult race, we model the likelihood that a legislator's first bid for the legislature was in a race against a Republican incumbent. The main variables of interest are interaction terms that determine if party efforts affected women and men differently. We employ three different measures to gauge the role of party. In Model 1, we use a dichotomous variable, *Party recruitment as reason*, which assesses whether or not recruitment by a party leader or elected official was the single most important reason the legislator sought her or his current office. In Model 2, we consider an alternative measure of party recruitment, *Party encouragement*, which is a dichotomous measure of whether leaders actively sought out and encouraged the legislator to run. In Model 3, we analyze the effect of the Democratic Party with a three-category measure of *Party support*: whether party leaders opposed, were neutral or divided, or supported the legislator's candidacy. Control variables include two contextual measures that may affect the likelihood of running in adverse circumstances: the level of the party's candidate recruitment activity in the district and state legislative professionalism.[12] Because our data set contains multiple respondents from the same state, we calculate robust standard errors clustering on state.

Table 5.4 reveals that women Democratic state representatives are not more likely than Democratic men to have faced a Republican incumbent in their very first bid for the legislature. The effect of being a woman legislator is not statistically significant in any of the three models predicting a difficult first race for the lower house.

But our main hypothesis is that the interaction terms of the party variables with gender will be statistically significant. The interaction effect for gender is statistically significant in the first model (Table 5.4), indicating

11. Given the increase in Democratic women's office holding over time, a focus on 2008 rather than 1981 yields more cases for analysis. We also have more cases in 2008 because we sampled male state representatives to equal one-half of the number of female state representatives in 1981, but in 2008 we sampled an equal number of male and female state representatives.

12. We asked legislators, "Generally speaking, how active are your party's leaders in recruiting candidates in the area you represent?" Responses are coded 1 to 4 from inactive to very active. Professionalism of the legislature is a three-category variable from the NCSL, from most to least professionalized <http://www.ncsl.org/legislatures-elections/legislatures/full-and-part-time-legislatures.aspx>. Accessed January 19, 2013.

Table 5.4. WERE WOMEN ENCOURAGED TO RUN AS SACRIFICIAL LAMBS? DEMOCRATIC STATE REPRESENTATIVES

	Model 1	Model 2	Model 3
Woman	−.16 (.19)	.21 (.31)	.26 (1.47)
Party recruitment as reason	−1.18* (.52)	–	–
Party recruitment as reason x Woman	1.33* (.62)	–	–
Party encouragement	–	.69* (.36)	–
Party encouragement x Woman	–	−.29 (.41)	–
Party support	–	–	.98* (.41)
Party support x Woman	–	–	−.12 (.54)
Control Variables			
Party recruitment activity in district	.24* (.10)	.13(.10)	.15 (.10)
Legislative professionalism	.28 (.15)	.33*(.16)	.26 (.14)
Intercept	−2.41** (.49)	−2.77** (.48)	−4.83** (1.15)
N	511	513	513
χ^2 (df)	24.35** (5)	17.89** (5)	22.57** (5)

*$p \leq .05$, ** $p \leq .01$

Note: Logistic regression model with robust standard errors in parentheses. The dependent variable is coded 1 if the legislator's first state legislative race was as a challenger against a Republican incumbent. *Party recruitment as reason* is coded 1 if the single most important reason the legislator sought his or her current office was because of recruitment, 0 otherwise; *party encouragement* is coded 1 if party leaders actively encouraged the legislator to seek his or her seat, 0 otherwise; *party support* is coded 1 if party leaders opposed the legislator's bid for office, 2 if party leaders were neutral or divided, and 3 if party leaders supported the legislator in his or her first bid for his or her current office.
Source: 2008 CAWP Recruitment Study.

that the effect of party (*Party recruitment as reason*) was different for women and men state representatives. Democratic male representatives were less likely to cite party recruitment as the single most important reason for their candidacies when they ran against Republican incumbents, suggesting that men were unlikely to have been recruited to run as sacrificial lambs. Meanwhile, party recruitment is not significantly related to the likelihood that women are sacrificial lambs. Therefore, the evidence is clearer that when men experience party recruitment, it is for a winnable race.

When we turn to the remaining models, we see that Democratic legislators who ran in races with Republican incumbents were more likely to receive *Party encouragement* and more likely to attract *Party support* than legislators who ran in more favorable electoral circumstances. However, in neither case does the interaction term of gender with party achieve

statistical significance. In short, then, we find no evidence in these two models and only limited evidence in the first that Democratic women legislators were more likely than men to have been encouraged by their party to run in adverse circumstances.

Another way to consider whether women are at a disadvantage in the Democratic Party is to determine if the personal backgrounds and experiences of legislators predict party support the same way regardless of the legislator's gender. Our hypothesis is summarized by one Democratic woman legislator who argued, "They won't even look at a woman unless she's got some experience, but they will look at a man without the same qualifications, if he is a warm body and he can work hard and raise money." This hypothesis is based on the notion that women may have more difficulty persuading the party of their strengths as candidates because office holding has been dominated by men. For example, David Niven (1998) and Kira Sanbonmatsu (2006b) argue that the parties often overlook women for state legislative races. And in a study of citizen potential candidates, Richard L. Fox and Jennifer Lawless (2010) find that women were less likely than men to report that they had been the subject of party recruitment.

We consider the effect of legislators' backgrounds on the likelihood that legislators attributed their bids for the legislature to recruitment (*Party recruitment as reason*), to whether party leaders encouraged them to run (*Party encouragement*), and to whether party leaders supported their candidacy (*Party support*) (Table 5.5). The credentials that we examine are educational attainment, occupation, political experience, and party experience. We measure education with a categorical variable coded 1 to 4, ranging from high school to advanced degree. For occupation, we examine the effect of being a lawyer (coded 0, 1). Political experience consists of three dichotomous variables capturing whether or not the legislator had worked on a campaign prior to running for the legislature, had worked as staff for a public official, and had served in a previous elective or appointive office. Party experience is a simple tally of three different types of party activity prior to serving (local party committee, state/national committee, and convention delegate), coded 0 to 3. We control for several factors that are likely to predict party support and recruitment: partisan composition of the district, whether the representative challenged a Democratic incumbent, the level of the party's candidate recruitment activity in the district, and legislative professionalism.[13]

13. Partisan composition of the district is measured with a three-category variable from least favorable to the legislator's party to most favorable. We asked legislators "In your first bid for the office you now hold, which of the following statements best characterizes the competitiveness of the legislative district in which you ran?"

Table 5.5. DETERMINANTS OF PARTY SUPPORT, DEMOCRATIC STATE REPRESENTATIVES

	Party Recruitment as Reason	Party Encouragement	Party Support
Woman	.69* (.35)	.34* (.17)	.47* (.23)
Legislator Background			
Education	−.32* (.13)	−.18 (.13)	−.02 (.11)
Lawyer	−.54 (.52)	−.17 (.34)	−.78* (.36)
Campaign experience	−.29 (.21)	.34 (.26)	−.12 (.28)
Staff experience	−.16 (.29)	−.75** (.22)	.28 (.23)
Elective or appointive experience	.02 (.24)	.58** (.18)	.60* (.25)
Party experience	−.26 (.13)	.09 (.16)	.01 (.13)
Control Variables			
Party recruitment activity in district	.46** (.14)	.76** (.10)	.43** (.10)
Partisan composition of district	−.07 (.13)	−.26 (.16)	−.53** (.18)
Challenged incumbent from own party	−.12 (.40)	−.29 (.33)	−1.08** (.32)
Legislative professionalism	.04 (.15)	−.007 (.14)	.25 (.16)
Intercept	−1.47 (.78)	−1.43 (.76)	−2.32 (.93)
Intercept 2	–	–	.14 (.89)
N	433	434	435
χ^2 (df)	45.45** (11)	103.74** (11)	81.80** (11)

* $p \leq .05$, ** $p \leq .01$
Note: The first two columns present the results of a logistic regression; the third column is an ordered logit. Robust standard errors are in parentheses. *Party recruitment as reason* is coded 1 if the single most important reason the legislator sought his or her current office was because of recruitment, 0 otherwise; *party encouragement* is coded 1 if party leaders actively encouraged the legislator to seek his or her seat, 0 otherwise; *party support* is coded 1 if party leaders opposed the legislator's bid for office, 2 if party leaders were neutral or divided, and 3 if party leaders supported the legislator in his or her first bid for his or her current office.
Source: 2008 CAWP Recruitment Study.

Table 5.5 reveals that several of the background variables that we hypothesized would affect the extent of party support do have effects, although they work somewhat differently across the three party measures. For example, educational attainment is negatively related to *Party recruitment as reason*, indicating that those with higher education were less likely to attribute their bid for their first current office solely to recruitment. This result also means that Democratic state representatives with advanced

degrees are more likely to attribute their candidacy to a public policy concern or a longstanding interest in politics.

The effect of elective or appointive experience behaves as expected in two of the three models. Legislators who had previous experience were more likely to have received *Party encouragement* to run and *Party support* for their candidacy than other legislators. The experience of working on the staff of a public official is unexpectedly negatively related to receiving *Party encouragement*, suggesting that a pathway to office that entails staff experience may be an alternative to a pathway that is initiated through the party. Being a lawyer has an unexpected, negative effect on the receipt of *Party support*.

Our main interest, however, is in whether gender conditions the effect of legislator backgrounds on attracting party support. Therefore, in a subsequent analysis, we added interaction terms of gender with those background factors that were statistically significant in Table 5.5 (e.g., education, lawyer, staff experience, and elective/appointive experience). In no case did we find that the interaction of the occupation or experience variable with legislator gender was statistically significant (results not shown). Therefore, we find no evidence that the types of background factors that predict party support and encouragement are different for Democratic women representatives compared with Democratic men representatives.

It is worth mentioning that in all three models in Table 5.5, being a woman remains statistically significant even once other factors are controlled. The positive effect of gender means that Democratic women are more likely than Democratic men to cite party recruitment as the single most important reason for seeking their current office, more likely to receive party encouragement, and more likely to receive party support.

In addition, Democratic women are more likely than Democratic men to cite party support as "very important" to their decisions to seek their current office. This gender difference persists in the face of control variables. In Table 5.6 we estimate the likelihood that a legislator cited party support as very important, controlling for other factors. As in our previous models, we control for legislator and contextual variables that are likely to explain the legislator's assessment of party support as a factor (Model 1). In this model, we add a control for the legislator's rating of "my longstanding desire to run" as a factor in the decision to seek their current office. Even after taking the extent to which the party encouraged the legislator to run into account (Model 2), perceptions of party support remain disproportionately important to Democratic women state representatives compared with their Democratic male counterparts.

Table 5.6. DETERMINANTS OF THE IMPORTANCE OF PARTY SUPPORT IN THE DECISION TO RUN, DEMOCRATIC STATE REPRESENTATIVES

	Model 1	Model 2
Woman	.56** (.20)	.52*(.22)
Control Variables		
Party encouragement	–	1.52** (.23)
Ambition as motivation	−.04 (.11)	.01 (.14)
Party experience	.30** (.10)	.26** (.10)
Party's recruitment activity	.54** (.10)	.32** (.10)
Challenged incumbent from own party	−.38 (.38)	−.30 (.41)
Partisan composition of district	.005 (.13)	.04 (.12)
Legislative professionalism	.03 (.16)	.02 (.17)
Intercept	−2.91 (.68)	−3.41 (.73)
N	*498*	*496*
χ^2 (df)	54.47** (7)	111.11** (8)

* $p \leq .05$, ** $p \leq .01$
Note: Logistic regression model with robust standard errors in parentheses. The dependent variable is coded 1 if the legislator rated party support as "very important" to his or her decision to seek his or her current office, 0 otherwise.
Source: 2008 CAWP Recruitment Study.

Despite these findings, it is still possible that women experienced more negative interactions with the Democratic Party than men prior to announcing a candidacy or when they campaigned. Because our respondents—legislators—are survivors, presumably they overcame any negative effects of interactions with the Democratic Party. In other words, the nature of our sample reduces the likelihood that we will find evidence of bias against women legislators. If women who received negative reactions failed to run or lost their races, they would not appear in our data set. Thus, because our data set only includes winners, we cannot rule out the possibility that Democratic women not serving in the state legislatures are disadvantaged earlier in the recruitment process.

Nevertheless, what we can conclude more definitively is that party backing is of greater importance to Democratic women than Democratic men. Consistent with our findings in Chapter 3 suggesting that women's candidacies are often more relationally embedded than men's, women appear to rely more on party recruitment and women are more likely to say they had party support. Consequently, Democratic women's representation appears more contingent than Democratic men's on the existence of receptive and encouraging party leaders.

CAMPAIGN RESOURCES: FUND-RAISING AND WOMEN'S OFFICE HOLDING

Perhaps the largest gender gap in perceptions to emerge from our study occurs on an aspect of politics that has long since been discredited as a barrier to women's candidacies. Here we address legislators' beliefs about the relationship between gender and campaign finance. In one of the most comprehensive investigations of women's congressional campaign receipts, Burrell (1994) failed to find evidence that women were at a disadvantage in fund-raising for U.S. House races and found some evidence of an advantage. Part of the explanation for the change in women's campaign fund-raising lies with the advent of women's PACs and particularly EMILY's List, founded in 1985, which has fundamentally changed the nature of women's fund-raising. Women's PACs modeled on EMILY's List have taken root across the states and EMILY's List itself contributes to some state legislative races.

However, we know far less about the success of women in raising funds at the state legislative than at the congressional level. The few existing studies have generated mixed evidence. Thompson, Moncrief, and Hamm (1998) found that women were at a fund-raising disadvantage, but only in states with professionalized legislatures. In a more recent analysis, Robert Hogan (2007) for the most part discovered gender parity in campaign spending in 1996 and 1998 general election races. Lawless and Fox (2010) found that women in the social eligibility pool were more discouraged than men by the prospect of raising money, suggesting that fund-raising might be a greater deterrent for women than for men who might run for the legislature or other offices. Still, many questions remain unanswered. We do not know, for example, whether women state legislative candidates have more difficulty raising early money, whether the cost of campaigning is more likely to deter women from running, or whether more effort is required by women to achieve the same funding levels as men. We might conclude that there is gender equality with respect to campaign finance should campaign receipts be equal; on the other hand, the conclusion is less rosy if women must work harder than men to obtain the same funds.

The women state legislators we surveyed in 2008 certainly perceive a very different situation than the picture of gender parity in fund-raising that has emerged from the congressional scholarship, although our survey question asked legislators for their perceptions of the campaign finance situation rather than reports on their personal fund-raising experiences. A sizable majority of Democratic women state representatives—and more than four times as many Democratic women as men (61.7 percent versus

13.5 percent)—agreed that "It is harder for female candidates to raise money than male candidates." In contrast, a clear minority of Democratic women state representatives (38.0 percent), compared with an overwhelming majority of their male counterparts (85.2 percent), expressed the view that "It is equally hard for both [male and female candidates]." Almost no respondents—women or men—believed that it is harder for male candidates to raise money than female candidates. The pattern of responses among Democratic state senators was nearly identical to that for state representatives.[14]

Among Democrats, women of color were significantly more likely than Anglo women to think raising money is more difficult for women candidates (73.8 percent compared with 58.5 percent). This difference may be due in large part to the fact that the districts represented by African American women tend to be less affluent and more liberal. As one minority woman legislator explained:

> ... there are some obstacles that are unique to African American women, for example, fundraising. I've had this conversation with a number of individuals who are campaign donors—that the coffers of our white female counterparts are usually more endowed than for us....I don't necessarily want to say it is a racist thing; I don't believe it is. I think a lot of it has to do with the areas we represent [and] the positions that we take.

Although Republicans in general were less likely than Democrats to perceive gender differences in fund-raising capabilities, a large gender gap in perceptions also was apparent among Republicans. Republican women representatives were more evenly divided in their perceptions than Democratic women representatives and less likely to perceive that raising money is harder for women candidates. Nevertheless nearly half perceived a disadvantage for women (43.9 percent), compared with only 3.4 percent of Republican male representatives (Figure 5.3). A narrow majority of Republican women (56.1 percent), compared with almost all Republican men (94.6 percent), agreed that it is "equally hard for both" women and men to raise money.[15]

14. Gender differences were statistically significant ($p \leq .01$). Because our survey question about gender equality in fund-raising did not appear on the 1981 CAWP Recruitment Study questionnaire, we cannot make over-time comparisons.
15. A chi-square test indicates that this relationship is statistically significant ($p \leq .01$).

Among the women legislators we interviewed, some reflected the view that fund-raising is equally difficult for both genders. For example, one Republican woman legislator explained, "It is hard to raise money, and it is equally hard [for women and men]. If you are a good candidate, then if there is money to be raised, you'll be able to raise it." However, most of the women legislators we interviewed viewed fund-raising as more difficult for women than men and suggested that gender discrepancies in perceptions might stem from male legislators' failure to understand the distinctive obstacles women face when they run for office. According to one Democratic woman, the fact that men are less likely than women to think that it is harder for women to fund-raise shows that they are "not aware that they are already ahead of women before the game even starts." Similarly, another Democratic female legislator suggested, "I don't think they know the nuts and bolts of what goes on for a female candidate running for office."

If the fund-raising playing field for women truly is as level as the congressional literature suggests and as male legislators believe, then a large majority of Democratic women and a sizable minority of Republican women who have successfully run for and won election to office are seriously misperceiving the reality they confront. We find it difficult to accept this conclusion, even more so because the perception of inequality is so prevalent among women in the very party (i.e., the Democratic Party) where women have fared relatively well in winning office.

We probed those survey respondents who believed that it is harder for women to raise money about the reasons for the gender disparity. According to women state representatives, the single most important reason that fund-raising is more difficult for women is that women do not have the same networks as men (Table 5.7), with 39.1 percent of Democrats and 48.6 percent of Republicans offering this reason. The second most common reason (34.9 percent of Democratic state representatives and 26.4 percent of Republican state representatives) is that women are less comfortable asking for money for themselves.

The reasons provided by Democratic women state senators were similar to those of Democratic women state representatives, except that women senators were slightly more likely to identify comfort level as an important reason (42.7 percent of state senators compared with 34.9 percent of state representatives) and slightly less likely to identify networks as important (32.4 percent of state senators compared with 39.1 percent of state representatives). Among Republican women senators, slightly fewer reported that women lack the same networks (36.0 percent of state senators compared with 48.6 percent of state representatives), and more said women

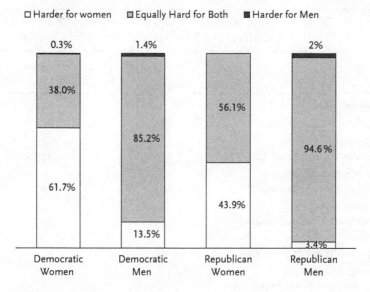

Figure 5.3
State Representatives' Perceptions of Gender and Fund-Raising
Source: 2008 CAWP Recruitment Study.

have to raise money in smaller denominations (28.0 percent of state senators compared with 15.3 percent of state representatives).

Most of the women legislators we interviewed echoed the views of women in the survey. We began each interview with an open-ended question about the reasons for women's under-representation in office, and many of the women we interviewed answered by pointing at least in part to fund-raising. For example, one woman legislator described the obstacle that money poses as she saw it:

> I think it is more difficult for women . . . to get supported with money. . . . Women historically have not given as robustly as men, and women historically have not been in charge of the money that gets given. [Women] have not been the decision makers on directing money into campaigns. Again, we are in a period where we have seen significant change, but the weight of history is heavy on the shoulders of women.

In response to our initial question about reasons for women's under-representation or to more specific questions about fund-raising that appeared later in the interview, many of the women we interviewed pointed to differences in the types of networks that legislators can access. Men who run for office often have well-heeled networks, consisting mostly of men who

Table 5.7 REASONS FOR INEQUALITIES IN FUND-RAISING: PERCEPTIONS OF WOMEN STATE LEGISLATORS

	Representatives %	Senators %
Democratic Women		
Women do not have the same networks	39.1	32.4
Women are less comfortable asking for money for themselves	34.9	42.7
Women raise money in smaller denominations	15.4	16.2
Women have less experience raising money	4.2	7.4
Women have to devote more time to raising money	1.9	0
Other: Bias, not taken as seriously or given same amount	4.2	1.5
Other	0.5	0
N =	*215*	*68*
Republican Women		
Women do not have the same networks	48.6	36.0
Women are less comfortable asking for money for themselves	26.4	28.0
Women raise money in smaller denominations	15.3	28.0
Women have less experience raising money	5.6	4.0
Women have to devote more time to raising money	2.8	4.0
Other: Bias, not taken as seriously or given same amount	1.4	0
Other	0	0
N =	*72*	*25*

Question wording: "Which of the following is the most important reason it is harder for them to raise money?"
Note: Responses are presented for those state legislators who stated it is harder for women to raise money.
Source: 2008 CAWP Recruitment Study.

are accustomed to giving political money in sizable amounts. Women who run often rely more on other women, who are less accustomed to political giving and write checks in smaller amounts. As one Republican woman legislator explained:

> The problem is these women think $100 is a lot of money. My last race was $250,000. Guys are used to writing big checks and they have more . . . male associates they can get that kind of money from. I don't have a best friend that owns a company. And I don't have a best friend that . . . is a big wheel in some particular outfit like the Chamber [of Commerce].

Similarly, another Republican woman legislator described how she received smaller contributions than a similarly situated male colleague—both of whom would be eligible to seek an opening for a state senate position. She explained that gender was the sole factor that differentiated her from the other representative: "It is a step up to higher office, so maybe they were comfortable with me being a representative, but they [donors] aren't sure I would be quite as good if I went to a higher office." She also argued that the problem partly lies with the giving—or lack thereof—by female supporters:

> In my experience, it has been tougher to raise money as a woman. In my experience, which is all I can speak about, I found that women don't financially support anyone nearly as much as men do. Men . . . in the business world are much more used to that. Although I have a lot of women supporters, I don't have a lot of women who give me money, who financially support me. That is one of the differences. . . . [W]omen are just much more conservative in how they spend their money.

Another legislator offered one possible explanation for the gender difference in contribution amounts. She explained, "Women . . . are giving because they are excited for another woman to be in politics, whereas some men may be understanding they are giving money for a certain reason, for a certain outcome, so they therefore give larger amounts to accomplish that outcome."

Some of the women legislators we interviewed also stressed that women are often less comfortable than men in asking for money to support their campaigns. For example, one Democratic woman, who described herself as a "prolific fundraiser," observed, "I see some of these guys, and they are aggressive in a way that most of our women candidates are not. They just have a different comfort level with asking for large amounts of money, which may explain why they are getting it." Another Democratic woman commented: "Men come

from an arena where they don't have any reservations about asking for money. They have relationships that help them raise money."

The 2008 findings from both our survey and interviews clearly demonstrate that women legislators both perceive money to be a major problem and believe that women are at a disadvantage when it comes to fund-raising. Since concern about gender inequalities in fund-raising may deter women from seeking office in the first place, our findings regarding fund-raising bolster our argument, put forward in chapter 3, that political considerations, including the availability of resources, strongly affect women's decision making about seeking office.

As state legislative campaign costs have increased over time, money has become an important consideration for larger proportions of both women and men than it was in 1981. For example, in 1981, 25.6 percent of Democratic women state representatives, compared with 24.6 percent of their male colleagues, rated "having sufficient financial resources to conduct a viable campaign" as very important to their decisions to run for the legislatures, while in 2008, 41.6 percent of Democratic women state representatives and 39.1 percent of men identified financial resources as very important. Among Republican state representatives, perceptions of the import of resources have also increased. In 1981, 27.5 percent of Republican women state representatives compared with 16.7 percent of their Republican male counterparts cited this factor as very important; in 2008, 33.1 percent of Republican women state representatives and 29.6 percent of their Republican male counterparts did so.[16]

The perceptions we find here of an uneven playing field for women in the area of fund-raising suggest that one way to increase the number of women's candidacies might be for more states to adopt laws that make public funds available for state legislative races. Preliminary analysis of such laws in Arizona and Maine find that women are, in fact, more likely to accept public funding for their races (Werner and Mayer 2007). Regardless, the issue of money is not going away for women candidates and, if anything, is becoming a more important factor in their decisions about seeking office.

CONCLUSION

Democratic women have gained legislative seats at a much higher rate than Republican women in recent years. To a great extent, the rise of women

16. The gender difference among 1981 Republicans is statistically significant ($p \leq .05$).

Democrats is about the rise of Democratic women of color. Although they do not hold office in proportion to their presence in the U.S. population, minority women have advanced in state legislatures. Of course, the Democratic Party need not have a monopoly on the candidacies of women of color. In 2010, in fact, among the most noteworthy accomplishments for women in politics was the election of two women of color to the office of governor, Susana Martinez in New Mexico and Nikki Haley in South Carolina, both of whom are Republican.

Women of color have made gains despite the fact that they seem in several respects to confront greater obstacles than white women. Resources and party support appear to be more difficult for women of color to attain, and minority women who are elected to the legislature seem to have overcome more efforts than Anglo women to discourage their candidacies.

The increase in the number of Democratic women is also about issues. Because the intersection of race and gender affects policy priorities and legislative life (Barrett 2001; Smooth 2001; Fraga et al. 2008), the election of more Democratic women of color is likely to have policy consequences in the states. But looking beyond women of color, Democratic women in general more often than men cite public policy as a reason for their candidacies, and the importance of policy as a motivational factor has increased over time. Because women have not traditionally aspired to a political career, it is understandable why other motivations, such as a strong desire to shape public policy, might be important to fueling women's bids for office. The women's movement provides some of the issue concerns that motivate Democratic women to run for office.

Our findings that the candidacies of women state legislators are increasingly motivated by public policy and that public policy plays a motivating role for larger proportions of women than men are noteworthy in relationship to the literature on the impact of women in office. One of the most consistent findings in scholarship about the behavior of women and men in legislative institutions is the gender gap in agenda setting. For example, a 2001 CAWP survey of state legislators found that the majority (two-thirds) of women legislators, compared with only 40 percent of their male colleagues, worked on a bill to benefit women (Center for American Women and Politics 2001). Research by CAWP and others has also found that women legislators are more likely than men to give priority to issues such as health care, education, and the welfare of children and families (Carroll 1989; Dodson and Carroll 1991; Thomas 1994; Swers 2002). Thus, not only do women bring different issues to the legislative agenda, but also policy motivations play a greater role in their decisions to seek office in the first place, suggesting that women often seek office to bring issues

and perspectives to the legislative agenda that they believe have not been adequately addressed.

Despite the forces leading to the election of Democratic women, including women's diversity, support from the Democratic Party, and the Democratic issue agenda, Democratic women have not yet reached parity with the men in their party. Women state legislators do not necessarily see a level playing field with respect to politics. This is evident on the topic of fund-raising, where large gender differences in perceptions are apparent within both the Democratic and Republican parties. Women's quest for campaign resources has led women's PACs, which have ideological criteria, to play a substantial role in women's candidacies; these PACs contribute to gender differences in legislator ideology and to the greater representation of Democratic women in office compared with Republican women. And while we generally do not find gender differences in how the parties dealt with the candidacies of women and men legislators, our analysis reveals that women's state legislative office holding is more dependent on, and therefore more contingent on, party support.

CHAPTER 6

The Future of Women's Office Holding

HOW WOMEN REACH OFFICE

Much has changed for women in politics since 1981. Surprisingly, though, much has stayed the same. Using data from the 1981 and 2008 Center for American Women and Politics recruitment studies, we found that many of the gender differences that characterized state legislators' pathways to office nearly three decades ago have been remarkably persistent. And many of the barriers that women faced in politics in 1981 still remain.

Our account offers an alternative to conventional ways of theorizing about the causes of women's election to office. It follows, as well, that our account points to different reasons for the continued under-representation of women in American politics. Our analysis also leads to different strategies for those interested in increasing women's election to office in the future.

To a large extent, studies about women's election to office have implicitly assumed that women's pathways to office will resemble men's pathways to office. The assumption of a single model of candidate emergence has led scholars to theorize that women's representation will increase through an assimilation process; once women as a group have acquired the same backgrounds and resources that men have long had, women will be able to occupy seats in the legislatures alongside men at equal rates.

The assumption of a single model has also led scholars to look outside the political realm for a solution to women's under-representation. This way of thinking has led to a focus on the socioeconomic status of women as a group, their social roles, and socialization. Scholars have emphasized the enhancement of personal resources, gains in occupational status, and overcoming socialization patterns as ways of increasing the numbers of women in office.

However, the growth of women's office holding that occurred between 1981 and 2008 did not require women's assimilation to the traditional pathways that men have taken to public office. Gender differences that were evident in legislators' occupational backgrounds in 1981 persisted in 2008. Comparing women's and men's pathways to the legislatures, we found that in both years women were more likely than their male colleagues to hail from the fields of health and education and less likely to be attorneys. Nevertheless, women state legislators come from a variety of occupations.

Just as many women legislators have not come from traditionally male-dominated occupations such as law and business, sizable numbers have not held a previous elective office, although most have some political experience. And while women legislators often have high levels of education, their levels of education vary. So too do their ages although women today more often wait until their children are older before running, just as they did in 1981. Those looking to identify more women candidates should recognize that holding a lower-level office is not necessarily a prerequisite; nor is it necessary to be young or to have an advanced degree.

Women do not take a single path to the legislature. Although for the most part women have not assimilated to the pathways that men take to office, there is no single "women's way" of reaching office that emerges from our analysis. Our research clearly suggests that those interested in electing more women to office should operate with an expanded notion of the pool of women who could be tapped to run. Recognizing that women legislators continue to emerge from a range of occupations and vary in age, education, and political experience, we conclude that the pool of women eligible to run is both wider than commonly perceived and more than sufficient for women to achieve parity in state legislatures. Widespread social change in women's occupational status, their family roles, or their socialization is not a necessary prerequisite for increasing the numbers of women in office. Those interested in increasing women's representation need not wait for a social revolution.

A more expansive view of who can run for office also emerges from our analysis of legislators' decision making about candidacy. For many men, and for some women, the initial decision to run for office is adequately captured by a traditional ambition framework. However, we find that a relationally embedded model of candidacy better explains women's decision making about running for office. Historically, women have been excluded from and marginalized in the realm of electoral politics; today, women in politics are sometimes met with skepticism on the part of voters, the media, and political parties, creating higher hurdles for women to surmount. Perhaps because of this differential treatment, external support

and encouragement are especially important to women's decisions to run for office, and women legislators report having received higher levels of support and encouragement compared with their male colleagues.

Women legislators are more likely to have received encouragement from parties and organizations. They are more likely to have sought campaign training at a workshop. On the home front, women's family lives add complexity to the decision to seek office; women who run for office more often wait to do so until their children are grown and their caregiving responsibilities have diminished. Moreover, women's candidacies are less likely than men's to be self-initiated and more likely to involve consideration of the needs and reactions of other people. These gender differences mean that the decision to run is more embedded in relationships for women than it is for men.

A majority of women legislators ran for elective office the first time because they were encouraged by others to do so. Women also were more likely than men to cite recruitment by a party leader or elected official as the single most important reason they sought their current legislative office. Thus, women need not harbor a long-standing interest in politics prior to deciding to run for public office. Instead, candidacy and ambition can, and often do, arise simultaneously. Therefore, the ambition framework, which is built on the idea that candidacy is self-initiated and stems primarily from a pre-existing desire to hold office, better captures how men decide to run for office than how women decide to run.

Political actors such as parties and interest groups can suggest candidacy and provide necessary resources; alternatively, they can discourage candidacy and withhold crucial resources. Attracting political support is key for anyone—male or female—to win office. But the relationally embedded candidacy framework, which seems more often applicable to women's candidacies than to men's, suggests an even stronger and more central role for recruitment and campaign support. Consequently, in order to understand women's office holding, we must expand our focus beyond the individual woman and consider the role of other actors, including political figures.

Our study indicates that a shift in our thinking about women's election to office is needed. Our analysis suggests that the lessening of barriers— social, psychological, and political—that can inhibit women's candidacies is a necessary, but insufficient, condition for women to reach elective office. In order for women to achieve gender parity in office holding in the medium term, more than an absence of impediments is required. Recruitment and resources are also generally needed for women to reach office. Women's political representation is produced both by the *absence* of impediments and the *presence* of encouragement and support.

For those interested in increasing the number of women in office, attention to the individual woman and her aspirations is likely to prove insufficient to notably change the level of women's office holding in the future. In addition to asking whether discrimination or obstacles exist and whether individual women are motivated to run, both practitioners and scholars will have to include the *presence* of support and encouragement in their thinking, and strategize about how to expand and institutionalize those supports and sources of encouragement in the future.

The persistence of gendered pathways to office between 1981 and 2008 and the existence of gender differences in decision making led us to look beyond social inequality and consider political factors in order to understand what produces women's representation. Instead of rising with women's gains in educational attainment and occupational status in recent years, the level of women's office holding has stagnated, and as our examination of trends over time revealed, this stagnation is largely a function of flagging numbers of Republican women. Most women (and men) arrive at the legislatures with party support, with women more likely than men to perceive party support as important. Consequently, political party receptivity seems a necessary ingredient for women's office holding. Because recruitment is critical to so many women's decisions to run, any solution to Republican women's under-representation would seem to require more party recruitment and greater receptivity to women's candidacies.

For Democratic women, women's organizations and the women's political movement have provided an important supplement and/or alternative to the support provided by parties. However, Republican women have had less organizational infrastructure on which to rely, and the support of women's organizations has not been able to compensate for any deficit in party receptivity to women's candidacies. The addition of more women to Republican party leadership ranks would seem to offer one of the most promising avenues for increasing the party's commitment to recruiting and supporting more women to run for the state legislatures in the years ahead.

Democratic women have fared better than Republican women. Higher levels of recruitment, a higher incidence of policy as a motivation for candidacy, and a larger presence of office holding by women of color distinguish the pathways of Democratic women compared with Republican women. But obstacles remain—even for Democratic women.

We found that even Democratic women—who are relatively successful compared with Republican women—perceive gender-based electoral obstacles. A large gender gap emerged when we queried state legislators about their perceptions of the money available to candidates; women legislators are much more likely than men to perceive gender inequality

in fund-raising. And these perceptions of inequities are more prevalent among Democratic women than Republican women.

The finding that a majority of women believe that fund-raising is more difficult for women than for men is surprising in light of existing scholarship on money and campaigns. Gender scholars often minimize barriers, such as fund-raising, that women active in politics perceive as part of their political reality. Because a scarcity of candidates seems to be at the heart of women's under-representation, scholars typically call upon women to step forward to take advantage of the opportunities that await them. Our findings indicate, however, that scholars may have prematurely dismissed the importance of some of the barriers that women continue to perceive in running for office.[1]

The existing research that observes few obstacles to women's election to office frequently suffers from the problem of selection; we generally do not study those women who were discouraged from running. Because women's candidacies are not distributed randomly across the United States, we do not know what gender differences might emerge were women to run in all districts (Sanbonmatsu 2006a); some districts appear to be more "women-friendly" than others (Palmer and Simon 2012). Meanwhile, an absence of gender differences in studies of campaign finance does not necessarily imply equality since these studies focus on outcomes and do not observe the processes that led to the attainment of campaign funds (Uhlaner and Schlozman 1986; Hogan 2007). In addition, much of the state legislative evidence emphasizing a relatively equal playing field for women is based on general election candidates rather than primary candidates (e.g., Seltzer, Newman, and Leighton 1997).

Research on party recruitment indicates that gender bias in the candidate emergence process persists (Niven 1998; Sanbonmatsu 2006b; Fox and Lawless 2010). Political party leaders, who tend to be male, may not personally know potential women candidates. They also may have concerns about voter attitudes and women's electability (Sanbonmatsu 2006a). Moreover, although we know little about the frequency of efforts to discourage candidates—male or female—negative recruitment appears not to be gender neutral (Niven 2006). In addition, party gate-keeping activity, in which parties seek to discourage candidates from running, is negatively related to women's state legislative office holding (Sanbonmatsu 2006b). In our study, two of the groups of women legislators who are least well represented in office—women of color and

1. On the perceptions of potential candidates, see Lawless and Fox (2010).

Republican women—experienced more efforts to discourage their candidacies than other legislators.

Most women legislators ran for elective office the first time because they were persuaded to do so. This means that what has given rise to women's representation, and what could expand it in the future, are concerted efforts to field women for specific (especially winnable) races. Legislative adoption of political party quotas or candidate quotas is probably not a politically attractive or feasible solution to the problem of women's political under-representation in the United States, where districts are primarily single-member. But advocates of electing more women to office can think beyond the presence of a woman in a single district. Instead, statistics about women's share of the party slate on a statewide or countywide basis can be used to persuade party leaders and elected officials of the need to recruit more women to run for office. This strategy broadens the notion of representation within the party in order to move beyond the seemingly intractable political problem posed by single-member districts. Moreover, Barack Obama's ability to win the presidency and be re-elected, and the success of women of color in recent gubernatorial races, can be used to persuade recruiters—party leaders, elected officials, and interest group leaders—as well as donors about the electability of people of color, including women. Widespread voter dissatisfaction with national politics and with incumbent members of Congress should provide a favorable climate for new candidates, including women from a range of backgrounds.

THE IMPACT OF WOMEN IN PUBLIC OFFICE

In the 1970s and much of the 1980s, researchers of women and politics were preoccupied with the descriptive representation question, asking, "Why are there so few women in public office? Why is the proportion of women serving in office so much smaller than the proportion of women in the general population?" By the late 1980s the numbers of women in office had increased sufficiently that some researchers began to turn their attention to the substantive representation question, asking "What difference, if any, does the presence of women elected officials make? Do women officeholders have a distinctive gender-related impact on public policy, political processes, and/or the institutions in which they serve?"

As women's presence among elected officials increased over the past two decades, researchers focused more and more on the substantive representation question. However, interest in the descriptive representation question has moved back to the forefront as researchers and activists have

observed and become frustrated by the slow rate of progress for women in elective office even as the interest in substantive representation has continued. Although scholars have long recognized that increased descriptive representation of women is likely to have consequences for substantive representation, the descriptive representation and substantive representation questions generally have been investigated in different studies and have resulted in the development of two distinct bodies of literature and research findings.

Substantive representation studies have found gender gaps in legislative priorities in state houses as well as in Congress (e.g., Thomas 1994; Carroll 2001; Center for American Women and Politics 2001; Swers 2002). Legislator surveys and analyses of bill sponsorship patterns reveal that women legislators are more concerned about women as a group and more likely to introduce legislation aimed at women. These agenda-setting gender differences are apparent within both parties (Center for American Women and Politics 2001). Moreover, gender differences can be found throughout all stages of the legislative process, including work within committees and behavior on the floor (Swers 2002).

Increasingly, studies of gender and office holding reveal a complex and contingent relationship between legislator gender and legislative behavior (Reingold 2008). While we might expect that women's ability to act for women would increase if women's presence in the legislature approached parity and was not limited to a mere token presence, evidence of a socalled critical mass effect has been scant in studies of American legislatures (Crowley 2004; Bratton 2005).

Political party also complicates the relationship between descriptive and substantive representation. For example, Michele Swers (2002) found that Republican congresswomen's willingness to cross party lines to work with Democratic women on women's issues depended on majority party status: when Republican women were in the minority party, they were less constrained in toeing the party line than when they were in the majority party. The increasing proportion of Republican women with conservative, as opposed to moderate, ideologies has added to the complexity of gender effects. It is no longer the case that Republican women are less conservative than their male counterparts in the U.S. House (Frederick 2009), and as we found in this study, Republican women state legislators, while more moderate than their male counterparts, are nevertheless more conservative than in the past.

Susan J. Carroll (2002), analyzing in-depth interviews with women in Congress, found that women legislators' actions on behalf of women as a group may look different precisely because women legislators may have

different ideas about how best to represent women. Tracy Osborn (2012) found that women state legislators have different ways of representing women depending on party, arguing that women legislators represent gendered issues through a partisan lens.

For the most part, the recruitment of women for office and the impact of women public officials have been treated as two separate areas of inquiry. But our research points to the need for future research to join the study of how women are elected with the study of how women legislate. Biases and gender differences in the recruitment of legislators may facilitate, or constrain, the ability of women to act in women's interests. Understanding how women reach office may affect our theories and research findings about how women's descriptive representation is related to women's substantive representation.

For example, we found that the relationship between women state legislators and women's organizations transcends party lines. Unsurprisingly, women legislators from both parties were much more likely than their male counterparts to have been active in women's organizations prior to running for elective office. Carroll (2005) has argued that women's organizations link women legislators to a collective perspective about women's lives. The persistence of a link between women legislators and women's organizations implies that women in elective office continue to bring distinctive organizational ties to their jobs as legislators. Although Republican women in elective office have become more conservative as the Republican Party has moved further to the right, our study suggests that Republican women's backgrounds and networks still distinguish them from their male counterparts.

At the same time, our study identified the challenges facing Republican women. Support and recruitment appear to be lacking for women within the Republican Party—particularly as the party has grown more conservative. The difficulty of gaining support from increasingly conservative party leaders and primary electorates has implications for the ability of Republican women to act for women as a group once they reach the legislatures. Because Republican women are believed to be less conservative than Republican men, Republican women who advocate for women or work across party lines may be viewed skeptically. We cannot assume that women will automatically change their legislative behavior once women reach a certain threshold within the institution. However, the pressure to conform to a male norm can be very real and is likely to be intensified in legislative settings in which women are vastly outnumbered, particularly given the substantial opposition to the modern women's movement that we found among Republican male legislators. Of course, partisan ideological

movements tend to ebb and flow over time, and the re-election of Barack Obama may signal a turning point for the Republican Party. A return of the party to more center-right politics would likely have a positive effect on Republican women's numerical representation and their ability to act on behalf of women as a group once elected.

Another implication from our research concerns gender differences in backgrounds. The occupational differences that characterize women's and men's pathways to office and the greater emphasis women place on family-related factors in their decisions to run mean that women bring perspectives to the legislative process that reflect gendered social and occupational experiences. In the past, women have brought expertise from traditionally female-dominated realms to bear on their legislative work (Carroll and Strimling 1983; Thomas 1994; Rosenthal 1998; Center for American Women and Politics 2001; Bratton, Haynie, and Reingold 2008). Our findings suggest that women can be expected to continue to do so for the foreseeable future.

We also found gender differences in the motivation for seeking a state legislative seat. Women legislators were more likely than their male colleagues to cite the desire to change public policy as a motivation for running. We do not know the details of the particular issues or policy domains that drive women to seek elective office. However, the perceived neglect of particular issues that are substantively important to women voters may be one important motivation. If so, the existence of gender differences in agenda setting may not be a result solely of social background differences between women and men. Instead, a more political explanation may underlie some of the gender differences in agenda setting; for some women a conscious desire to better incorporate women's perspectives in public policy may provide the motivation for political careers.

Finally, the process of reaching office may shape legislative behavior. Although some women may not enter the legislature with a distinctive, gendered policy agenda, the experience of serving within the institution may lead them to perceive that particular gender-related issues have been neglected and need their attention (Carroll 2002). The process of how women reach office may play a similar consciousness-raising role. Women legislators perceive gendered obstacles in the electoral process that also may heighten their gender consciousness. As a result, once in the legislature, women legislators may find gender to be a more salient category and may be more cognizant of challenges facing women as a group.

One way that scholars have viewed the relationship between women's presence in office and women's incorporation to politics more broadly is through the lens of symbolic representation. A larger presence of women

in elective office may be needed before women in the mass public feel more politically engaged and participate in politics at the same levels as men. Women's descriptive representation affects the political engagement of women citizens (Burns, Schlozman, and Verba 2001; Atkeson 2003; Wittmer 2011; but see Lawless 2004a; Dolan 2006). Women citizens may not aspire to a career in politics without higher levels of descriptive representation (Lawless and Fox 2010). Meanwhile, Eileen McDonagh (2009) contends that public policies themselves shape women's access to elective office; maternalistic public policies, which institutionalize women's caregiving role, signal to voters that the concerns typically associated with women are political questions. Voter support for women for elective office is thereby enhanced.

While scholars have tended to emphasize the necessity of achieving social equality prior to achieving political equality, our analysis suggests a different perspective. Political factors clearly are critical in affecting women's election to office and therefore women's equitable representation among public officials. Not only may social equality be insufficient to bring about parity in office holding, but perhaps social equality for women is not attainable without equality for women in elective office holding. Gender parity in office holding may be a prerequisite for women to be fully incorporated into America's democracy. The problems women confront in the family, economy, and society are unlikely to be remedied without a greater voice for women in the political sphere itself. With the achievement of political equality may come the policy solutions that can bring about gender equality in other domains.

APPENDIX

METHODOLOGY, 2008 AND 1981 CAWP RECRUITMENT STUDIES

The 2008 CAWP Recruitment Study was administered by the research firm Abt/SRBI Inc. Data collection began in late January 2008 and continued through early September 2008. Respondents received an initial letter informing them of the study and inviting them to complete the survey online. This letter was also sent electronically to those respondents with publicly available email addresses. Respondents who did not complete the web survey after this initial invitation were sent a paper copy of the survey instrument with a postage-paid, self-addressed return envelope. Nonrespondents were subsequently recontacted with reminder messages and additional copies of the survey instrument. Toward the end of the data collection period, remaining nonrespondents received phone call reminder messages as well as invitations to complete the survey by phone. Most respondents (63.2 percent) completed the paper version of the survey although some respondents completed the web version (27.6 percent) or phone version (9.1 percent). Respondents were promised confidentiality.

The 2008 response rate was higher among women than men (the response rates were as follows: women state senators, 40.7 percent; men state senators, 27.9 percent; women state representatives, 40.7 percent; and men state representatives, 33.6 percent). We examined the response rates of women and men with a multivariate analysis, finding that professionalism negatively affected the likelihood of responding. Among women, moving from a legislature with moderate professionalism to a highly professionalized legislature decreased the likelihood of responding by 5.9 percent; among men, this effect was 8.3 percent. Among men only, chamber affected the likelihood of responding; state

representatives were 5.0 percent more likely to respond than state senators.

Data collection for the 1981 CAWP Recruitment Study took place between May and July 1981. CAWP mailed state legislators a paper copy of the survey instrument along with a postage-paid, self-addressed return envelope. Two weeks later, all nonrespondents received a second copy of the questionnaire. The 1981 response rates were as follows: women state senators, 53.3 percent; men state senators, 50.0 percent; women state representatives, 58.1 percent; and men state representatives, 52.6 percent.

INTERVIEW QUESTIONS, 2009 SEMISTRUCTURED FOLLOW-UP TELEPHONE INTERVIEWS

1. Why do you think there aren't more women in the legislature?
 Probe:
 Do you think women are less interested in running for office than men? If yes, why? What deters them from running?
 Do you think women need more encouragement than men before running for office? If yes, why is that? And why aren't they receiving it?
 Do you think women face more obstacles in running for office? If yes, what are they?

2. Nationally, Democratic women state legislators outnumber Republican women state legislators by about 2:1 while men state legislators are about equally divided between the two parties. And in recent years the increases in the number of women legislators have been greater in the Democratic Party than in the Republican Party. Why do think there are fewer Republican women legislators than Democratic women legislators?

3. ASK TERM LIMITED WOMEN ONLY
 Do you think term limits have helped or hurt in terms of the number of women serving in the legislature in your state?
 Probe:
 Are women running for term-limited seats?
 Are efforts being made to recruit women to run for term-limited seats? By whom? How successful are these?

4. What kinds of qualifications and experience, if any, do you think women need to have before they run for the legislature?

4a. We find on several measures that women have had more political experience than men before they run for the legislature. Why do you think this is the case?
Probe:
Do you think it is because women hold themselves to higher standards?
Do you think it is because voters or party leaders expect women to be more qualified?

5. We find in our study that women legislators are more likely than men to say that party support was very important in their decisions to run for the legislature. Why do you think that is the case?
Follow-up:
How active is your party in recruiting candidates for the legislature in your state?
How supportive is your party of women candidates in your state?

6. In your state are any organizations other than the parties playing a role in getting women to run for office and in supporting their candidacies? If so, can you describe which organizations are important and what their role is?

7. We found in our survey that women legislators tend to think that it is harder for women candidates to raise money while most men in legislatures think that fund-raising is equally hard for women and men. Can you help us explain this finding? Why do you think women think women have a harder time raising money while men do not think raising money is tougher for women?

8. We also find in our study that women are more likely than men to have attended a campaign training or workshop. Do you think campaign trainings and workshops are important to women?
Probe: Why do you think they're important to women?

9. Do you think considerations regarding children and spouses or partners affect women's and men's decisions to run for office in about the same ways and to about the same extent, or do you think in deciding to run for the legislature women and men weigh considerations about children and spouses differently?

RUTGERS
THE STATE UNIVERSITY
OF NEW JERSEY

SURVEY OF STATE LEGISLATORS
Eagleton Institute of Politics
New Brunswick, NJ 08901-8557

1. What term are you now serving in your current legislative office?
☐ 1st ☐ 2nd ☐ 3rd ☐ 4th ☐ ____th (please specify)

2. Did you first reach this office through winning an election or through an appointment?
☐ Election ☐ Appointment

3. Other than your desire to serve the public, what was the <u>single most important reason</u> that you decided to seek the office you now hold?
☐ My concern about one or more specific public policy issues.
☐ My longstanding desire to be involved in politics.
☐ It seemed like a winnable race.
☐ Dissatisfaction with the incumbent.
☐ My desire to change the way government works.
☐ A party leader or an elected official asked me to run or serve.
☐ Other (please specify):

4. Do you plan to seek an additional term in the office that you now hold?
☐ Definitely
☐ Probably
☐ Probably not
☐ Definitely not
☐ Can't because of term limits
☐ Not sure

5. If you had the necessary political support and the right opportunities, are there other elective or appointive political offices at any level of government that you would eventually like to hold?
☐ Yes ☐ No (If no, please go to Question 6.)

5a. Which office would you like to hold next?

5b. What is the highest office you would like to hold in the future?

6. Just before you were elected to your current legislative office, was the person holding this position:
a. ☐ a member of your party
☐ a member of the opposing party
☐ not applicable; multimember district
b. ☐ a man
☐ a woman
☐ not applicable; multimember district

7. Generally speaking, how active are your party's leaders in recruiting candidates in the area you represent?
☐ Very active
☐ Somewhat active
☐ Slightly active
☐ Inactive
☐ Don't know

8. Prior to serving in your current office, had you ever held an elective or appointive position—including boards and commissions—at any level of government? (Do <u>not</u> include political party positions.)
☐ Yes
☐ No (If no, please go to Question 9.)

8a. Please indicate <u>all</u> former governmental offices - including board and commission memberships - you held prior to serving in your current office. (Do <u>not</u> include political party positions.)

POSITION	LEVEL (local, county, state, national)	YEARS IN OFFICE	ELECTIVE (E) or APPOINTIVE (A)?
_____	_____	____TO____	__E __A
_____	_____	____TO____	__E __A
_____	_____	____TO____	__E __A
_____	_____	____TO____	__E __A
_____	_____	____TO____	__E __A

9. Did you ever attend a candidate training program or workshop?

☐ Yes ☐ No

9a. If yes: Who sponsored the workshop(s)?

WE ARE NOW GOING TO ASK YOU A SERIES OF QUESTIONS ABOUT <u>THE VERY FIRST TIME</u> YOU RAN FOR THE LEGISLATIVE OFFICE YOU NOW HOLD.

10. What year was your very first race for this office?

11. What situation best describes your very first race for this office?

☐ Incumbent of my party was seeking reelection.
☐ Incumbent of other party was seeking reelection.
☐ It was a race for an open seat.
☐ Not applicable; multimember district.

11a. What happened in this very first race?

☐ I won the primary and the general election.
☐ I won the primary and lost the general election.
☐ I lost the primary.

12. Before you ran the very first time for your current office, had you held any of the following party positions?

	YES	NO
a. Member or chair of local party committee	☐	☐
b. Member or chair of state/national committee	☐	☐
c. Delegate to local/state/national convention	☐	☐

13. Think back to the first time you ran for the legislative office you now hold. Did leaders from your party actively seek you out and encourage you to run for this office?

☐ Yes ☐ No

14. Again, think back to the first time you ran for the office you now hold. Which of the following statements best characterizes the reactions of your party's leaders to your candidacy?

☐ Generally they supported my candidacy.
☐ Generally they opposed my candidacy.
☐ They neither supported nor opposed my candidacy.
☐ They were divided in their reactions to my candidacy; some were supportive but others were opposed.

15. In your first bid for the office you now hold, were you opposed by one or more serious candidates within your own party in the primary?

☐ Yes ☐ No (Please go to Question 16.)

15a. Was your most serious opponent within your party a man or a woman?

☐ a man ☐ a woman

16. In your first bid for the office you now hold, which of the following statements best characterizes the competitiveness of the legislative district in which you ran?

☐ More voters identified with my party.
☐ More voters identified with the opposition party.
☐ Voters divided about equally between the two parties.

17. Excluding your political party, was there an organization that played a particularly important role in getting you to run the first time for the office you now hold?

☐ Yes (please specify):_____

☐ No

18. Did any women's organization(s) actively encourage you to run the first time for the office you now hold?

☐ Yes (please specify):_____

☐ No

19. Below are various factors that have been suggested to be important in influencing decisions to run for office. Please indicate how important each factor was in affecting your decision to run the first time for the office you now hold.

	Very Important	Somewhat Important	Not Important	Not Applicable
a. Having sufficient financial resources to conduct a viable campaign.	☐	☐	☐	☐
b. Approval of my spouse or partner.	☐	☐	☐	☐
c. My children being old enough for me to feel comfortable not being home as much.	☐	☐	☐	☐
d. Making sure I had sufficient prior political experience.	☐	☐	☐	☐
e. Having an occupation that would allow me sufficient time and flexibility to hold office.	☐	☐	☐	☐
f. The realization that I was just as capable of holding office as most officeholders.	☐	☐	☐	☐
g. Making contacts that would enhance my business or professional (not political) career.	☐	☐	☐	☐
h. My perception that this office was an important stepping-stone toward higher office.	☐	☐	☐	☐
i. My concern about one or two particular public policy issues.	☐	☐	☐	☐
j. My longstanding desire to run.	☐	☐	☐	☐
k. Having participated in a candidate training program or workshop.	☐	☐	☐	☐
l. My assessment that I could handle any public scrutiny I might face.	☐	☐	☐	☐
m. Having the support of my party.	☐	☐	☐	☐

NOW WE ARE GOING TO ASK YOU A SERIES OF QUESTIONS ABOUT THE <u>VERY FIRST TIME</u> YOU RAN FOR <u>ANY</u> ELECTIVE OFFICE.

20. Before you ran for any public office, had you:

	Yes, Unpaid Position	Yes, Paid Position	No
a. Worked on the campaign of a male candidate?	☐	☐	☐
b. Worked on the campaign of a female candidate?	☐	☐	☐
c. Worked on the staff of a male elected public official?	☐	☐	☐
d. Worked on the staff of a female elected public official?	☐	☐	☐

21. What was the <u>very first elective office</u> you ran for?

☐ My current office is the first elective office I ran for. (Please go to Question 27.)
☐ The first elective office I ran for was (please specify):_____

22. In what year did you first run for this office?

23. Did you win or lose this first race?
☐ Won
☐ Lost and ran for it again
☐ Lost and never ran for this office again

24. Other than your desire to serve the public, what was the <u>single most important reason</u> that you decided to run for elective office the very first time?
☐ My concern about one or more specific public policy issues.
☐ My longstanding desire to be involved in politics.
☐ It seemed like a winnable race.
☐ Dissatisfaction with the incumbent.
☐ My desire to change the way government works.
☐ A party leader or an elected official asked me to run.
☐ Other (please specify): _____

25. Did leaders from your party actively seek you out and encourage you to run for the first office you ran for?
☐ Yes
☐ No
☐ Party leaders were not involved in the race. (Please go to Question 27.)

26. Again, think back to the first elective office you sought. Which of the following statements best characterizes the reactions of your party's leaders to your candidacy?

☐ Generally they supported my candidacy.
☐ Generally they opposed my candidacy.
☐ They neither supported nor opposed my candidacy.
☐ They were divided in their reactions to my candidacy; some were supportive but others were opposed.

27. In thinking about your initial decision to seek elective office the very first time, which of the following statements most accurately describes your decision? (Please check only one.)

☐ It was entirely my idea to run. (Please go to Question 28.)

☐ I had already thought seriously about running when someone else suggested it.

☐ I had not seriously thought about running until someone else suggested it.

27a. Who was the most influential person in encouraging you to run? (Please check only one.)

☐ A party official and/or legislative leader from my party

☐ An elected or appointed officeholder

☐ A member of a women's organization

☐ A member of another organization or association

☐ My spouse or partner

☐ A family member (other than spouse)

☐ A friend, co-worker, or acquaintance

☐ Other (please specify): _____

28. When you were making your initial decision to seek elective office the very first time, did anyone try to discourage you from running?

☐ Yes

☐ No (If no, please go to Question 29.)

28a. Who tried to discourage you? (Please check as many as apply.)

☐ A party official and/or legislative leader from my party

☐ An elected or appointed officeholder

☐ A member of a women's organization

☐ A member of another organization or association

☐ My spouse or partner

☐ A family member (other than spouse)

☐ A friend, co-worker, or acquaintance

☐ Other (please specify): _____

29. Prior to becoming a candidate for the first time, how active were you in any of the following organizations?

	Very Active	Active	Not Active
a. Business or professional group	☐	☐	☐
b. Service club (e.g., Rotary)	☐	☐	☐
c. Teachers' organization	☐	☐	☐
d. Labor organization	☐	☐	☐
e. Children or youth organization	☐	☐	☐
f. Women's organization	☐	☐	☐
g. A church-related or other religious group	☐	☐	☐
h. Civil rights or race/ethnic group	☐	☐	☐

NOW WE ARE GOING TO ASK YOU A SERIES OF QUESTIONS ABOUT YOUR ISSUE POSITIONS AND MEMBERSHIP IN ORGANIZATIONS.

30. On most contemporary issues, do you generally think of yourself as:

☐ Very conservative

☐ Conservative

☐ Middle-of-the-road

☐ Liberal

☐ Very liberal

☐ Other (Please specify): _____

31. Below is a short list of labels that some people reject, but others use to describe themselves. For each one, please indicate whether you do or do not identify with the label.

		Yes	No	Don't Know
a.	Political outsider	☐	☐	☐
b.	Feminist	☐	☐	☐
c.	Christian Conservative	☐	☐	☐

32. Please indicate your degree of agreement or disagreement with each of the following statements by placing a number from 1 to 5 in the blank provided.

1 = strongly agree 2 = agree 3 = disagree 4 = strongly disagree 5 = don't know

___ If left alone, except for essential regulations, the private sector can find ways to solve our economic problems.

___ Minors should be able to obtain a legal abortion without parental consent.

___ The death penalty should be an option as a punishment for those who commit murder.

___ The women's movement has gone too far in pushing for equality between the sexes.

___ Government-funded school vouchers should be available to parents for tuition at the public, private or religious school of their choice.

___ I would like to see the United States Supreme Court overturn the Roe versus Wade decision which made abortion legal during the first three months of pregnancy.

___ Affirmative action programs are needed to help women and minorities overcome discrimination.

33. Which of the following statements best reflects your view?

☐ It is harder for female candidates to raise money than male candidates.
☐ It is harder for male candidates to raise money than female candidates.
☐ It is equally hard for both. (Please go to Question 34.)

33a. Which of the following is the most important reason it is harder for them to raise money? (Please check only one.)

☐ They have to devote more time to raising money.
☐ They raise money in smaller denominations.
☐ They do not have the same networks.
☐ They are less comfortable asking for money for themselves.
☐ They have less experience raising money.
☐ Other reason (please specify): _____

34. Have you ever been a member of the following organizations? If yes, please indicate whether you were a member before you ran the first time for any elective office or whether you joined later.

	Yes, member before I ran	Yes, I joined after I ran	No
a. League of Women Voters	☐	☐	☐
b. Other women's civic organization	☐	☐	☐
c. A business or professional women's organization	☐	☐	☐
d. A conservative women's group (e.g., Concerned Women for America, Eagle Forum)	☐	☐	☐
e. A feminist group (e.g., National Organization for Women, Women's Political Caucus)	☐	☐	☐
f. An organization of women public officials	☐	☐	☐
g. A sorority	☐	☐	☐
h. A women's PAC (e.g., EMILY's List, WISH List, Susan B. Anthony List)	☐	☐	☐

FINALLY, WE WOULD LIKE TO ASK YOU SOME QUESTIONS ABOUT YOUR BACKGROUND.

35. In what year were you born? 19 ____

36. What is the highest level of education you have completed?

☐ High school
☐ Some college
☐ College graduate (e.g., BA)
☐ Post-graduate degree (please specify): _____

37. Aside from holding public office, what is or was your primary occupation?

37a. Are you presently employed in this occupation?

☐ Yes, full-time
☐ Yes, part-time
☐ No, retired
☐ No

38. What is your marital status?

☐ Married ☐ Divorced or separated
☐ Widowed ☐ Single, never married
☐ Living as married

38a. If currently married or living as married, would you say that your spouse/partner:

☐ is very supportive of your holding public office.
☐ is somewhat supportive of your holding public office.
☐ is indifferent toward your holding public office.
☐ is somewhat resistant toward your holding public office.

39. If you have children, what is the age of your youngest child?

40. What is your racial/ethnic heritage?

☐ White, non-Hispanic
☐ Black or African-American
☐ Hispanic or Latino
☐ Asian or Pacific Islander
☐ American Indian
☐ Mixed-race
☐ Other (please specify): _____

41. Would you describe yourself as a born-again or Evangelical Christian?

☐ Yes ☐ No ☐ Don't know

THANK YOU VERY MUCH FOR FILLING OUT THIS QUESTIONNAIRE.
PLEASE RETURN THE COMPLETED QUESTIONNAIRE IN THE ENCLOSED, POSTAGE PAID ENVELOPE.

BIBLIOGRAPHY

Abramson, P. R., Aldrich, J. H., & Rohde, D. W. (1987). Progressive Ambition Among United States Senators: 1972-1988. *Journal of Politics*, 49, 3–35.

Adams, G. D. (1997). Abortion: Evidence of an Issue Evolution. *American Journal of Political Science*, 41, 718–737.

Aldrich, J. H. (1995). *Why Parties? The Origin and Transformation of Political Parties in America*. Chicago: University of Chicago Press.

Alexander, D. & Andersen, K. (1993). Gender as a Factor in the Attribution of Leadership Traits. *Political Research Quarterly*, 46, 527–545.

Ambrosius, M. & Welch, S. (1984). Women and Politics at the Grassroots: Women Candidates for State Office in Three States, 1950-1978. *Social Science Journal*, 21, 29–42.

American National Election Studies. n.d. *The ANES Guide to Public Opinion and Electoral Behavior*. Ann Arbor: University of Michigan, Center for Political Studies [producer and distributor]. Available: <www.electionstudies.org>.

Atkeson, L. R. (2003). Not All Cues Are Created Equal: The Conditional Impact of Female Candidates on Political Engagement. *Journal of Politics*, 65, 1040–1061.

Baer, D. L. (2003). Women, Women's Organizations, and Political Parties. In S. J.Carroll (Ed.), *Women and American Politics: New Questions, New Directions* (pp. 111–145). Oxford, UK: Oxford University Press.

Barbara Lee Family Foundation. (2001). *Keys to the Governor's Office*. Barbara Lee Family Foundation. Cambridge, MA.

Barbara Lee Family Foundation. (2002). *Speaking with Authority: From Economic Security to National Security*. Barbara Lee Family Foundation. Cambridge, MA.

Barrett, E. J. (2001). Black Women in State Legislatures: The Relationship of Race and Gender to the Legislative Experience. In S. J. Carroll (Ed.), *The Impact of Women in Public Office* (pp. 185–204). Bloomington: Indiana University Press.

Bejarano, C. (2007). Latina's Diminishing Electoral Disadvantages. University of Iowa. Ph.D. Dissertation.

Bejarano, C. (forthcoming). *The Latina Twist on U.S. Political Success*. Austin: University of Texas Press.

Black, G. (1972). A Theory of Political Ambition: Career Choices and the Role of Structural Incentives. *American Political Science Review*, 66, 144–159.

Blair, D. K. & Henry, A. R. (1981). The Family Factor in State Legislative Turnover. *Legislative Studies Quarterly*, 6, 55–68.

Bourque, S. C. & Grossholtz, J. (1974). Politics an Unnatural Practice: Political Science Looks at Female Participation. *Politics and Society*, 4, 225–266.

Brace, P. (1984). Progressive Ambition in the House: A Probabilistic Approach. *Journal of Politics, 46*, 556–571.

Bratton, K. A. (2005). Critical Mass Theory Revisited: The Behavior and Success of Token Women in State Legislatures. *Politics & Gender, 1*, 97–125.

Bratton, K. A., Haynie, K., & Reingold, B. (2008). Gender, Race, Ethnicity and Representation: The Changing Landscape of Legislative Diversity. In *Book of the States 2008* (pp. 73–79). Lexington, KY: Council of State Governments.

Brooks, D. J. (2011). Testing the Double Standard for Candidate Emotionality: Voter Reactions to the Tears and Anger of Male and Female Politicians. *Journal of Politics, 73*, 597–615.

Burns, N. (2007). Gender in the Aggregate, Gender in the Individual, Gender and Political Action. *Politics & Gender, 3*, 104–124.

Burns, N., Schlozman, K. L., & Verba, S. (2001). *The Private Roots of Public Action: Gender, Equality, and Political Participation*. Cambridge, MA: Harvard University Press.

Burrell, B. (1994). *A Woman's Place Is in the House: Campaigning for Congress in the Feminist Era*. Ann Arbor: University of Michigan Press.

Burrell, B. (2010). Political Parties and Women's Organizations: Bringing Women into the Electoral Arena. In S. J. Carroll & R. L. Fox (Eds.), *Gender and Elections: Shaping the Future of American Politics* (pp. 210–238). New York: Cambridge University Press.

Burt-Way, B. J. B. & Kelly, R. M. (1992). Gender and Sustaining Political Ambition: A Study of Arizona Elected Officials. *The Western Political Quarterly, 45*, 11–25.

Carey, J. M., Niemi, R. G., & Powell, L. W. (1998). Are Women State Legislators Different? In S. Thomas & C. Wilcox (Eds.), *Women and Elective Office: Past, Present, & Future* (pp. 87–102). New York: Oxford University Press.

Carroll, S. J. (1989). The Personal Is Political: The Intersection of Private Lives and Public Roles Among Women and Men in Elective and Appointive Office. *Women & Politics, 9*, 51–67.

Carroll, S. J. (1994). *Women as Candidates in American Politics* (2nd ed.). Bloomington: Indiana University Press.

Carroll, S. J. (2001). *The Impact of Women in Public Office*. Bloomington: Indiana University Press.

Carroll, S. J. (2002). Representing Women: Congresswomen's Perceptions of Their Representational Roles. In C. S. Rosenthal (Ed.), *Women Transforming Congress* (pp. 50–68). Norman: University of Oklahoma Press.

Carroll, S. J. (2003). Have Women State Legislators in the United States Become More Conservative? A Comparison of State Legislators in 2001 and 1988. *Atlantis: A Women's Studies Journal, 27*(2), 128–139.

Carroll, S. J. (2005). Are Women Legislators Accountable to Women? The Complementary Roles of Feminist Identity and Women's Organizations. In B. O'Neill & E. Gidengil (Eds.), *Gender and Social Capital* (pp. 357–378). New York: Routledge.

Carroll, S. J. (2009). Reflections on Gender and Hillary Clinton's Presidential Campaign: The Good, the Bad, and the Misogynic. *Politics & Gender, 5*, 1–20.

Carroll, S. J. & Dittmar, K. (2010). The 2008 Candidacies of Hillary Clinton and Sarah Palin: Cracking the "Highest, Hardest Glass Ceiling." In S. J. Carroll & R. L. Fox (Eds.), *Gender and Elections: Shaping the Future of American Politics* (pp. 44–77). New York: Cambridge University Press.

Carroll, S. J. & Jenkins, K. (2001). Do Term Limits Help Women Get Elected? *Social Science Quarterly, 82*, 197–201.

Carroll, S. J. & Strimling, W. S. (1983). *Women's Routes to Elective Office: A Comparison with Men's*. New Brunswick, NJ: Center for the American Woman and Politics.

Casellas, J. P. (2011). *Latino Representation in State Houses and Congress*. New York: Cambridge University Press.

CBS News Poll. (2008). Breaking the Glass Ceiling: A Woman Presidential Candidate, June 3. Press release.

Center for American Women and Politics. (1981). *"Women in State Legislatures 1981."* New Brunswick, NJ, Center for American Women and Politics, National Information Bank on Women in Public Office, Eagleton Institute of Politics, Rutgers University.

Center for American Women and Politics. (2001). *"Women State Legislators: Past, Present and Future."* New Brunswick, NJ, Center for American Politics, Eagleton Institute of Politics, Rutgers University.

Center for American Women and Politics. (2008). Gender Gap Evident in the 2008 Election: Women, Unlike Men, Show Clear Preference for Obama over McCain. November 5. Press release.

Center for American Women and Politics. (2011a). *"Gender Differences in Voter Turnout."* New Brunswick, NJ, Center for American Women and Politics, National Information Bank on Women in Public Office, Eagleton Institute of Politics, Rutgers University.

Center for American Women and Politics. (2011b). *"Women in State Legislative Leadership Positions 2010."* New Brunswick, NJ, Center for American Women and Politics, National Information Bank on Women in Public Office, Eagleton Institute of Politics, Rutgers University.

Center for American Women and Politics. (2013a). *"Statewide Elective Executive Women 2013."* New Brunswick, NJ, Center for American Women and Politics, National Information Bank on Women in Public Office, Eagleton Institute of Politics, Rutgers University.

Center for American Women and Politics. (2013b). *"Women in Elective Office 2013."* New Brunswick, NJ, Center for American Women and Politics, National Information Bank on Women in Public Office, Eagleton Institute of Politics, Rutgers University.

Center for American Women and Politics. (2013c). *"Women in State Legislatures 2013."* New Brunswick, NJ, Center for American Women and Politics, National Information Bank on Women in Public Office, Eagleton Institute of Politics, Rutgers University.

Center for American Women and Politics. (2013d). *"Women in the U.S. Congress 2013."* New Brunswick, NJ, Center for American Women and Politics, National Information Bank on Women in Public Office, Eagleton Institute of Politics, Rutgers University.

Center for American Women and Politics. (2013e). *"Women in the U.S. House of Representatives 2013."* New Brunswick, NJ, Center for American Women and Politics, National Information Bank on Women in Public Office, Eagleton Institute of Politics, Rutgers University.

Center for American Women and Politics. (2013f). *"Women in the U.S. Senate 1922-2013."* New Brunswick, NJ, Center for American Women and Politics, National Information Bank on Women in Public Office, Eagleton Institute of Politics, Rutgers University.

Center for American Women and Politics. (2013g). *"Women of Color in Elective Office 2013."* New Brunswick, NJ, Center for American Women and Politics, National

Information Bank on Women in Public Office, Eagleton Institute of Politics, Rutgers University.

Coontz, S. (2012). The Myth of Male Decline. *The New York Times.* September 30.

Cooperman, R. (2006). Women or Party First? How Party Activists Shape Women's Candidacies for Congress. Paper presented at the American Political Science Association Annual Meetings, Philadelphia, PA.

Cotter, D. A., Hermsen, J. M., & Vanneman, R. (n.d.). End of the Gender Revolution? [Online]. Available: <http://www.bsos.umd.edu/socy/vanneman/endofgr/matrix.html>.

Council of State Governments. *Book of the States.* Lexington, KY: Council of State Governments. Various years.

Cox, E. M. (1996). *Women State and Territorial Legislators, 1895-1995: A State-by-State Analysis, with Rosters of 6,000 Women.* Jefferson, NC: McFarland and Co.

Crenshaw, K. (1989). Demarginalizing the Intersection of Race and Sex: A Black Feminist Critique of Antidiscrimination Doctrine, Feminist Theory and Antiracist Politics. *University of Chicago Legal Forum*, 129, 139–167.

Crespin, M. H. & Deitz, J. L. (2010). If You Can't Join 'Em, Beat 'Em: The Gender Gap in Individual Donations to Congressional Candidates. *Political Research Quarterly*, 63, 581–593.

Critchlow, D. T. (2011). *The Conservative Ascendancy: How the Republican Right Rose to Power in Modern America* (2nd ed., rev. and expanded ed.). Lawrence: University Press of Kansas.

Crowder-Meyer, M. (2010). *Local Parties, Local Candidates, and Women's Representation: How County Parties Affect Who Runs for and Wins Political Office.* Princeton University. Ph.D. Dissertation.

Crowley, J. E. (2004). When Tokens Matter. *Legislative Studies Quarterly*, 29, 109–136.

Darcy, R. & Schramm, S. S. (1977). When Women Run Against Men. *Public Opinion Quarterly*, 41, 1–12.

Darcy, R., Welch, S., & Clark, J. (1994). *Women, Elections, and Representation* (2nd ed., rev). Lincoln: University of Nebraska Press.

DeBell, M., Wilson, C., Segura, G., Jackman, S., & Hutchings, V. (2011). *Methodology Report and User's Guide for the ANES 2010-2012 Evaluations of Government and Society Study.* Palo Alto, CA, and Ann Arbor: Stanford University and the University of Michigan.

Deber, R. (1982). The Fault, Dear Brutus: Women as Congressional Candidates in Pennsylvania. *Journal of Politics*, 44, 463–479.

Diamond, I. (1977). *Sex Roles in the State House.* New Haven, CT: Yale University Press.

Dittmar, K. (2012). *Campaigns as Gendered Institutions: Stereotypes and Strategy in Statewide Races.* Rutgers University. Ph.D. Dissertation.

Dodson, D. L. (2006). *The Impact of Women in Congress.* Oxford, UK: Oxford University Press.

Dodson, D. L. & Carroll, S. J. (1991). *Reshaping the Agenda: Women in State Legislatures.* Rutgers, NJ: Center for the American Woman and Politics.

Dolan, K. (2004). *Voting for Women Candidates: How the Public Evaluates Women Candidates.* Boulder, CO: Westview Press.

Dolan, K. (2006). Symbolic Mobilization? The Impact of Candidate Sex in American Elections. *American Politics Research*, 34, 687–704.

Dolan, K. (2010). The Impact of Gender Stereotyped Evaluations on Support for Women Candidates. *Political Behavior*, 32, 69–88.

Dolan, K. & Ford, L. (1997). Change and Continuity Among Women State Legislators: Evidence from Three Decades. *Political Research Quarterly*, 50, 137–151.

Driscoll, A. & Krook, M. L. (f2012). Feminism and Rational Choice Theory. *European Political Science Review*, 4, 195–216.

Duerst-Lahti, G. (2005). Institutional Gendering: Theoretical Insights into the Environment of Women Officeholders. In S. Thomas & C. Wilcox (Eds.), *Women and Elective Office: Past, Present, and Future* (2nd ed.) (pp. 230–243) New York: Oxford University Press.

Eagly, A. H. & Johannesen-Schmidt, M. C. (2001). The Leadership Styles of Women and Men. *Journal of Social Issues*, 57, 781–797.

Elder, L. (2008). Whither Republican Women: The Growing Partisan Gap Among Women in Congress. *Forum-A Journal of Applied Research in Contemporary Politics*, 6.

Elder, L. (2012). The Partisan Gap Among Women State Legislators. *Journal of Women Politics & Policy*, 33, 65–85.

England, P. (1989). A Feminist Critique of Rational-Choice Theories: Implications for Sociology. *The American Sociologist*, 20, 14–28.

File, T. & Crissey, S. (2012). *Voting and Registration in the Election of November 2008* Washington, DC: U.S. Census Bureau.

Flammang, J. A. (1997). *Women's Political Voice: How Women are Transforming the Practice and Study of Politics*. Philadelphia: Temple University Press.

Fowler, L. L. (1993). *Candidates, Congress, and the American Democracy*. Ann Arbor: University of Michigan Press.

Fox, R. L. (2000). Gender and Congressional Elections. In S. Tolleson-Rinehart and J. Josephson (Eds.), *Gender and American Politics: Women, Men, and the Political Process (pp. 227–256)*. Armonk, NY: Sharpe.

Fox, R. L. & Lawless, J. L. (2004). Entering the Arena? Gender and the Decision to Run for Office. *American Journal of Political Science*, 48, 264–280.

Fox, R. L. & Lawless, J. L. (2005). To Run or Not to Run for Office: Explaining Nascent Political Ambition. *American Journal of Political Science*, 49, 642–659.

Fox, R. L. & Lawless, J. L. (2010). If Only They'd Ask: Gender, Recruitment, and Political Ambition. *Journal of Politics*, 72, 310–326.

Fraga, L. R., Lopez, L., Martinez-Ebers, V., & Ramirez, R. (2008). Representing Gender and Ethnicity: Strategic Intersectionality. In B. Reingold (Ed.), *Legislative Women: Getting Elected, Getting Ahead* (pp. 157–174). Boulder, CO: Lynne Rienner.

Frankovic, K. (1977). Sex and Voting in the U.S. House of Representatives: 1961-1975. *American Politics Quarterly*, 5, 315–331.

Frederick, B. (2009). Are Female House Members Still More Liberal in a Polarized Era? The Conditional Nature of the Relationship Between the Descriptive and Substantive Representation. *Congress & the Presidency*, 36, 181–202.

Freeman, J. (1987). Whom You Know Versus Whom You Represent: Feminist Influence in the Democratic and Republican Parties. In M. F. Katzenstein & C. M. Mueller (Eds.), *The Women's Movements of the United States and Western Europe: Consciousness, Political Opportunity, and Public Policy* (pp. 215–244). Philadelphia, PA: Temple University Press.

Freeman, J. (1993). Feminism vs. Family Values: Women at the 1992 Democratic and Republican Conventions. *PS: Political Science and Politics*, 26, 21–27.

Freeman, J. (1999). Sex, Race, Religion, and Partisan Realignment. In P. E. Scheele (Ed.), *We Get What We Vote For… Or Do We? The Impact of Elections on Governing* (pp. 167–190). Westport, CT: Praeger.

Freeman, J. (2000). *A Room at a Time: How Women Entered Party Politics*. Lanham, MD: Rowman & Littlefield.

Fry, R. & Cohn, D. V. (2010). *New Economics of Marriage: The Rise of Wives*. Washington, DC: Pew Research Center Publications.

Fulton, S. (2012). Running Backwards and in High Heels: The Gendered Quality Gap and Incumbent Electoral Success. *Political Research Quarterly* 65, 303–314.

Fulton, S. A., Maestas, C. D., Maisel, L. S., & Stone, W. J. (2006). The Sense of a Woman: Gender, Ambition, and the Decision to Run for Congress. *Political Research Quarterly*, 59, 235–248.

García Bedolla, L., Tate, K., & Wong, J. (2005). Indelible Effects: The Impact of Women of Color in the U.S. Congress. In S. Thomas & C. Wilcox (Eds.), *Women and Elective Office: Past, Present, and Future, Second Edition (pp. 152–175)*. New York: Oxford University Press.

Gertzog, I. N. (1995). *Congressional Women: Their Recruitment, Integration, and Behavior*. (2nd ed., rev. and updated ed.). Westport, CT: Praeger.

Gertzog, I. N. & Simard, M. (1981). Women and "Hopeless" Congressional Candidacies: Nomination Frequency, 1916-1978. *American Politics Quarterly*, 9, 449–466.

Giddings, P. (1996). *When and Where I Enter: The Impact of Black Women on Race and Sex in America*. (1st Quill ed.) New York: W. Morrow.

Gilligan, C. (1993). *In a Different Voice: Psychological Theory and Women's Development*. Cambridge, MA: Harvard University Press.

Githens, M. & Prestage, J. L. (1977). *A Portrait of Marginality: The Political Behavior of the American Woman*. New York: David McKay.

Grofman, B. & Davidson, C. (1992). *Controversies in Minority Voting: The Voting Rights Act in Perspective*. Washington, DC: Brookings Institution.

Hancock, A.-M. (2007). When Multiplication Doesn't Equal Quick Addition: Examining Intersectionality as a Research Paradigm. *Perspectives on Politics*, 5, 63–79.

Hardy-Fanta, C., Lien, P. T., Pinderhughes, D. M., & Sierra, C. M. (2006). Gender, Race, and Descriptive Representation in the United States: Findings from the Gender and Multicultural Leadership Project. *Journal of Women Politics & Policy*, 28, 7–41.

Hartmann, S. M. (1996). *From Margin to Mainstream: American Women and Politics Since 1960*. New York: McGraw-Hill.

Hegewisch, A., Liepmann, H., Hayes, J., & Hartmann, H. (2010). *Separate and Not Equal? Gender Segregation in the Labor Market and the Gender Wage Gap*. Washington, DC: Institute for Women's Policy Research.

Hill Collins, P. (1990). *Black Feminist Thought: Knowledge, Consciousness, and the Politics of Empowerment*. Boston: Unwin Hyman.

Himmelstein, J. L. (1990). *To the Right: The Transformation of American Conservatism*. Berkeley: University of California Press.

Hogan, R. E. (2007). The Effects of Candidate Gender on Campaign Spending in State Legislative Elections. *Social Science Quarterly*, 88, 1092–1105.

Huddy, L. & Terkildsen, N. (1993a). The Consequences of Gender Stereotypes for Women Candidates at Different Levels and Types of Office. *Political Research Quarterly*, 46, 503–525.

Huddy, L. & Terkildsen, N. (1993b). Gender Stereotypes and the Perception of Male and Female Candidates. *American Journal of Political Science*, 37, 119–147.

Humes, K. R., Jones, N. A., & Ramirez, R. R. (2011). *Overview of Race and Hispanic Origin: 2010*. U.S. Department of Commerce, U.S. Census Bureau.

Jacobson, G. C. & Kernell, S. (1981). *Strategy and Choice in Congressional Elections*. New Haven: Yale University Press.

Jacobson, L. (2010). 2010 State Legislatures: Democrats Buckle Up for Wild Ride [Online]. <http://www.governing.com/blogs/politics/2010-state-legislatures-democrats-wild-ride.html>.

Johnson, M. & Carroll, S. (1978). *Profile of Women Holding Office II*. New Brunswick, NJ: Center for the American Woman and Politics. <http://www.cawp.rutgers.edu/research/reports/ProfileWomenOfficeII.pdf>.

Johnson, M. & Stanwick, K. (1976). *Profile of Women Holding Office*. New Brunswick, NJ: Center for the American Woman and Politics. <http://www.cawp.rutgers.edu/research/reports/ProfileWomenOfficeI.pdf>.

Jones-Correa, M. (1998). *Between Two Nations: The Political Predicament of Latinos in New York City*. Ithaca, NY: Cornell University Press.

Junn, J. (2007). Square Pegs and Round Holes: Challenges of Fitting Individual-Level Analysis to a Theory of Politicized Context of Gender. *Politics & Gender*, 3, 124–134.

Junn, J. & Haynie, K. L. (2008). *New Race Politics in America: Understanding Minority and Immigrant Politics*. Cambridge, UK: Cambridge University Press.

Kahn, K. F. (1996). *The Political Consequences of Being a Woman: How Stereotypes Influence the Conduct and Consequences of Political Campaigns*. New York: Columbia University Press.

Karol, D. (2009). *Party Position Change in American Politics: Coalition Management*. Cambridge, UK: Cambridge University Press.

Katzenstein, M. F. (1998). *Faithful and Fearless: Moving Feminist Protest Inside the Church and Military*. Princeton, NJ: Princeton University Press.

Kaufmann, K. M. & Petrocik, J. R. (1999). The Changing Politics of American Men: Understanding the Sources of the Gender Gap. *American Journal of Political Science*, 43, 864–887.

King, D. K. (1988). Multiple Jeopardy, Multiple Consciousness: The Context of a Black Feminist Ideology. *Signs*, 14, 42–72.

King, D. C. & Matland, R. E. (2003). Sex and the Grand Old Party: An Experimental Investigation of the Effect of Candidate Sex on Support for a Republican Candidate. *American Politics Research*, 31, 595–612.

Kirkpatrick, J. J. (1974). *Political Woman*. New York: Basic Books.

Kittilson, M. C. (2006). *Challenging Parties, Changing Parliaments: Women and Elected Office in Contemporary Western Europe*. Columbus: Ohio State University Press.

Koch, J. W. (2000). Do Citizens Apply Gender Stereotypes to Infer Candidates' Ideological Orientations? *Journal of Politics*, 62, 414–429.

Koch, J. W. (2002). Gender Stereotypes and Citizens' Impressions of House Candidates' Ideological Orientations. *American Journal of Political Science*, 46, 453–462.

Krook, M. L. (2009). *Quotas for Women in Politics: Gender and Candidate Selection Reform Worldwide*. Oxford, UK: Oxford University Press.

Kurtz, K. T., Cain, B. E., and Niemi, R. G. (2007). *Institutional Change in American Politics: The Case of Term Limits*. Ann Arbor: University of Michigan Press.

Lawless, J. L. (2004a). Politics of Presence? Congresswomen and Symbolic Representation. *Political Research Quarterly*, 57, 81–99.

Lawless, J. L. (2004b). Women, War, and Winning Elections: Gender Stereotyping in the Post-September 11th Era. *Political Research Quarterly*, 57, 479–490.

Lawless, J. L. & Fox, R. L. (2005). *It Takes a Candidate: Why Women Don't Run for Office.* Cambridge, UK: Cambridge University Press.

Lawless, J. L. & Fox, R. L. (2010). *It Still Takes a Candidate: Why Women Don't Run for Office* (rev. ed.) New York: Cambridge University Press.

Lawless, J. L. & Pearson, K. (2008). The Primary Reason for Women's Underrepresentation? Reevaluating the Conventional Wisdom. *Journal of Politics*, 70, 67–82.

Leader, S. G. (1977). The Policy Impact of Elected Women Officials. In L. Maisel & J. Cooper (Eds.), *The Impact of the Electoral Process (pp. 265–284).* Beverly Hills, CA: Sage.

Lee, M. M. (1977). Toward Understanding Why Few Women Hold Public Office: Factors Affecting the Participation of Women in Local Politics. In M. Githens & J. L. Prestage (Eds.), *A Portrait of Marginality.* New York: David McKay.

Lien, P. T., Conway, M. M., & Wong, J. (2004). *The Politics of Asian Americans: Diversity and Community.* New York: Routledge.

Lien, P., Hardy-Fanta, C., Pinderhughes, D. M., & Sierra, C. M. (2008). *Expanding Categorization at the Intersection of Race and Gender: "Women of Color" as a Political Category for African American, Latina, Asian American, and American Indian Women.* Paper presented at the American Political Science Association, Boston, MA.

Lublin, D. (1997). *The Paradox of Representation: Racial Gerrymandering and Minority Interests in Congress.* Princeton, NJ: Princeton University Press.

Maisel, L. S., Fowler, L. L., Jones, R. S., & Stone, W. J. (1990). The Naming of Candidates: Recruitment or Emergence? In *The Parties Respond: Changes in the American Party System* (pp. 137–159). Boulder, CO: Westview Press.

Mansbridge, J. J. (1986). *Why We Lost the ERA.* Chicago: University of Chicago Press.

Mansbridge, J. (1999). Should Blacks Represent Blacks and Women Represent Women? A Contingent "Yes." *Journal of Politics*, 61, 628–657.

McCarthy, S. J. (2000). The Big Tent: Too Small for Women? Women in the Republican Party. The Humanist [Online]. <http://www.questia.com/read/1G1-78889726/the-big-tent-too-small-for-women>.

McClain, P. D., Carter, N. M., & Brady, M. C. (2005). Gender and Black Presidential Politics: From Chisholm to Moseley Braun. *Women and Politics*, 27, 51–68.

McDonagh, E. L. (2009). *The Motherless State: Women's Political Leadership and American Democracy.* Chicago: University of Chicago Press.

Melich, T. (1996). *The Republican War Against Women: An Insider's Report from Behind the Lines.* New York: Bantam Books.

Mettler, S. (1998). *Dividing Citizens: Gender and Federalism in New Deal Public Policy.* Ithaca, NY: Cornell University Press.

Mettler, S. (2005). *Soldiers to Citizens: The G.I. Bill and the Making of the Greatest Generation.* Oxford, UK: Oxford University Press.

Mohanty, C. T. (1984). Under Western Eyes: Feminist Scholarship and Colonial Discourses. *Boundary 2*(12/13), 333–358.

Moncrief, G. F., Squire, P., & Jewell, M. E. (2001). *Who Runs for the Legislature?* Upper Saddle River, NJ: Prentice Hall.

Moncrief, G., & Thompson, J. (1991). Gender, Race, and the State Legislature: A Research Note on the Double Disadvantage Hypothesis. *Social Science Journal*, 28, 481–488.

Mueller, C. (1988). The Empowerment of Women: Polling and the Women's Voting Bloc. In C. M. Mueller (Ed.), *The Politics of the Gender Gap* (pp. 16–36). Newbury Park, CA: Sage.

Reingold, B. (2008). Women as Officeholders: Linking Descriptive and Substantive Representation. In C. Wolbrecht, K. Beckwith, & L. Baldez (Eds.), *Political Women and American Democracy* (pp. 128–147). New York: Cambridge University Press.

Reiter, H. L. & Stonecash, J. M. (2011). *Counter Realignment: Political Change in the Northeastern United States*. Cambridge: Cambridge University Press.

Ritter, G. (2006). *The Constitution as Social Design: Gender and Civic Membership in the American Constitutional Order*. Stanford, CA: Stanford University Press.

Rohde, D. W. (1979). Risk-Bearing and Progressive Ambition: The Case of Members of the United States House of Representatives. *American Journal of Political Science, 23*, 1-26.

Rosener, J. B. (1990). Ways Women Lead. *Harvard Business Review, 68*, 119–125.

Rosenthal, C. S. (1998). *When Women Lead: Integrative Leadership in State Legislatures*. New York: Oxford University Press.

Rozell, M. (2000). Helping Women Run and Win: Feminist Groups, Candidate Recruitment and Training. *Women & Politics, 21*, 101–116.

Rule, W. (1990). Why More Women Are State Legislators: A Research Note. *Western Political Quarterly, 43*, 437–448.

Rymph, C. E. (2006). *Republican Women: Feminism and Conservatism from Suffrage Through the Rise of the New Right*. Chapel Hill: University of North Carolina Press.

Sanbonmatsu, K. (2002a). *Democrats, Republicans, and the Politics of Women's Place*. Ann Arbor: University of Michigan Press.

Sanbonmatsu, K. (2002b). Gender Stereotypes and Vote Choice. *American Journal of Political Science, 46*, 20–44.

Sanbonmatsu, K. (2006a). Do Parties Know that "Women Win"? Party Leader Beliefs About Women's Electoral Chances. *Politics & Gender, 2*, 431–450.

Sanbonmatsu, K. (2006b). *Where Women Run: Gender and Party in the American States*. Ann Arbor: University of Michigan Press.

Sanbonmatsu, K., Carroll, S., & Walsh, D. (2009). *Poised to Run: Women's Pathways to the State Legislatures*. New Brunswick, NJ: Center for American Women and Politics, Eagleton Institute of Politics, Rutgers University.

Sanbonmatsu, K. & Dolan, K. (2009). Do Gender Stereotypes Transcend Party? *Political Research Quarterly, 62*, 485–494.

Sayer, L. C. (2005). Gender, Time, and Inequality: Trends in Women's and Men's Paid Work, Unpaid Work, and Free Time. *Social Forces, 84(1)*, 285–303.

Sayer, L. C., P. England, M. Bittman, and S. M. Bianchi. (2009). How Long Is the Second (Plus First) Shift? Gender Differences in Paid, Unpaid, and Total Work Time in Australia and the United States. *Journal of Comparative Family Studies, 40(4)*, 523–544.

Schlesinger, J. A. (1966). *Ambition and Politics: Political Careers in the United States*. Chicago: Rand McNally.

Schlozman, K. L., Burns, N., & Verba, S. (1994). Gender and the Pathways to Participation: The Role of Resources. *Journal of Politics, 56*, 963–990.

Schmidt, R., Sr., Alex-Assensoh, Y. M., Aoki, A. L., & Hero, R. E. (2010). *Newcomers, Outsiders, and Insiders: Immigrants and American Racial Politics in the Early Twenty-first Century*. Ann Arbor: University of Michigan Press.

Seltzer, R., Newman, J., & Leighton, M. V. (1997). *Sex as a Political Variable: Women as Candidates and Voters in U.S. Elections*. Boulder, CO: Lynne Rienner.

Shea, D. M. & Harris, R. C. (2006). Gender and Local Party Leadership in America. *Journal of Women Politics & Policy, 28*, 61–85.

Mulligan, C. B. (2010). In a First, Women Surpass Men on U.S. Payrolls. *New York Times* [Online]. <http://economix.blogs.nytimes.com/2010/02/05/in-historical-first-women-outnumber-men-on-us-payrolls/?scp=1-b&sq=women&st=nyt>.

National Center for Education Statistics. (2010). Table 8: Percentage of persons age 25 and over and 25 to 29, by race/ethnicity, years of school completed, and sex: Selected years, 1910 through 2009 [Online]. <http://nces.ed.gov/programs/digest/d09/tables/dt09_008.asp?referrer=list>.

National Conference of State Legislatures. n.d. Legislator Demographics [Online]. Available: <http://www.ncsl.org/default.aspx?tabid=14850>.

National Conference of State Legislatures. (2010). Republicans Make Historic Gains. [On-line]. <http://www.ncsl.org/legislatures-elections/elections/statevote-2010-archive.aspx>.

National Conference of State Legislatures. (2011). 2011 State and Legislative Partisan Composition [Online]. <http://www.ncsl.org/documents/statevote/2010_Legis_and_State_post.pdf>.

National Conference of State Legislatures. (2013). Party Composition of State Legislatures [Online]. <http://www.ncsl.org/legislatures-elections/elections/statevote-charts.aspx>. Accessed January 2, 2013.

National Women's Political Caucus. (1984). Women as Candidates in the 1984 Congressional Elections: A Post-Election Survey of Five Congressional Districts. Prepared by Cooper & Secrest Associates, Inc.

National Women's Political Caucus. (1987). The New Political Woman Survey. Prepared by Hickman-Maslin and American Viewpoint.

Niven, D. (1998). *The Missing Majority: The Recruitment of Women as State Legislative Candidates*. Westport, CT: Praeger.

Niven, D. (2006). Throwing Your Hat Out of the Ring: Negative Recruitment and the Gender Imbalance in State Legislative Candidacy. *Politics & Gender*, 2, 473–489.

Osborn, T. L. (2012). *How Women Represent Women: Political Parties, Gender, and Representation in the State Legislatures*. New York: Oxford University Press.

Palmer, B. & Simon, D. M. (2003). Political Ambition and Women in the U.S. House of Representatives, 1916-2000. *Political Research Quarterly*, 56, 127–138.

Palmer, B. & Simon, D. M. (2012). *Women & Congressional Elections: A Century of Change*. Boulder, CO: Lynne Rienner.

Pearson, K. & McGhee, E. (2004). *Strategic Differences: The Gender Dynamics of Congressional Candidacies, 1982-2002*. Paper presented at the American Political Science Association Annual Meeting, Chicago.

Philpot, T. S. & Walton, H. (2007). One of Our Own: Black Female Candidates and the Voters Who Support Them. *American Journal of Political Science*, 51, 49–62.

Pierson, P. & Skocpol, T. (2007). *The Transformation of American Politics: Activist Government and the Rise of Conservatism*. Princeton, NJ: Princeton University Press.

Prestage, J. L. (1977). Black Women State Legislators: A Profile. In M. Githens & J. L. Prestage (Eds.), *A Portrait of Marginality: The Political Behavior of the American Woman* (pp. 401–418). New York: David McKay.

Puwar, N. (2004). *Space Invaders: Race, Gender and Bodies Out of Place*. Oxford, UK: Berg.

Rawls, C. (2011). Moderate Republicans Lament GOP Shift Further Right. *Newsmax*. July 27 [Online]. <http://www.newsmax.com/Politics/Republican-right-moderate-teaparty/2011/07/27/id/405055>.

Simon, Cecilia Capuzzi (2011, July 24). R.O.I. New York Times Education Life.

Skocpol, T. & Williamson, V. (2012). *The Tea Party and the Remaking of Republican Conservatism*. New York: Oxford University Press.

Smooth, W. (2001). African American Women State Legislators: The Impact of Gender and Race on Legislative Influence. University of Maryland, College Park. Ph.D. Dissertation.

Smooth, W. (2006). Intersectionality in Electoral Politics: A Mess Worth Making. *Politics & Gender*, 2, 400–414.

Snowe, O. (2009). We Didn't Have to Lose Arlen Specter. *New York Times* [Opinion-editorial]. April 28.

Soule, J. W. & McGrath, W. E. (1977). A Comparative Study of Male-Female Political Attitudes at Citizen and Elite Levels. In M. Githens & J. L. Prestage (Eds.), *A Portrait of Marginality (pp. 178–195)*. New York: David McKay.

Squire, P. & Moncrief, G. F. (2010). *State Legislatures Today: Politics Under the Domes*. Boston: Longman.

Stone, W. J., Maisel, L. S., & Maestas, C. D. (2004). Quality Counts: Extending the Strategic Politician Model of Incumbent Deterrence. *American Journal of Political Science*, 48, 479–495.

Stoper, E. (1977). Wife and Politician: Role Strain Among Women in Public Office. In M. Githens & J. L. Prestage (Eds.), *A Portrait of Marginality (pp. 320–327)*. New York: David McKay.

Streb, M. J., Burrell, B., Frederick, B., & Genovese, M. A. (2008). Social Desirability Effects and Support for a Female American President. *Public Opinion Quarterly*, 72, 76–89.

Swers, M. L. (2002). *The Difference Women Make: The Policy Impact of Women in Congress*. Chicago: University of Chicago Press.

Takash, P. C. (1997). Breaking Barriers to Representation: Chicana/Latina Elected Officials in California. In C. J. Cohen, K. B. Jones, & J. C. Tronto (Eds.), *Women Transforming Politics: An Alternative Reader* (pp. 412–434). New York: New York University Press.

Tate, K. (2003). *Black Faces in the Mirror: African Americans and their Representatives in the U.S. Congress*. Princeton, NJ: Princeton University Press.

Thomas, S. (1994). *How Women Legislate*. New York: Oxford University Press.

Thomas, S., Herrick, R., & Braunstein, M. (2002). Legislative Careers: The Personal and the Political. In C. S. Rosenthal (Ed.), *Women Transforming Congress* (pp. 397–421). Norman: University of Oklahoma Press.

Thompson, J. A., Moncrief, G. F., & Hamm, K. E. (1998). Gender, Candidate Attributes, and Campaign Contributions. In J. A. Thompson & G. F. Moncrief (Eds.), *Campaign Finance in State Legislative Elections* (pp. 117–138). Washington, DC: CQ Quarterly.

Tubbesing, C. & Miller, V. (2007). Fractured Fiscal System (April) [Online]. <http://www.ncsl.org/magazine/weekly/SLWeeklyApr_fiscal.htm>.

Uhlaner, C. J. & Schlozman, K. L. (1986). Candidate Gender and Congressional Campaign Receipts. *Journal of Politics*, 48, 30–50.

U.S. Bureau of Labor Statistics, Department of Labor. (2009). Table 11: Employed persons by detailed occupation and sex, 2008 annual averages [Online]. <http://www.bls.gov/cps/wlftable11.htm>.

U.S. Census Bureau. (2010). Census Bureau Reports Nearly 6 in 10 Advanced Degree Holders Age 25-29 Are Women, Press Release [Online]. <http://www.census.gov/newsroom/releases/archives/education/cb10-55.html>.

U.S. Census Bureau. (2011). Statistical Abstract of the United States: 2012 (131st ed.). Washington, DC: U.S. Census Bureau. [Online]. <http://www.census.gov/compendia/statab/>.

Van Hightower, N. R. (1977). The Recruitment of Women for Public Office. *American Politics Quarterly*, 5, 301–314.

Welch, S. (1977). Women as Political Animals? A Test of Some Explanations for Male-Female Political Participation Differences. *American Journal of Political Science*, 21, 711–730.

Welch, S. (1985). Are Women More Liberal Than Men in the U.S. Congress? *Legislative Studies Quarterly*, 10, 125–134.

Werner, E. E. (1968). Women in the State Legislatures. *The Western Political Quarterly*, 21, 40–50.

Werner, T. & Mayer, K. R. (2007). Public Election Funding, Competition, and Candidate Gender. *PS: Political Science and Politics*, 40, 661–667.

Whitman, C. T. (2005). *It's My Party Too: The Battle for the Heart of the GOP and the Future of America*. New York: Penguin Press.

Wilcox, C. (1994). Why Was 1992 the "Year of the Woman"? Explaining Women's Gains in 1992. In E. A.Cook, S. Thomas, & C. Wilcox (Eds.), *The Year of the Woman: Myths & Realities* (pp. 1–24). Boulder, CO: Westview Press.

Williams, L. F. (2001). The Civil Rights-Black Power Legacy: Black Women Elected Officials at the Local, State, and National Levels. In B. Collier-Thomas & V. P. Franklin (Eds.), *Sisters in the Struggle: African American Women in the Civil Rights-Black Power Movement* (pp. 306–331). New York: New York University Press.

Wirls, D. (1986). Reinterpreting the Gender-Gap. *Public Opinion Quarterly*, 50, 316–330.

Wittmer, D. (2011). Toward a Theory of Institutional Representation: The Link Between Political Engagement & Gendered Institutions. Ohio State University. Ph.D. Dissertation.

Wolbrecht, C. (2000). *The Politics of Women's Rights: Parties, Positions, and Change*. Princeton, NJ: Princeton University Press.

Wong, J. (2006). *Democracy's Promise: Immigrants & American Civic Institutions*. Ann Arbor: University of Michigan Press.

Woodward, C. (2010). Grizzled Moderates, Not Mama Grizzlies. *The Daily Beast*. October 12 [Online]. <http://www.thedailybeast.com/newsweek/2010/10/01/susan-collins-and-olympia-snowe-face-tea-party.html>.

Young, L. (2000). *Feminists and Party Politics*. Ann Arbor: University of Michigan Press.

INDEX

abortion
 as a public policy issue, 79, 81 table
 4.3, 83–84, 86, 97
 Democratic positions on, 83–84
Abramson, P., 43
Adams, G., 83
age
 of children as factor in decision to run,
 31, 32 table 2.7, 46, 124
 of state legislators, 32, 34 table 2.9
 of children of, 33 table 2.8
 of women with advanced degrees, 26
Aldrich, J., 43, 44
Alexander, D., 4
ambition, 7, 43–44
 and a gender gap, 7–8, 11
 and women candidates, 6, 17, 43–44,
 51, 60
 citizen, 21
 theory, 42–44, 52, 59, 61, 113 table
 5.6, 124, 125
Ambrosius, M., 9
Andersen, K., 4
Atkeson, L., 132

Bachmann, Michele, 1, 71, 78
Baer, D., 10
Barbara Lee Family Foundation, 4, 14
Barrett, E., 96, 121
Bejarano, C., 105
Black, G., 43
Blair, D., 28
Bourque, S., 11
Brace, P., 43
Brady, M., 100
Bratton, K., 101, 129, 131

Braunstein, M., 19
Brooks, D., 5
Burns, N., 7–8, 132
Burrell, B., 3, 5, 9, 13, 19, 84, 86,
 113–120
Burt-Way, B., 11

candidate
 emergence, 1–17, 43, 45, 48
 gender bias in, 127
 model of, 62, 123
 training, 9
 women and, 35, 37, 125
Carey, J., 79
Carroll, S., 3, 4, 5, 6, 8, 9, 12, 19, 28,
 30, 72, 79, 90, 100, 101, 107,
 128–129, 130, 131
Carter, N., 100
Casellas, J., 104
CBS, 47
Center for American Women and
 Politics, 12, 13, 18, 64
 and credentials of women of color,
 100
 and women's movement, 87
 breakdown by party, 66, 67, 70
 gender gaps in legislative priorities,
 129
 increase of women of color office
 holders, 102, 103
 recruitment studies, 14–16, 21, 28,
 65, 75, 97
 and feminist issues, 84, 85
 methodology of, 133–134
 obstacles faced by candidate women
 of color, 106–113

Center for American (*Cont.*)
 patterns of districts electing
 legislators of color, 104
 pathways of women candidates,
 123
 regional shifts affecting candidacies,
 72–74
 Republican women as more moderate
 than Republican men, 79
 women in party leadership roles,
 90–91
 women office holders working toward
 legislation to benefit women,
 121–122, 131
Charles H. Revson Foundation, 14
Chenoweth, Helen, 78
children
 age of as a consideration for women
 deciding to run, 6, 8, 28, 31, 32
 table 2.7, 37, 41, 124, 125
 and consideration of men and women
 candidates, 47, 46
 as a priority for women legislators,
 121
 grandchildren as consideration for
 women deciding to run, 71
 of state legislators, 33 table 2.8
 organizations for, as background focus
 for legislators, 39, 55 table 3.3
Christian right movement, 77, 94
Clark, J., 3, 7, 19, 21, 25–26
Clinton, Hillary, 1
Concerned Women for America, 84
Conway, M., 101
Cooperman, R., 84
Cox, E., 66
Crenshaw, K., 100
Crespin, M., 86
Crissey, S., 70
Critchlow, D., 77
Crowder-Meyer, M., 9
Crowley, J., 129

Darcy, R., 3, 5, 7, 9, 19, 21, 25–26
Davidson, C., 104
Deber, R., 9
decision to run, 42–62, 49 fig. 3.1,
 age of children as factor, 31, 32 table
 2.7, 46
 ambition as factor, 17, 43–48, 124

first office sought, 51 table 3.1, 52 fig.
 3.2
gender and, 42–62, 125
 among Republicans, 68–69
parenting as factor, 30
political experience of candidate and,
 33, 34 table 2.9
public policy as factor, 90 fig. 4.8, 97
reasons for running, 58–60, 59 table
 3.6
spousal support of candidate and, 29
 table 2.4, 31 table 2.6, 46–47
source of encouragement, 58 table 3.5
Democratic party
 gender gap in political ideology, 95
 party identification and, 70 fig. 4.2
 party support
 importance of in decision to run,
 113 table 5.6
 of Democratic state representatives,
 111 table 5.5
 pathways of women of color, 103–106
 policy issues
 and women candidates, 90 fig. 4.8,
 94–98
 and women of color, 96
 reaction to women's movement,
 83–91
 recruitment by, 94
 to be sacrificial lambs, 109 table 5.4
 women
 and obstacles to candidacy,
 106–113, 107 table 5.3
 as major party members, 64 fig.4.1
 as state legislators in, 68 fig. 4.3,
 102 fig. 5.1, 103 fig. 5.2, 104, 105
 in party leadership, 90–91
 of color, rise of in, 93–94, 98–103
Democratic women office holders. *See*
 Democratic party; legislators,
 state.
Diamond, I., 12, 19, 72
Dietz, J., 86
Dittmar, K., 5, 9
Dodson, D., 13, 79
Dolan, K., 5, 19, 47–48, 82, 132
Duerst-Lahti, G., 46–47

Eagle Forum, 84
Eagly, A., 45

ideology (*Cont.*)
 rightward shift of Republican Party,
 66, 77–83, 80 fig. 4.6, 81 table
 4.3, 79, 84
impediments to women candidates,
 20–22,
incumbency, effect on women
 candidates, 3, 20
interview questions used, 134–135

Jacobson, G., 43
Jacobson, L., 67
Jenkins, K., 4
Jensen, T., 77
Jewell, M., 44
Johannesen-Schmidt, M., 45
Johnson, M., 12, 72, 79
Jones, N., 101
Jones-Correa, M., 101
Junn, J., 12, 101

Kahn, K., 4, 5, 9
Karol, D., 83
Katzenstein, M., 98
Kaufmann, K., 69, 70
Kelly, R., 11
Kernell, S., 43
King, D., 82, 100
Kirkpatrick, J., 6, 7, 12, 19
Kittilson, M., 10
Koch, J., 82
Krook, M., 10

Lawless, J., 5, 7, 8, 9, 21, 43–44, 46–47,
 114, 127, 132
Leader, S., 79
League of Women Voters, 72
Lee, M., 6, 7, 30
legislators, state
 age of, 34 table 2.9
 as pipeline to national office holding,
 13
 civic involvement prior to candidacy,
 55 table 3.3
 data on, 14–16
 decision to run, 42–62, 48–53, 49
 fig.3.1
 age of children as factor, 31, 32
 table 2.7
 public policy as factor, 97 table 5.1,
 99 table 5.2

reason to run, 59–60, 59 table 3.6,
 90 fig, 4.8
Democratic women as, 67, 68 fig. 4.3,
 93–122
 increase in numbers of women of
 color, 93
 organizational memberships prior
 to candidacy, 85 table 4.4, 86
 table 4.5
 public policy and Democratic
 women's representation, 93,
 94–98
 regional shifts affecting, 72–74
educational attainment of, 27 table
 2.3, 37
family factors of, 28–33
first office sought, 51 table 3.1
gender
 differences in occupation before
 candidacy, 124
 differences on issues, 81 table 4.3
 fund-raising and, 117 fig. 5.3
 gaps in legislative priorities,
 128–132
in New England, 12
increase in governance of current
 issues, 13
marital status of, 30 table 2.5
parental status of, 33 table 2.8
party support of Democratic state
 representatives, 111 table 5.5
political experience of, 33, 34 table 2.9
Republican women as, 63–94, 65 fig.
 4.1, 68 fig. 4.3
 decision to run, 68–69
 gender of party leaders' effect on
 recruitment, 90
 party support for, 74–77, 76 table
 4.1, 77 table 4.2
 organizational memberships prior
 to candidacy, 85 table 4.4, 86
 table 4.5
 regional shifts affecting, 72–74, 74
 fig. 4.5
 shrinking pool of, 69–72
 trends in, 66–68
 See also Republican party, shifting
 ideology of
spousal support of, 31 table 2.6
spouse/partner approval, 29 table 2.4
successful pathways to, 16–17, 18–41

women in, 12–14
 breakdown by party, 65 fig. 4.2
 fund-raising by, 114–120, 117 fig.
 5.3, 118 table 5.7, 120–122
 impact of, 128–132
 occupation backgrounds of, 21–25,
 23 table 2.1, 24 table 2.2
 women of color in, 101, 102 fig. 5.1,
 103 fig 5.2, 103–106
 See also women's movement
Leighton, M., 5, 127
Lien, P., 100, 101
Lublin, D., 104

Maestas, C., 43
Maisel, L., 43
Mansbridge, J., 2, 83
marital status
 and support by spouse of state
 legislators, 31 table 2.6
 impact on decision to run, 6, 29 table
 2.4
 of state legislators, 29, 30 table 2.5
Martinez, Susana, 121
Matland, R., 82
Mayer, K., 120
McCain, John, 70
McCarthy, S., 78
McClain, P., 100
McDonagh, E., 132
McGhee, E., 43
McGrath, W., 7
McKenna, Dolly Madison, 78
McKenzie, W., 14
Melich, T., 84, 87
Miller, V., 13
Mohanty, C., 100
Moncrief, G., 44, 100, 114
Morella, Connie, 77
Mueller, C., 69
Mulligan, C., 18

National Center for Education Statistics,
 26
National Conference of State
 Legislatures, 13, 32, 67
National Organization for Women
 (NOW), 84, 85
National Women's Political Caucus, 4
Newman, J., 5, 127
Niemi, R., 79

Niven, D., 9, 110, 127

Obama, Barack, 128
occupations
 and women of color as candidates, 100
 and pathway to office, 19, 20, 21, 37,
 38, 41, 43, 64, 110, 123
 as a measure of the gender gap in
 participation, 7, 8, 112, 124, 131
 backgrounds, 21–25
 of state representatives, 23 table 2.1
 of state senators, 24 table 2.2
 female-dominated, and participation,
 25, 37
 law or business as background for
 male legislators, 7, 36
 status of women in, 28
 women and the importance of
 occupation in deciding to run, 39
organizations
 antifeminist, 83
 children's, 39
 church-related, 39
 civic, 55
 community, 55
 feminist, 83, 85, 86
 giving encouragement to potential
 candidates, 62, 125
 involvement in as candidate
 credentials, 38, 39, 54
 importance in decision to run, 2, 9,
 62, 56 table 3.4
 of women state representatives, 85
 table 4.4
 party, 90
 professional, 39, 55
 service, 39
 women's, 9, 10, 56, 84, 86, 98, 126,
 130
Osborn, T., 130

Palin, Sarah, 1, 71
Palmer, B., 5, 13, 43, 127
party leaders' effect on women
 candidates, 6, 10, 17
pathways to office, 18–41, 84, 103–106,
 123
 alternative, 16
 and PACs, 84
 assimilation model, 20, 36–40
 civic activism, 39

pathways to office (*Cont.*)
 convergence model, 20, 36–40
 education and, 25–28, 27 table 2.3
 gendered, 10–12, 16, 17, 19, 21, 126
 implications for recruitment, 36–39
 occupational backgrounds and, 21–25,
 23 table 2.1, 22 table 2.2
 of women of color, 103–106, 123–128
 persistent differences model, 20
 women's, 19, 124
Pearson, K., 5, 43, 77
Pelosi, Nancy, 1
Petrocik, J. R., 69
Pew Research Center, 18
Philpot, T. S., 100
Pierson, P., 77
political action committees (PACs), 9,
 84, 122
 EMILY's List, 94, 114
political opportunity, 3–4
 affecting ambition, 44, 51, 61
Powell, L., 79
presidential candidates, women as, 1
Prestage, J., 7
public policy
 and attitudes of Republican women
 legislators, 79
 and left-leaning candidates, 95
 as motivation for candidates, 90 fig.
 4.8, 94–98, 97 table 5.1, 99 table
 5.2, 131
 as motivation for Democratic women
 and women of color, 17, 93, 121
 with advanced degrees, 112
 as motivation for legislators, 59 table
 3.6
 women in forefront of, 14, 72, 128
Public Policy Polling, 77
Puwar, N., 47–48

Ramirez, R., 101
Rankin, Jeannette, 66
Rawls, C., 77
Reagan, Ronald, 18, 77, 94
recruitment
 and changing the occupational
 distribution of women, 20, 21
 and women with young children, 46
 by the Republican party, 17
 gender and, 42

gender of party leaders effect on, 90,
 127
 implications for, 36–40
 political sources and, 57
 role of party leaders, 9, 38, 66, 108,
 109 table 5.4, 110, 111 table 5.5,
 112, 113 table 5.6, 125, 127
 and women of color, 105
 Democratic, 94, 105, 107
 Republican, 69, 89, 92, 126
 to encourage women to run, 2, 16, 44,
 52, 60, 61, 130
 women's organizations and, 86
 See also Center for American Women
 and Politics
region
 and women among Republican State
 Legislators in , 74 fig. 4.5
 changes in Republican Party strength,
 66, 92
 shifts in party strength, 72–74
Reingold, B., 101, 129, 131
relationally embedded candidacy, 17,
 43–48
 women and, 56, 59, 62, 68, 125
Republican party
 conservative attitudes in candidates,
 82
 gender and decision to run, 68–69
 party identification and, 70 fig. 4.2
 public policy issues and women
 candidates, 90 fig. 4.8, 94–98
 reaction to women's movement,
 83–91
 shifting ideology of, 77–83, 80 fig.
 4.6, 95
 trends in women's office holding,
 66–68
 women as major party members, 64
 fig.4.1
 shrinking pool of, 69–72
 women as state legislators, 68
 fig. 4.3
Republican women office holders. *See*
 legislators, state
Rohde, D., 43
Rosener, J., 45
Rosenthal, C., 131
Rozell, M., 9
Rymph, C., 71

women's movement
 and electing women to public office,
 9, 83–91
 party reactions to, 83–91
Wong, J., 101

Woodward, C., 77